THIS LAND

An American Portrait

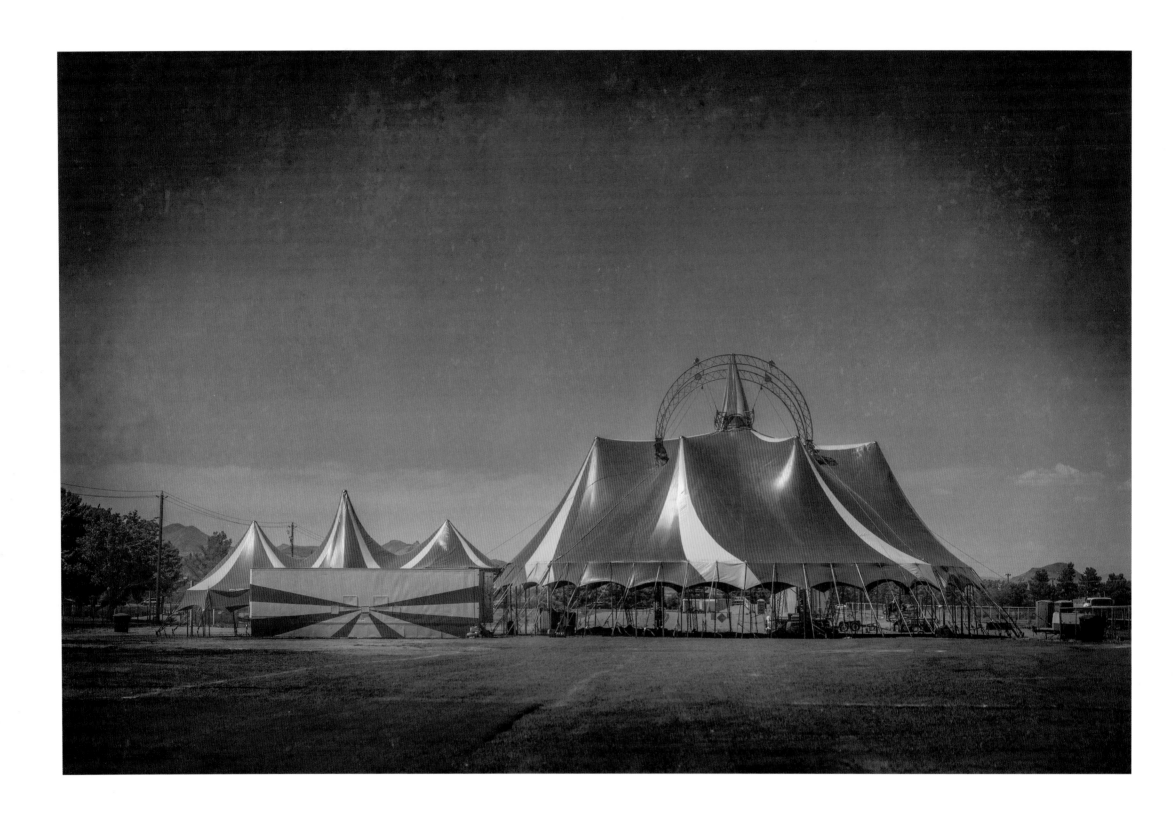

THIS LAND

An American Portrait

JACK SPENCER

Foreword by Jon Meacham

University of Texas Press　AUSTIN

Requests for permission to reproduce material from this work should be sent to:
Permissions | University of Texas Press | P.O. Box 7819 | Austin, TX 78713-7819
http://utpress.utexas.edu/index.php/rp-form

∞ The paper used in this book meets the minimum requirements of
ANSI/NISO Z39.48-1992 (R1997) (Permanence of Paper).

LIBRARY OF CONGRESS CATALOGING DATA
Names: Spencer, Jack, author, photographer. | Meacham, Jon, writer of supplementary textual content.
Title: This land : an American portrait / Jack Spencer ; foreword by Jon Meacham.
Description: First edition. | Austin : University of Texas Press, 2017.
Series: The William and Bettye Nowlin series in art, history, and culture of the Western Hemisphere
Identifiers: LCCN 2016014230
ISBN 978-1-4773-1189-9 (alk. paper)
Subjects: LCSH: Landscape photography—United States. | United States—Pictorial works.
Classification: LCC TR660.5 .S68 2017 | DDC 770.92—dc23
LC record available at https://lccn.loc.gov/2016014230

Frontispiece

CIRCUS TENT

2014, Needles, California

THE WILLIAM & BETTYE NOWLIN SERIES
in Art, History, and Culture of the Western Hemisphere

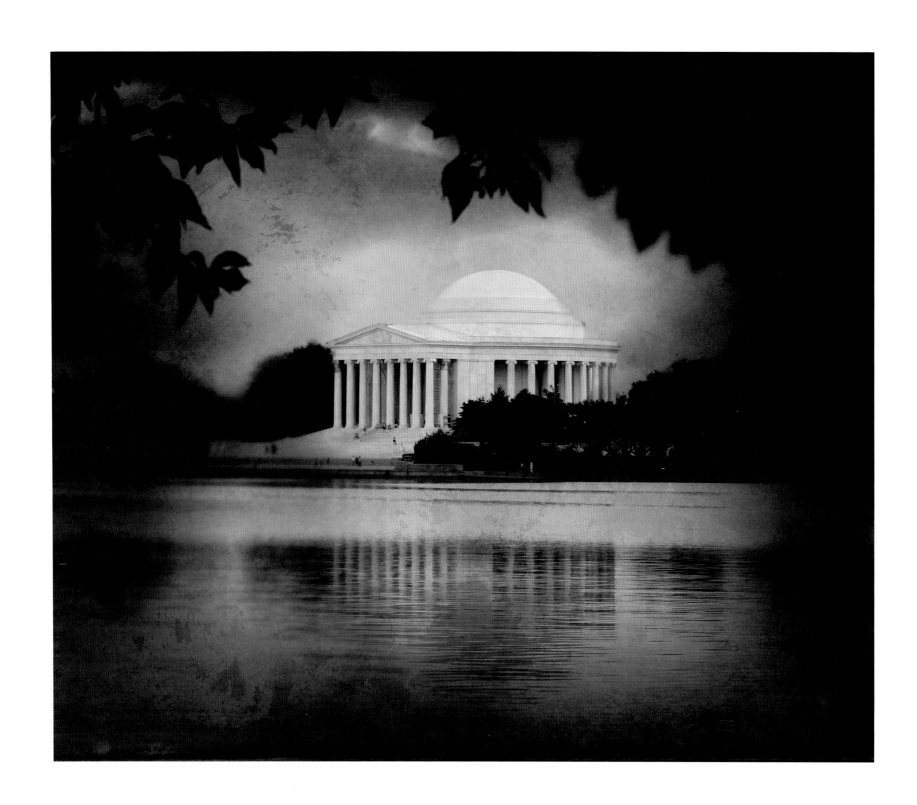

JEFFERSON MEMORIAL

2007, Washington, DC

FOREWORD

Jon Meacham

It had been a long day. On New Year's Eve 1950, after hours of work on a novel, Shelby Foote sat down to send holiday greetings to his friend Walker Percy. Musing about the nature of their common literary concerns, Foote was feeling philosophical, and he offered a definition of the single overriding duty of an artist. "Some want to teach (or preach); some want to communicate sensation," Foote wrote. "I suppose I want a share in both of those. Yet I think I know at last what it is that I really want. I want to teach people how to *see*."

I thought of Foote's old letter as I looked through the powerful and surprising images Jack Spencer has brought together in this collection. Great art of any kind—written, photographed, painted, sung—is great not least because it is at once temporal and transcendent. When something particular (a page, an image, a song) suggests something universal, then we know that we are in the presence not of the ephemeral or of the manufactured but of true art—the work of a master's hands—that engages us not only in the moment (though it does that) but also alters everything else we see. Because the honest artist does not merely entertain, he informs and ultimately transforms.

Such is the journey you are about to undertake. Spencer has given us an important gift. Like Steinbeck or Kerouac—or, perhaps the closer analogy, Huck Finn—Jack "lit out for the territories" in 2003 to create a series of images of an America in search of its footing in the aftermath of the attacks of September 11 (the bloodiest day on American soil since Antietam) and on the cusp of the Iraq War. The country he found was various and wondrous, mundane and sublime, elusive and explicable. There are magical photographs of a wooded path on Cumberland Island, Georgia, a dirt road in West Texas, and you will encounter pictures that will put you in mind of Hopper or O'Keefe or Grandma Moses. You will visit Panther Burn, Mississippi; Washington, DC; Death Valley, California; Pine Ridge, South Dakota.

You will, however, see few faces. This is a portrait of America, not of Americans, and that is an important point. There are not many people in these pages. The landscapes of our lives take center stage—an abandoned classroom, an old jail, a café on Route 66. Spencer was largely struck, it seems, by two kinds of reality: that of the created order (mountain ranges, ocean horizons), and what men have made of that order (shops, statues). It is almost as though

Spencer is saying, with Woody Guthrie, that this land is your land, even if—maybe *especially* if—the regions seem remote from our daily worlds. There is something else, too: many of the photographs suggest that someone has just been there, in the frame, but time and chance have taken them away, just as time and chance will take all of us in the end. Spencer's America, then, is a transitory place, a place forever in flux. Whether we are progressing or regressing is a question Spencer leaves us to answer as we travel in his footsteps, encountering landmarks in ruins or, at least, on the edge of a broad cultural dusk.

An odyssey is, of course, an ancient and venerable artistic device. What does Spencer's thirteen-year project tell us about ourselves? That the glib and the generic are just that: glib and generic. These are challenging images of an America that, defying easy categorization, inspires eternal investigation. From Tocqueville forward, travelers have sought to understand the mysterious nature of a nation so large and so varied that it inevitably exhausts even the most indefatigable of searchers. And yet the quest goes on.

One image recurs in these pages: that of Thomas Jefferson, both on the Tidal Basin and, nearly a continent away, on Mount Rushmore. This is fitting, for Spencer is working in a Jeffersonian tradition, seeking out the truth as best he can, hoping for the best in an imperfect world. "Mr. Jefferson meant that the American system should be a democracy," wrote the historian Henry Adams, "and he would rather have let the whole world perish than that this principle, which to him represented all that man was worth, should fail." There is a similar kind of tragic optimism, if you will, to this book. "Whatever they can, they will," Jefferson wrote of Americans. At least, so he hoped, and his hope was rooted in the sheer size of the country, in the endless possibilities of the West, a region Spencer explores with the precision and the passion of Lewis and Clark.

To me, the compelling meaning of Spencer's work is that we remain a frontier people. Modernity could be said to have begun at sundry points—Gutenberg, the Protestant Reformation, the American and French Revolutions. One thing is clear: the US government declared the end of the frontier in 1890. Spencer, I think, disproves this. His most surprising images are of a country that I suspect many of us believed had disappeared. The fading churches, the roaming bison, the running horses: Spencer has found a mythical world, except it is real, and it is now, and it is ours.

That is what he has taught me to see.

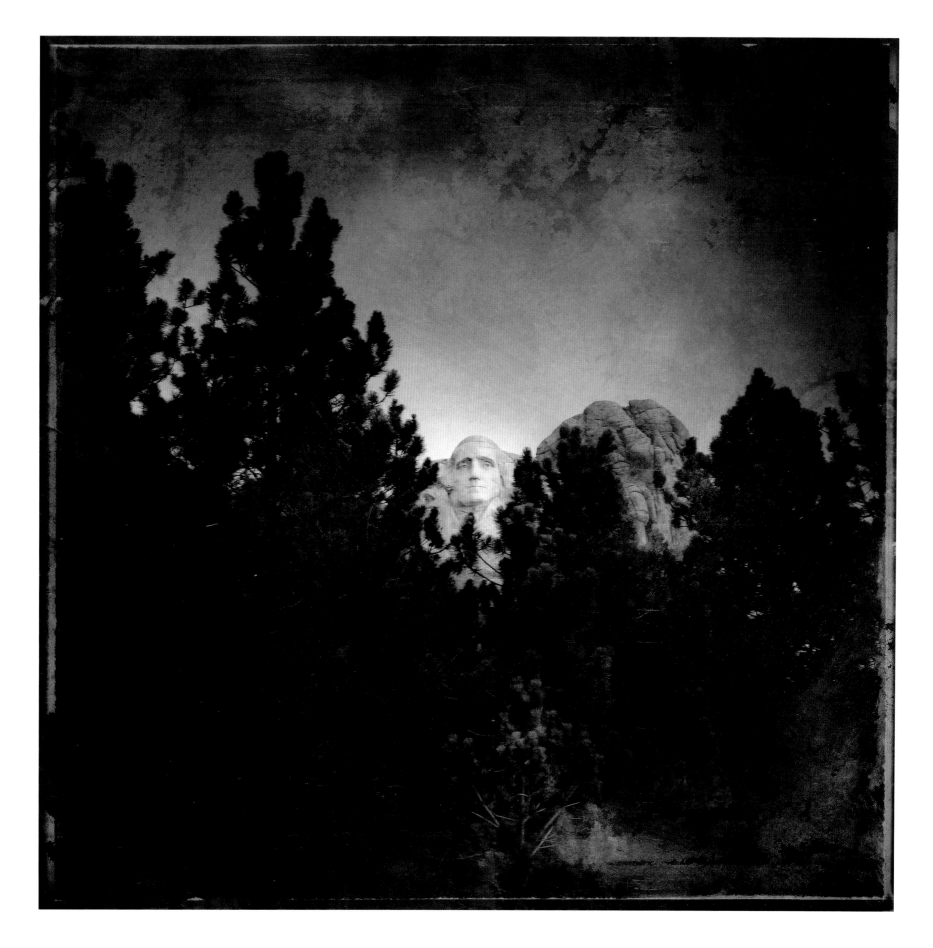

MOUNT RUSHMORE

2005, South Dakota

Until we understand what the land is, we are at odds with everything we touch. And to come to that understanding it is necessary, even now, to leave the regions of our conquest—the cleared fields, the towns and cities, the highways—and reenter the woods. For only there can a man encounter the silence and the darkness of his own absence. Only in this silence and darkness can he recover the sense of the world's longevity, of its ability to thrive without him, of his inferiority to it and his dependence on it. Perhaps then, having heard that silence and seen that darkness, he will grow humble before the place and begin to take it in—to learn from it what it is. As its sounds come into his hearing, and its lights and colors come into his vision, and its odors come into his nostrils, then he may come into its presence as he never has before, and he will arrive in his place and will want to remain. His life will grow out of the ground like the other lives of the place, and take its place among them. He will be with them—neither ignorant of them, nor indifferent to them, nor against them— and so at last he will grow to be native-born. That is, he must reenter the silence and the darkness, and be born again.

WENDELL BERRY
THE ART OF THE COMMONPLACE:
THE AGRARIAN ESSAYS OF WENDELL BERRY

Trees go wandering forth in all directions with every wind, going and coming like ourselves, traveling with us around the sun two million miles a day, and through space, heaven knows how fast and far!

JOHN MUIR
JOHN OF THE MOUNTAINS:
THE UNPUBLISHED JOURNALS OF JOHN MUIR

THIS LAND

Jack Spencer

Recently, on my final shooting trip for this book, I was traveling on New York Highway 14 along the western flank of the Finger Lakes on my way to Watkins Glen. It had been a very long day, starting at five a.m. in Pennsylvania, then up to Buffalo and on to Niagara Falls, which turned out to be a jarring experience. This is a place I'd always wanted to visit, and like the Grand Canyon it's challenging to describe adequately in words or pictures. Surrounding the falls on both the US and Canadian sides is a tourist-trap riot of motels and fast-food joints and lame attractions, and most people seem more interested in taking "selfies" than in this powerful scene that nature has displayed before them. Although the falls are truly spectacular, the overwhelming crowds and runaway commercialism were so unsettling that I couldn't wait to get out of there.

As I continued south on Highway 14 that same evening, on a bucolic and peaceful stretch in the dramatic early-evening light that some photographers refer to as "the golden hour," out of the corner of my eye I saw a young girl—perhaps ten or twelve years old—running down a hillside. Out of instinct I braked slightly, causing the tailgater behind me to lean on his horn, no doubt in a great hurry to get someplace hugely important. (I'm quite used to such impertinent impatience, having logged nearly 80,000 miles over the past thirteen years and being dogged by would-be speed demons during the entire odyssey, missing some great shots because of them.) The scene itself was out of an Old World painting. The girl was Amish, wearing a plain cotton dress, with bonnet in hand as she scurried down to the mailbox, conceivably to retrieve handwritten letters—nowadays unheard of—from family and friends. Above her on the hill, her two sisters watched from a horse-drawn wagon. The fantastic light and the tumbling landscape, along with three wonderful subjects, was an artist's dream. But there was no chance of capturing this, not with a car riding my bumper and nowhere to pull over. So I drove on, dismayed but thrilled by the experience of an extraordinary moment that has stayed with me ever since, as an idyllic reminder that the simplest of lives are often the happiest as well. The Amish are of course an anomaly in American culture, and as alien to most of us as actual extraterrestrials. Though I disagree with their religious strictures, I admire their tenacious independence and the purity of their way of life. Also, you never see them flipping off other travelers.

The contrast between that scene and the America I found elsewhere on my journey is stark and bracing. This society has a deepening, narcissistic and consumer-driven neurosis that urges its members to buy something—*anything*—in order to fill some unidentified hole in their lives, and to get someplace—*anywhere*—as quickly as possible. The majority are largely oblivious to the world around them, and fail to notice golden-hour light steaming across the lake or any of the other tranquil and poetic instances that occur almost daily, and not only in wonderland circumstances. To be sure, there are many people whose awareness is attuned to the America I was looking for. But on these trips, I was constantly stunned by the sheer volume of sleepwalking masses.

Having been through all of the lower forty-eight states, I've seen hundreds and hundreds of towns and cities that were homogenized by countless nationwide restaurants, big-box stores and massive shopping malls—all owned by the same corporations whose employees shuffle their salaries between one outlet or another in an insane economic system in which the only profit shown, other than the workers' minimum wages, is funneled through some distant headquarters and then distributed to Wall Street investors and finally out into some mystical global ether. Like Niagara Falls or the Grand Canyon, but on the other end of the spectrum entirely, this too is mind-boggling. Yet few people ever notice, because it has become so ubiquitous that it just seems "normal." A glaring exception to this is European friends who, when visiting me, are astonished by the rawness of this phenomenon, and shocked and saddened that so few Americans ever really see the beautiful land they inhabit—too distracted by the cars, phones, televisions, toys, and games that enable them to squander their time, after working so incredibly hard to attain these things in the first place. I'm not religious by any means, but a phrase from the

Gnostic Gospels of Thomas does come to mind: "The kingdom of heaven is spread out across the earth but men do not see it."

In this project I've elected to stay far away from Americans per se, though their existence is evident throughout the book—in Dearborn and Detroit, Toledo and even Lost Nation, Iowa, for that matter. This is the dichotomy of my country. If there's a single word that might define it, I believe it's *irony*. I have an idea of America as a vast cacophony of contradictions: at once loved/hated, ugly/beautiful, rich/poor, wise/ignorant, sublime/obnoxious, enormous/small, new/crumbling, crowded/desolate, and on and on. Literally, every last adjective and its antonym can describe it.

I began this pilgrimage in 2003. Although I had already made landscape and Americana images for many years, a scant few of those are included in this volume, where the main body of work was done following the attacks of 9/11. The United States invaded Iraq on flimsy evidence, and with what I perceived to be an outrageous fervor for vengeance of any kind against whatever target seemed obvious and available. *Shock and Awe. These Colors Don't Run.* This jingoistic zealotry and flag-waving vitriol completely unnerved me. By coincidence, an exhibition of my photographs was scheduled in Ketchum, Idaho, that summer, and instead of flying there I decided to drive, in hopes of making a few "sketches" of America in order to gain some clarity on what it meant to be living in this nation at this moment in time. I wanted to avoid, as much as possible, flagrant symbols of that endemic hatred, whether signs or slogans or barns painted red, white, and blue. That seemed to me low-hanging fruit. I was looking for deeper, more ambiguous metaphors that might reveal my country.

On that trip I drove over nine thousand miles in six weeks, mostly on back roads to escape the interstate highways

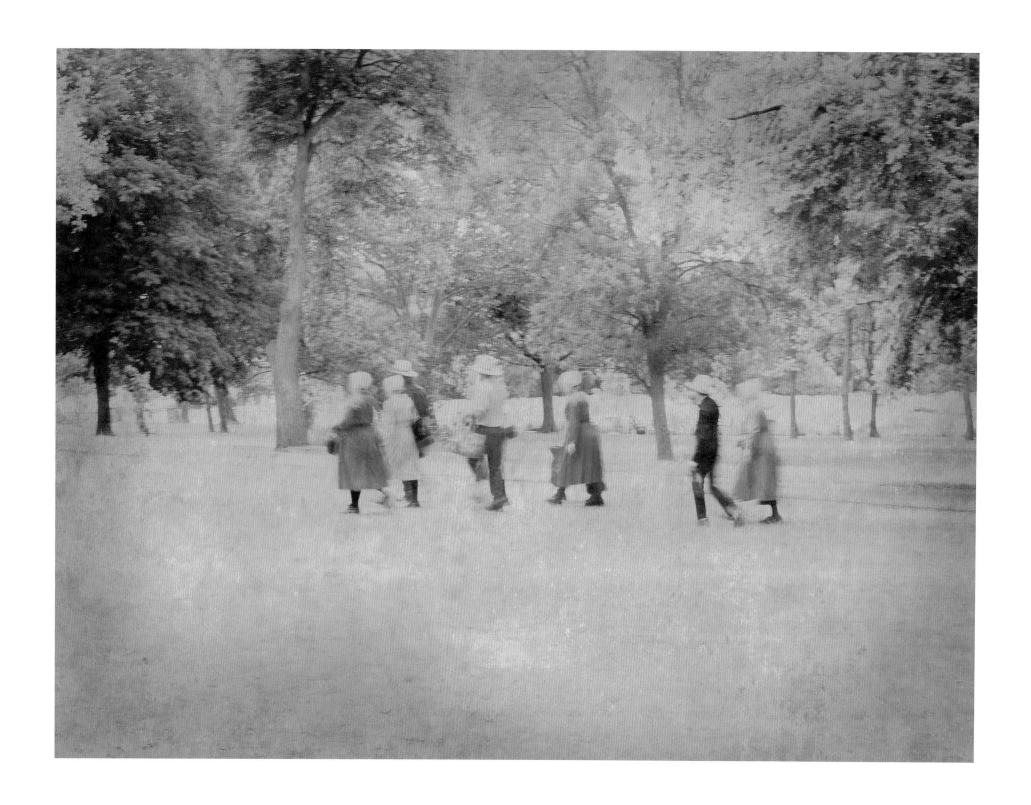

MENNONITE TOURISTS

2016, Niagara Falls, New York

and those generic offenses. Initially, anger made me tear and distress my first prints to an extreme degree, pouring on caustic substances and bending and even burning them as an expression of my disgust with what had become an increasingly strange land. In the images *Wounded Knee, Fourteen Trees of Wounded Knee* and *Mount Rushmore*, I hoped to expose some of the bones rattling around in what I'd begun to consider America's closet. Our greatest sins include slavery, the Civil War, Vietnam, and Iraq, but let's start with the near genocide of the *only* native Americans. For example, there was the grievous crime of the 1868 treaty that granted a vast expanse of land to the Sioux "for all of perpetuity," only to be ripped up once gold was discovered in the Black Hills of South Dakota. Later, Sitting Bull, Crazy Horse, and Red Cloud heroically defended their people from the likes of George Armstrong Custer and William Tecumseh Sherman, who planned to end the Indian Wars by killing, up to the point of extinction, the millions of buffalo that had provided their tribes' livelihood. (Ironically, Sherman was named after the great Shawnee warrior chief Tecumseh.) Then there was the massacre at Wounded Knee of over two hundred unarmed old men, women, and children, mowed down with Hotchkiss guns; for this, twenty soldiers were awarded the Medal of Honor, while the bodies of their victims were left lying in deep snow for three days (near the site of *Fourteen Trees*). This was followed by Americans carving into one of their sacred mountains, now casually known as Mount Rushmore, the likenesses of politicians who were no "Great Fathers" to the natives—just more salt in their wounds. Finally, the more recent events at Oglala and Pine Ridge made me ashamed to be a white man.

On subsequent trips, my rage slowly mellowed and I started to incorporate color into the pictures. I also began to realize that the things embittering me told only a small part of what this country was truly about. However, the themes of space and loneliness kept recurring, the infinite emptiness, the detritus of abandonment, and how relentlessly time erodes everything—these became the running intent of my work. The America I thought I'd been promised had by now become only a fading nostalgia, at best an evanescent myth. Animals became my symbols and metaphors of the country's past, along with decrepit, once-proud structures. Also apparent during my travels was the inescapable and breathtaking beauty of this massive land—a beauty sometimes far too profound to ever be registered by any machine. I often didn't even bother to take out my camera. Sitting in a redwood forest in northern California or in a wheat field in North Dakota at dawn, I simply enjoyed and immersed myself in what I was witnessing. There were many moments of sublime quiet and wonder, and these visions soon outweighed my anger and aggravation.

This book is not a documentary or dogmatic statement, but rather an expression of the perception of an ideal. The inspiration of painters such as Rothko, Bierstadt, and Hopper is evident in some cases, though *photographic* influence rarely is. The images and how they are rendered is more from a "stream of consciousness" perspective than the effort to produce "perfect" pictures. I make no apologies for that. I am a pictorialist at heart and have only slight regard for what the machine itself records, other than as a jumping-off point. I don't place a lot of stock in the literal, and always think that something mysteriously implied gives you more information than so-called facts.

Hardly a *National Geographic* survey, these are my own observations of where we're living, on a planet orbiting a star at 70,000 miles per hour. That star and solar system orbit the center of our galaxy, the Milky Way, at half a million miles an hour. That galaxy revolves around the universe at 1.2 million miles per hour, so a single orbit—the galactic

year—takes a mere 225 million years. However ridiculously solipsistic this is, given how infinitesimally tiny we are, our importance seems magnificently grand to us. We consider ourselves self-contained, here on this incredible swath of land on this speck of a planet. Our wars and politics and environmental concerns are petty and meaningless to the universe, which has perhaps a hundred billion planets that fall into the "Goldilocks" category of those that have liquid water and can support life. Many of them likely have civilizations far older than our own.

Over those thirteen years and 80,000 miles—at about an hour of the Earth's orbital speed—I saw not only the astonishing beauty of this land but also scars of change ever more blatant and pervasive. Strip mines, fracking, drought, overdevelopment, raging fires, disintegrating infrastructure, habitat loss, and intolerable traffic congestion all contribute to an epic tragedy that has gone unchecked in favor of greed and, even worse, political avarice and apathy. Yet somehow the land endures, almost as if to say: "I will survive you. You are not necessary. You can go now. I've sustained you long enough, for so little gratitude in return." And at the rate the climate is warming, this sustenance might not last much longer.

It seems more and more difficult to defend humanity as we bumble toward the precipice. We are young and relatively unevolved as a species. As *Homo sapiens* we've been walking upright for only about 200,000 years and have had a semblance of agriculture for 10,000 or so. Lewis and Clark explored the American West just over two hundred years ago, and Einstein's theory of relativity is barely a hundred years old. Television and telephones became common sixty years ago, the personal computer around twenty, and the iPhone barely ten. Considering that the Big Bang occurred some 14 billion years ago and the creation of the Earth just 4 billion,

essentially we've only been around for a few seconds. We're youngsters, really. Youngsters who play with loaded guns, nuclear weapons, and unbridled indulgence.

If we don't blow ourselves to smithereens or burn ourselves down to ash, we might yet evolve into beings who regard this planet as our wonderful home: a home that should be honored and cared for, instead of exploited so we can make more money to buy things we don't need, or wage senseless wars so we can acquire more and more of an increasingly archaic form of energy, namely fossil fuels. Humanity's watch over the land hasn't been what anyone could call "good stewardship."

This land of ours is utterly amazing. What we've done to it is far less admirable. Thanks to visionaries like Theodore Roosevelt, John Muir, and others, a lot of it has been preserved in pristine condition. A lot more should be protected and allowed to return to its natural state. I'm not sure if there's any way to undo the wrongs that have despoiled the land and continue to be recklessly committed. Being an idealist about how we should treat life on Earth, I always think there is some hope. My misanthropic side, of course, argues that improvement will come only after some lesson-inducing cataclysm. It is not likely that people will finally wake up on their own, suddenly enlightened, and realize the environment that gives us life is worth safeguarding for future generations. As John James Audubon once said, "A true conservationist is a man who knows that the world is not given by his fathers, but borrowed from his children."

As this body of work comes to a close, I walk away with some strata of personal knowledge about this land. I have sought to display that understanding with either brutal metaphors or more graceful visions. It is a wholly subjective interpretation, and of course not without bias. But tell me, who can be unbiased in their notions of America? None

of us see the same country. We should, nonetheless, see the grave peril that apathy or ignorance ensures, regardless of political party, religion, education, or economic and social status. To save the Earth cannot be left to the worst of us. To ignore (the root word of ignorance) is "to refuse to take notice of," and that's exactly what people who believe preservation should be restricted to national parks and coastlines are doing. Some even think these paltry gestures are too much. It should go without saying that our own backyards are certainly worthy of protection. Still, there is a lot of ignoring going on.

In 1951, when I was born, the world's population was around two and a half billion people, with about 150 million living in the United States. In 2016, as I write this, the former number has tripled to seven and a half billion and our own population has more than doubled to 320 million. By 2050, both numbers are expected to skyrocket, respectively, to upwards of nine and a half billion and 420 million people. With ever-recurring environmental catastrophes— droughts, floods, and rising sea levels, not to mention gratuitous political fiascoes like the one in Flint, Michigan—how can the human race maintain itself in an even more intensely dystopian world? Do you know how to grow your own food, build a shelter, and make clothes for yourself and your family? Do you respect the land you live on, and on which your very survival depends, as well as that of every last one of your descendants?

Maybe the Amish are on to something. . . .

THIS LAND

An American Portrait

MOUNT HOOD

2014, Oregon

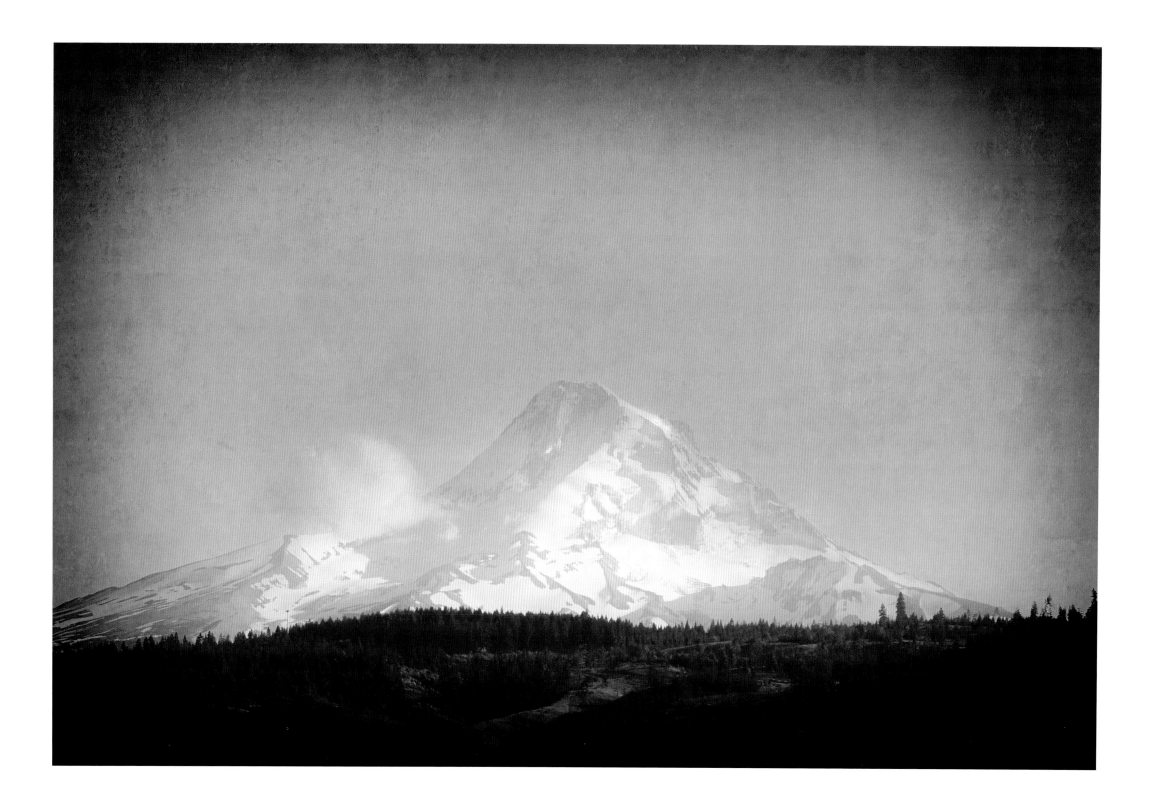

OREGON SILO

2014, Eastern Oregon

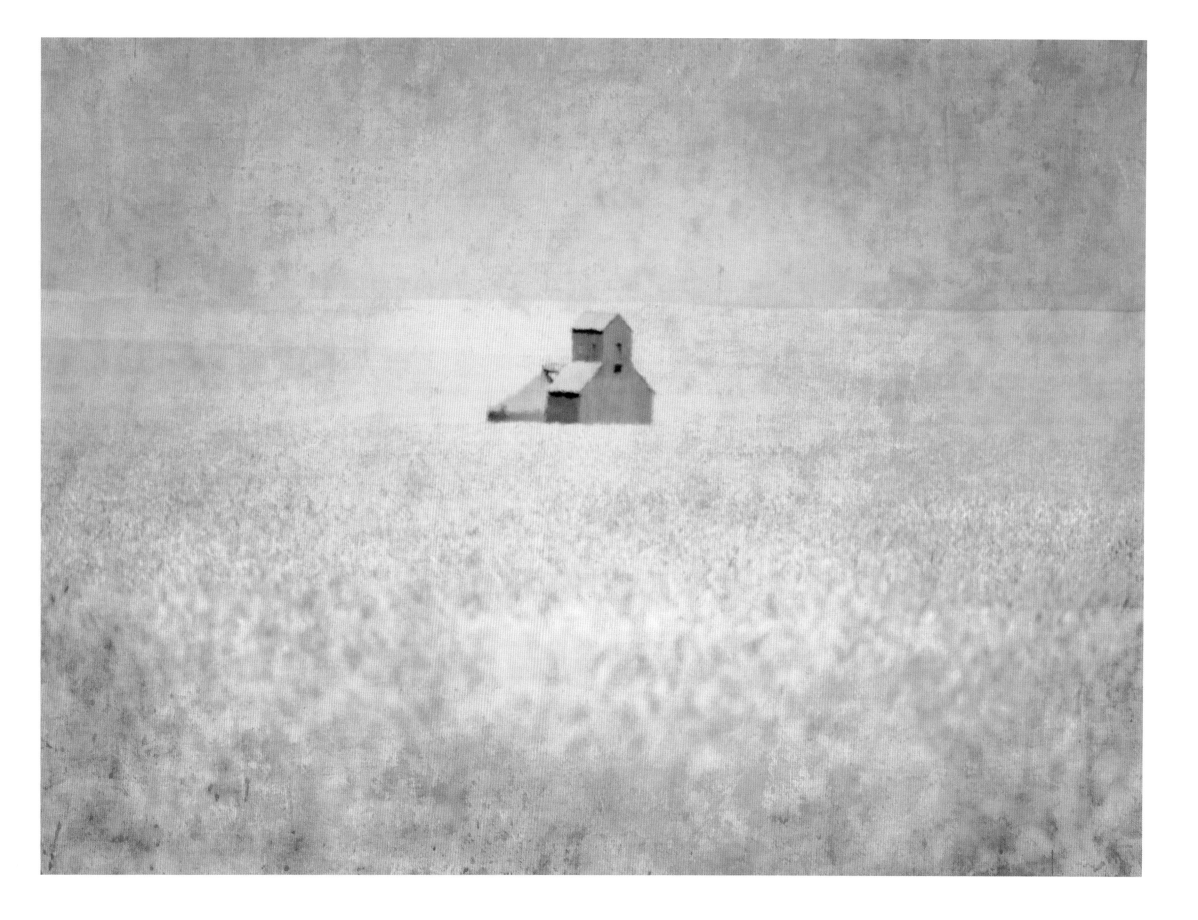

SECOND HAND

2014, Baker City, Oregon

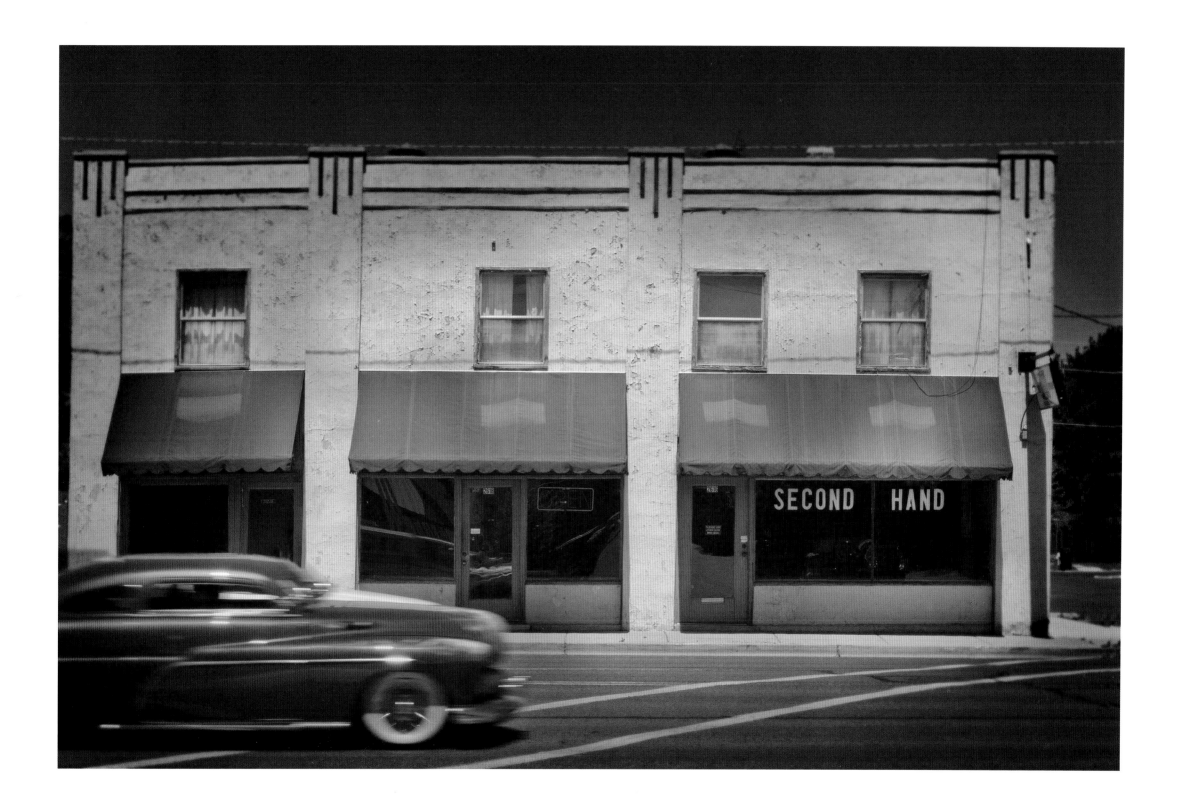

OREGON SILO, DUSK

2014, Oregon

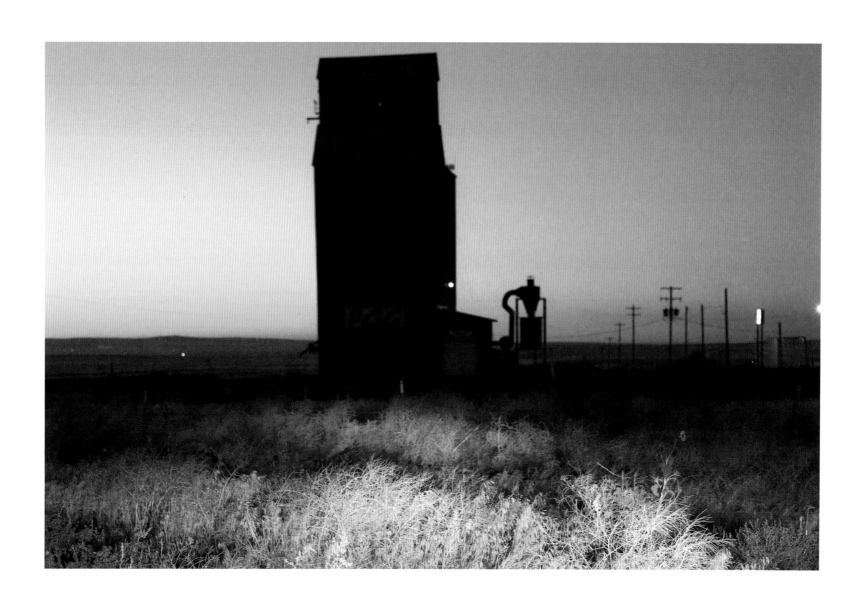

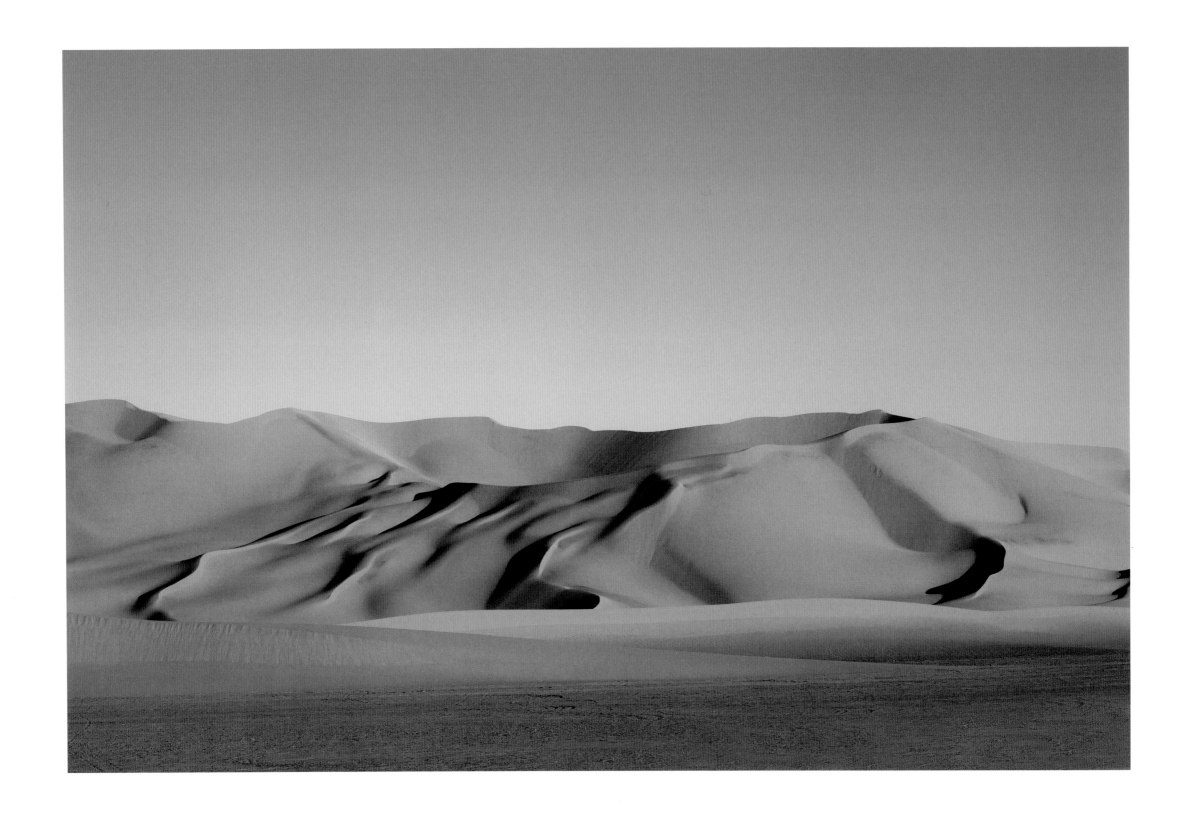

DUMONT DUNES

2014, California

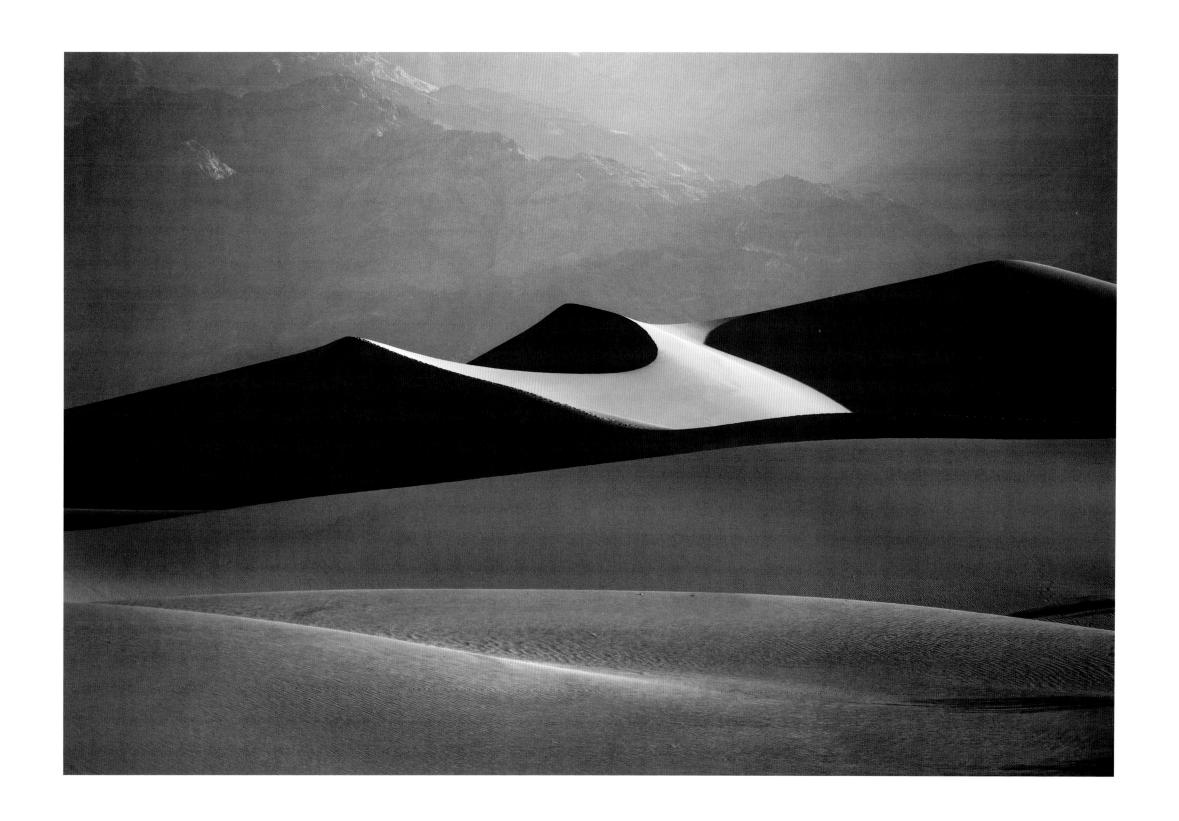

DUNES / FUNERAL MOUNTAINS

2014, Death Valley, California

ABOVE THE FOG

2014, Eureka, California

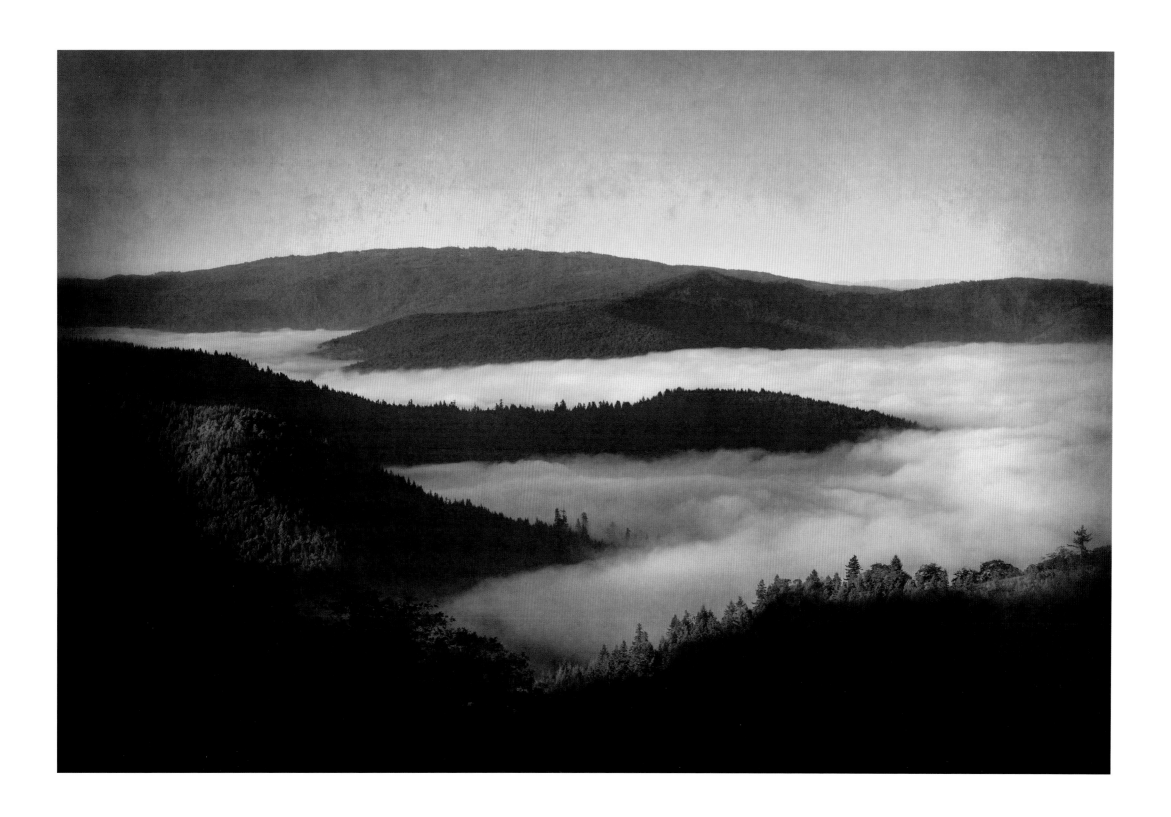

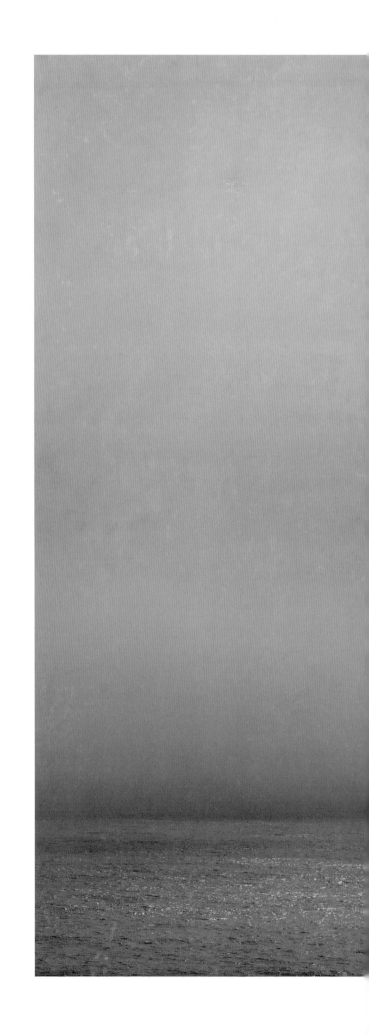

FOG BANK

2014, California

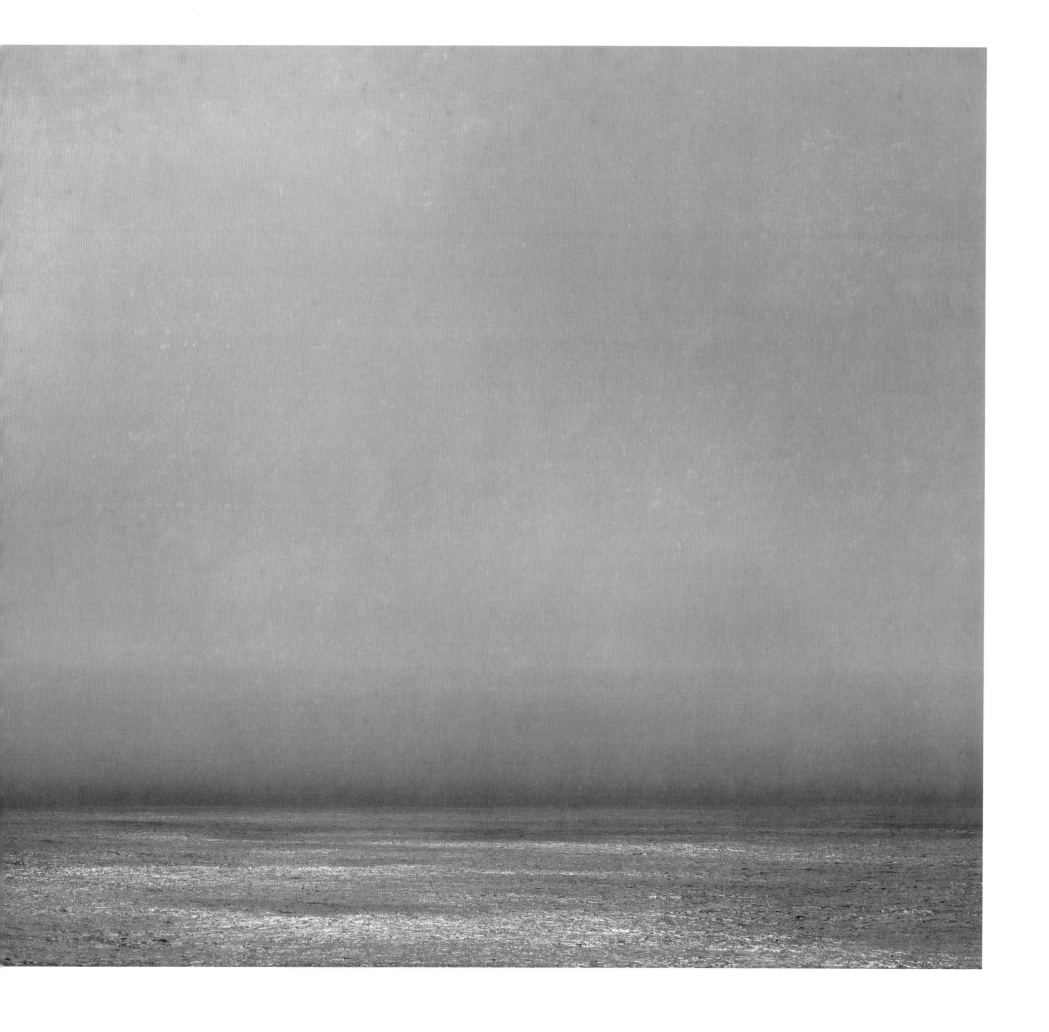

CARNIVAL CLOUD

2001, Santa Monica, California

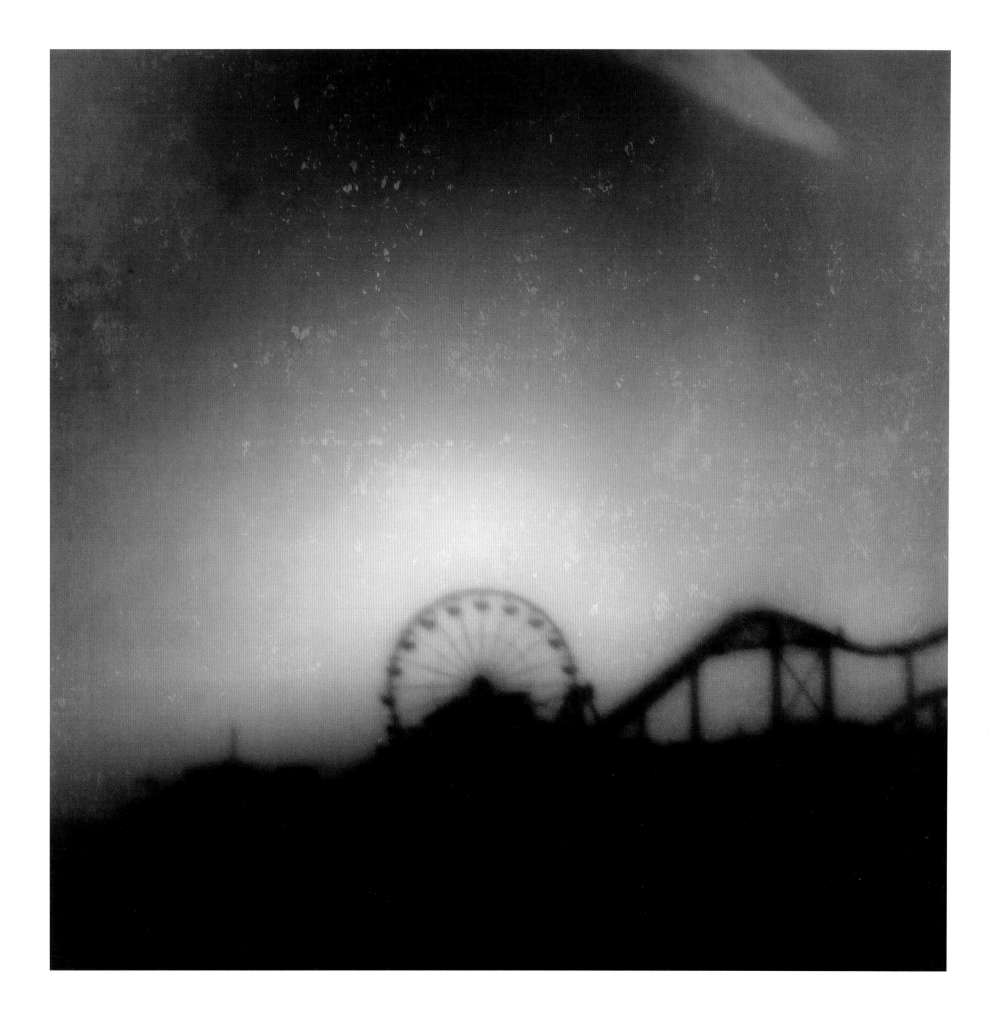

TREES / FOG

2014, Point Reyes, California

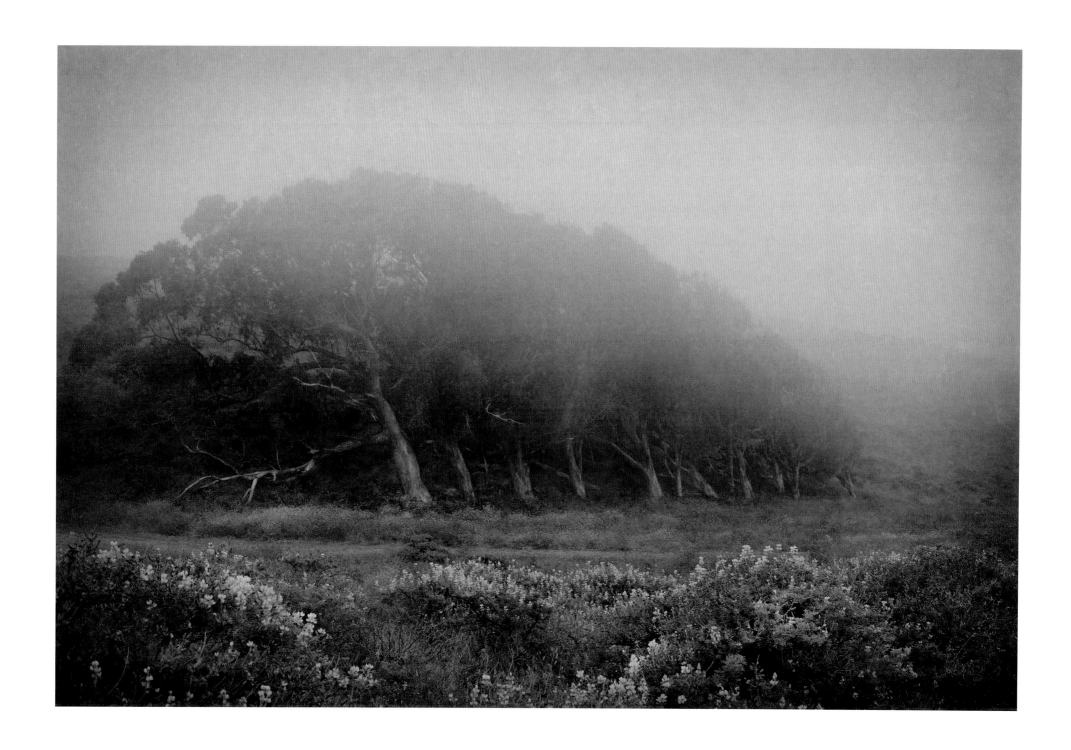

RED SCHOOL

2014, Orick, California

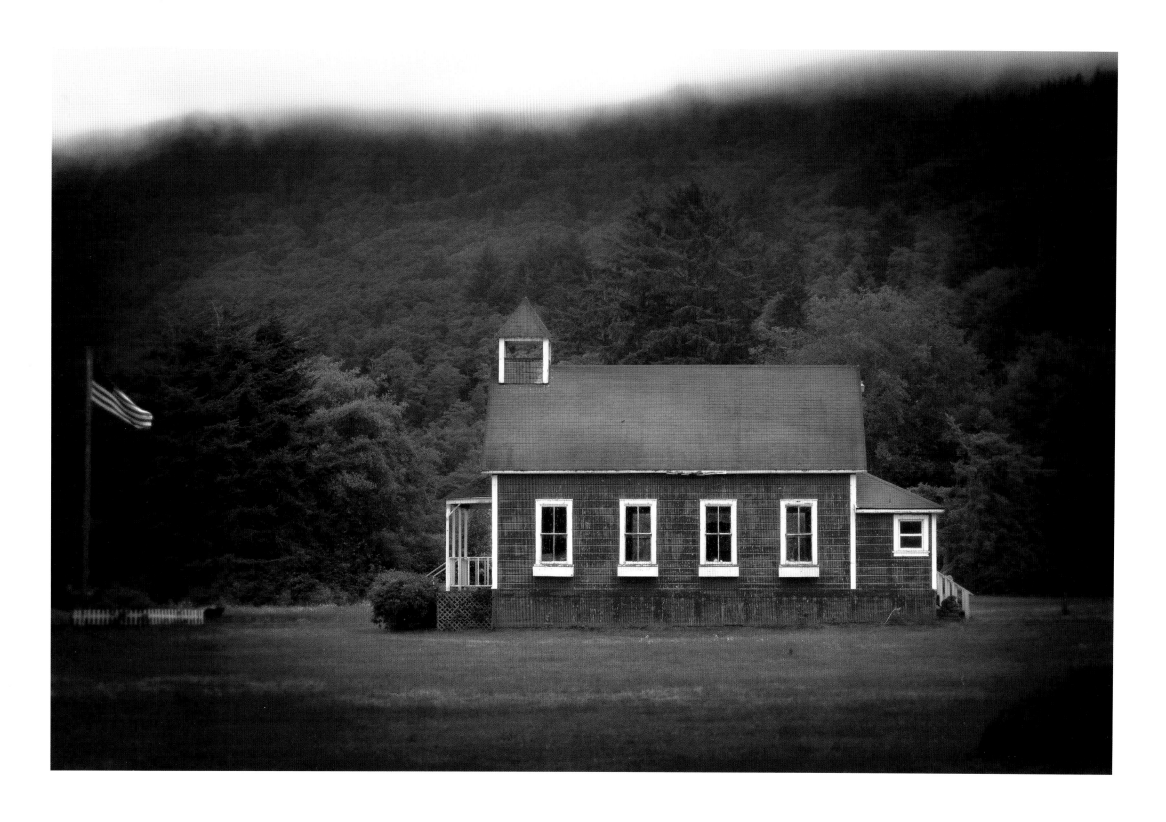

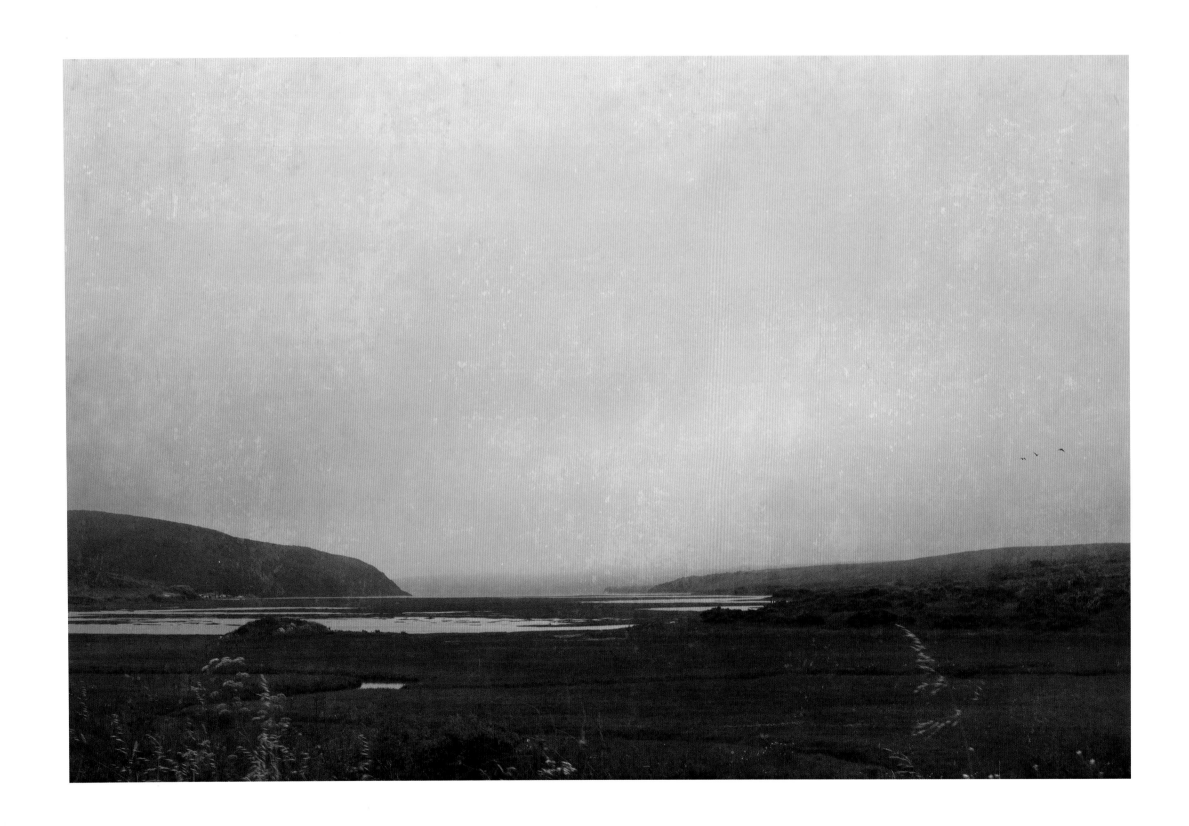

CREAMERY BAY

2014, Point Reyes, California

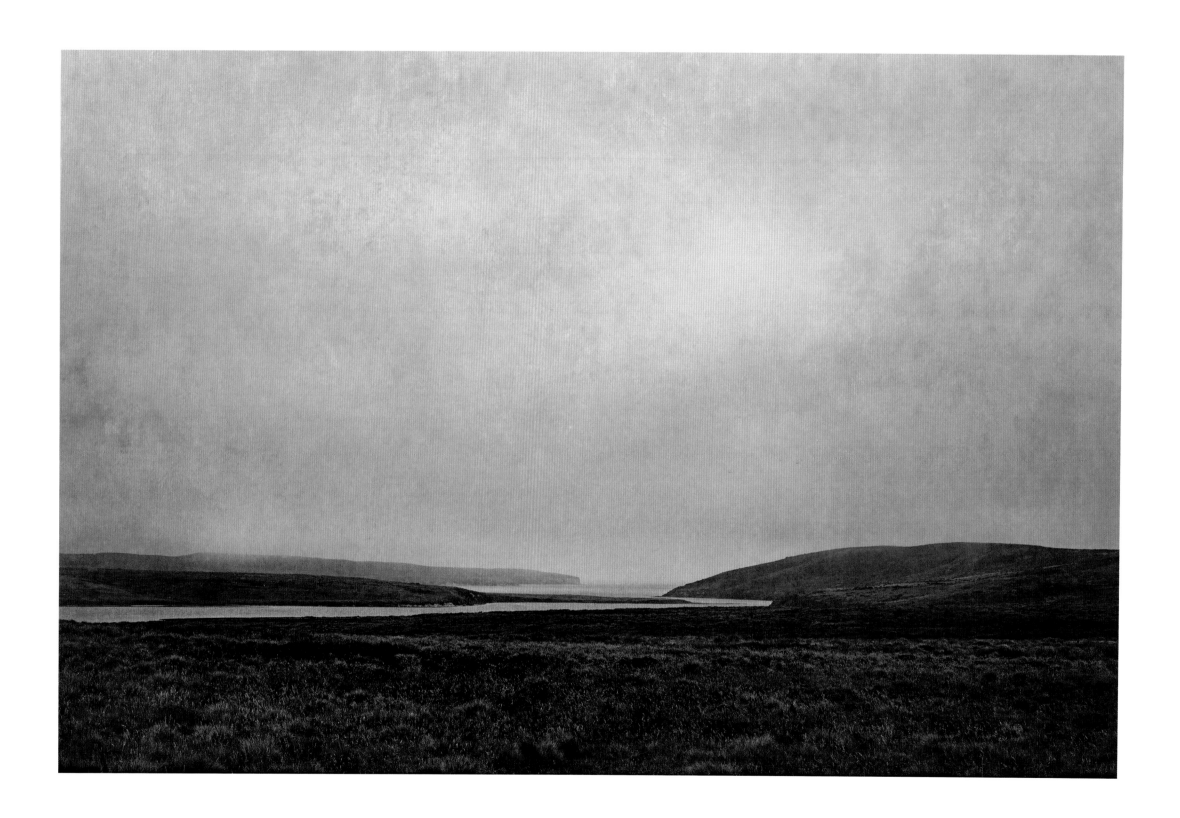

SCHOONER BAY

2014, Point Reyes, California

VENUS OVER FURNACE CREEK

2014, Death Valley, California

2 ELK

2014, Point Reyes, California

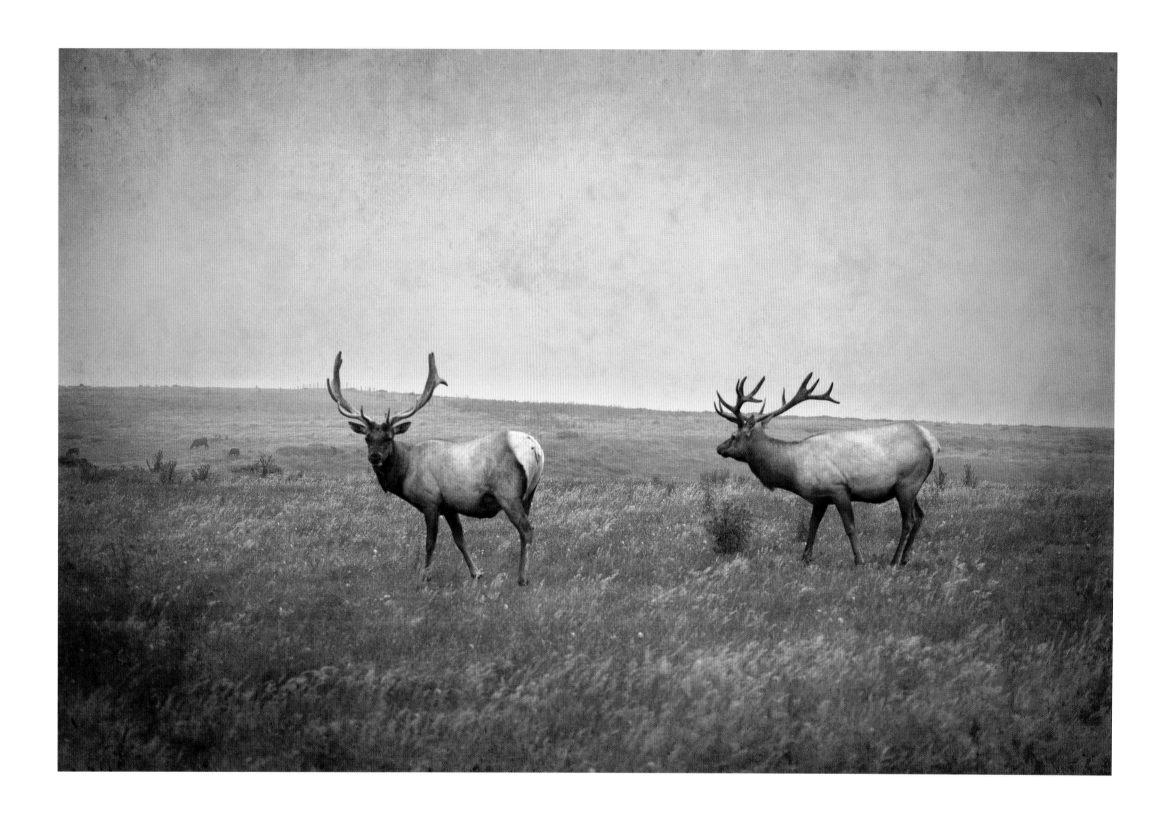

HALF DOME

2014, Yosemite, California

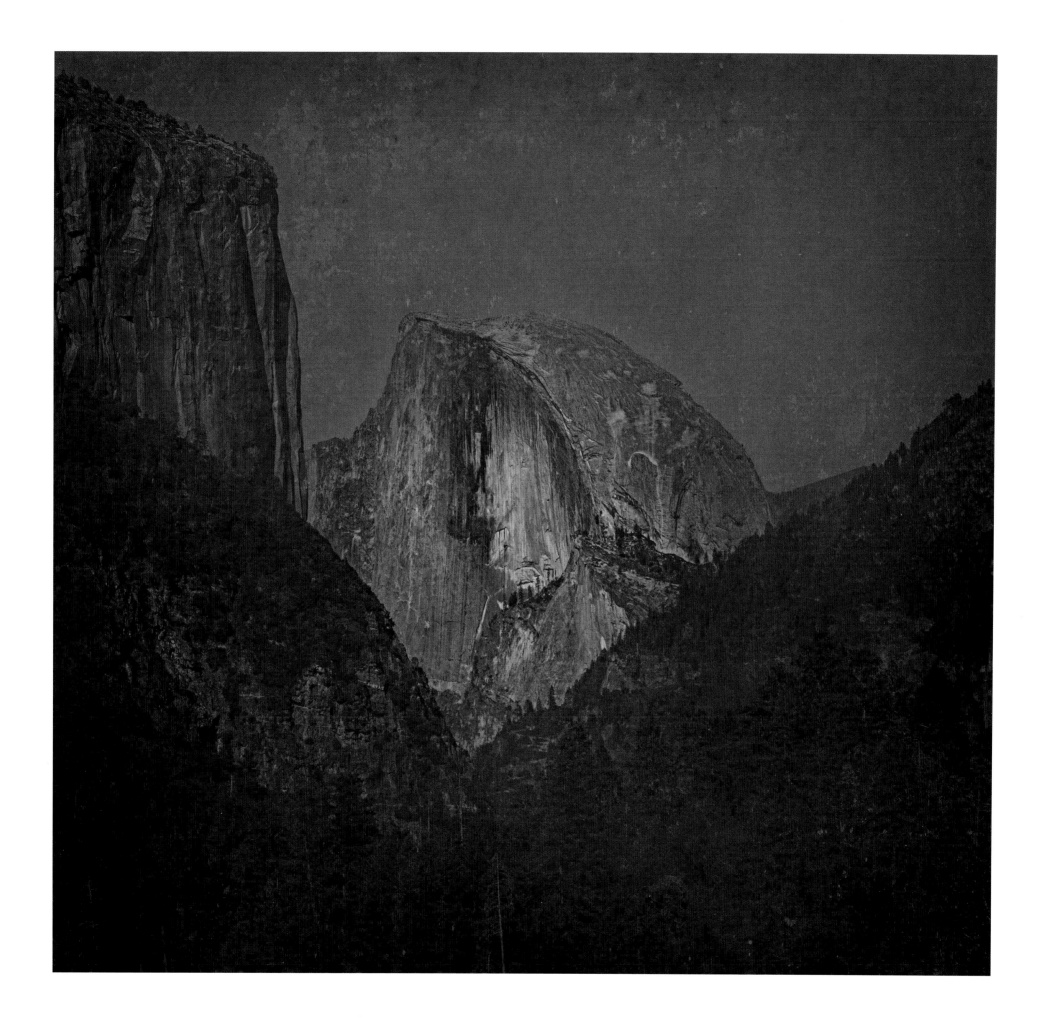

BOLINAS

2014, Bolinas, California

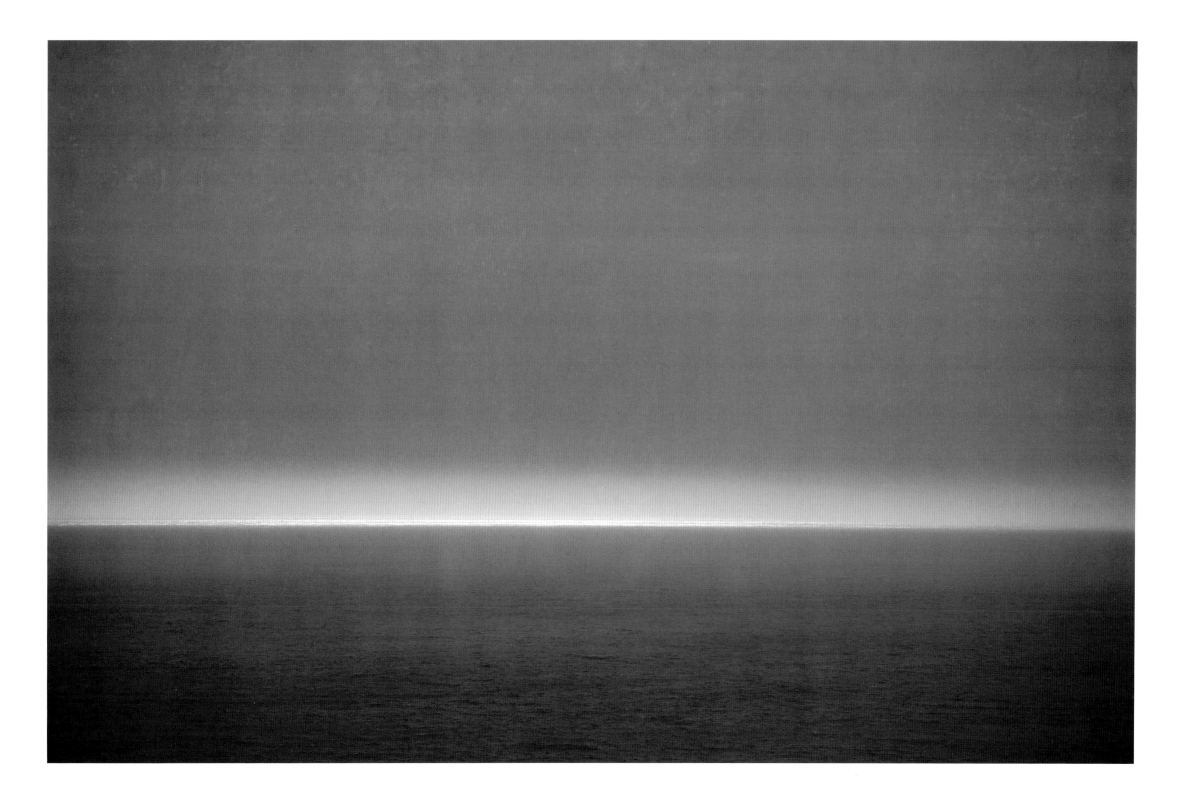

ZABRISKI POINT

2014, Death Valley, California

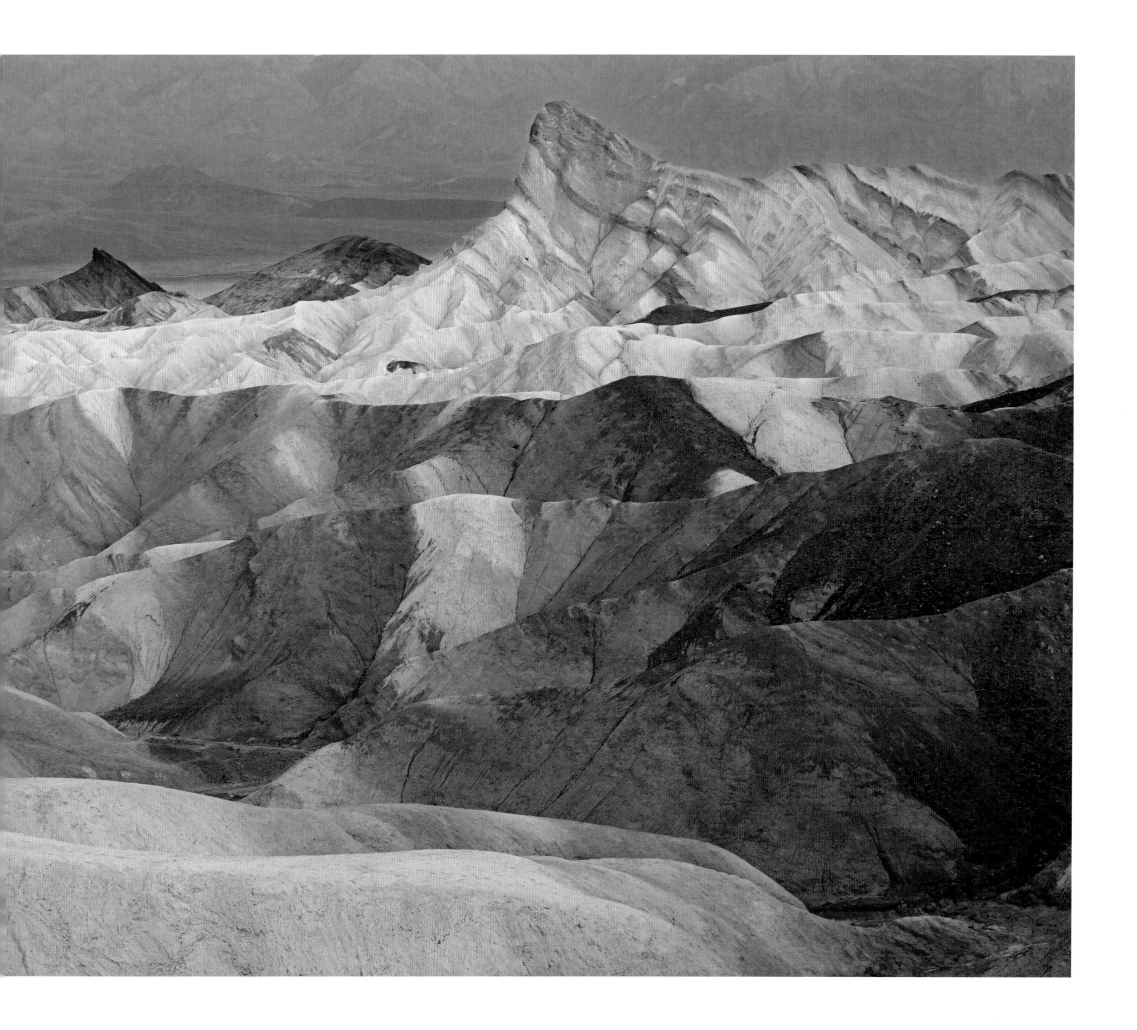

JAIL

2014, Rhyolite, Nevada

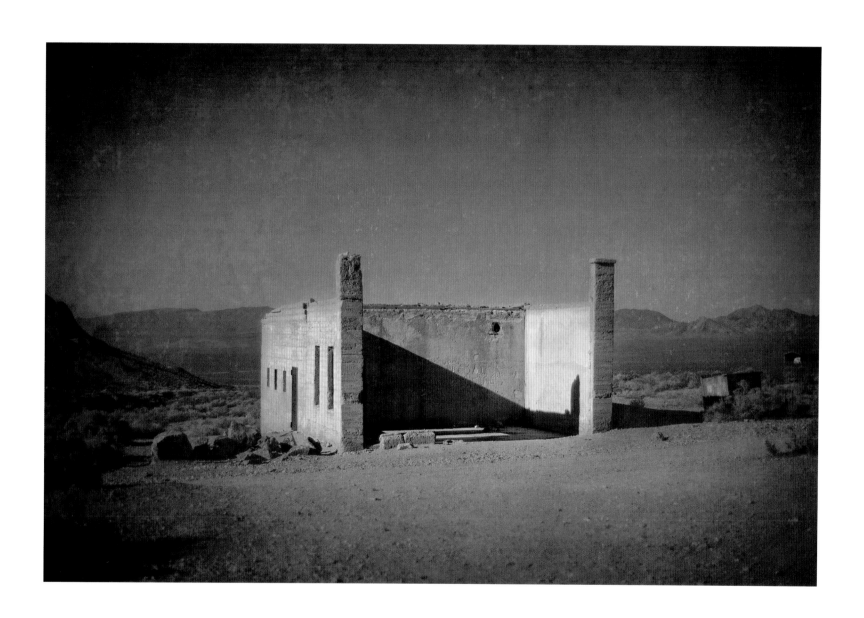

HOUSE IN MONUMENT VALLEY

2008, Utah

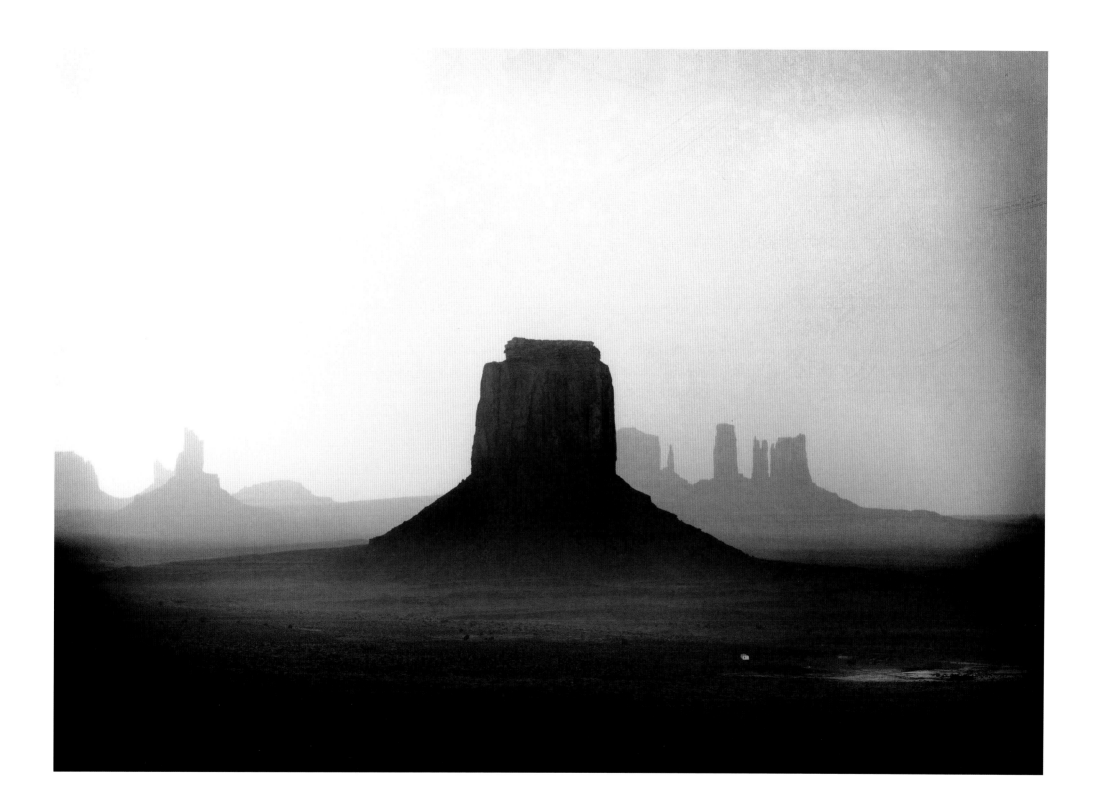

ROAD TO FLAMING GORGE

2008, Utah

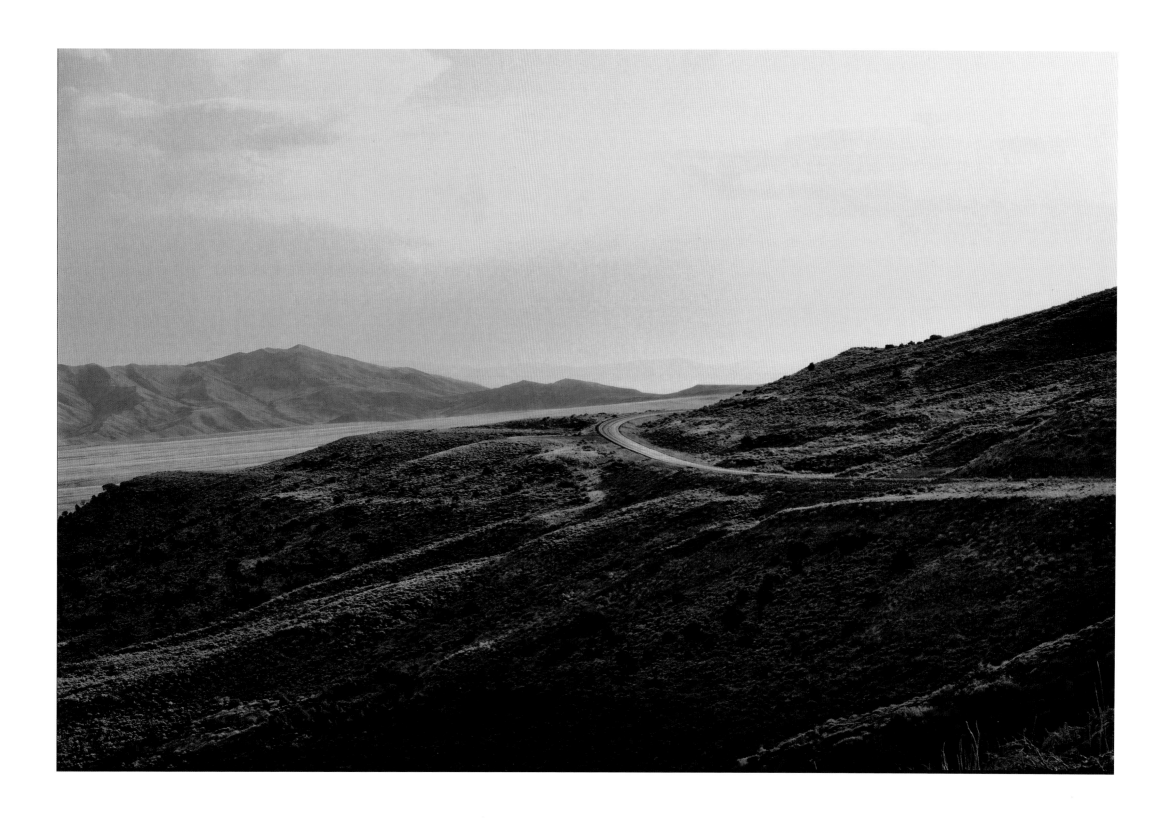

MUSTANG / MONUMENT VALLEY

2008, Utah

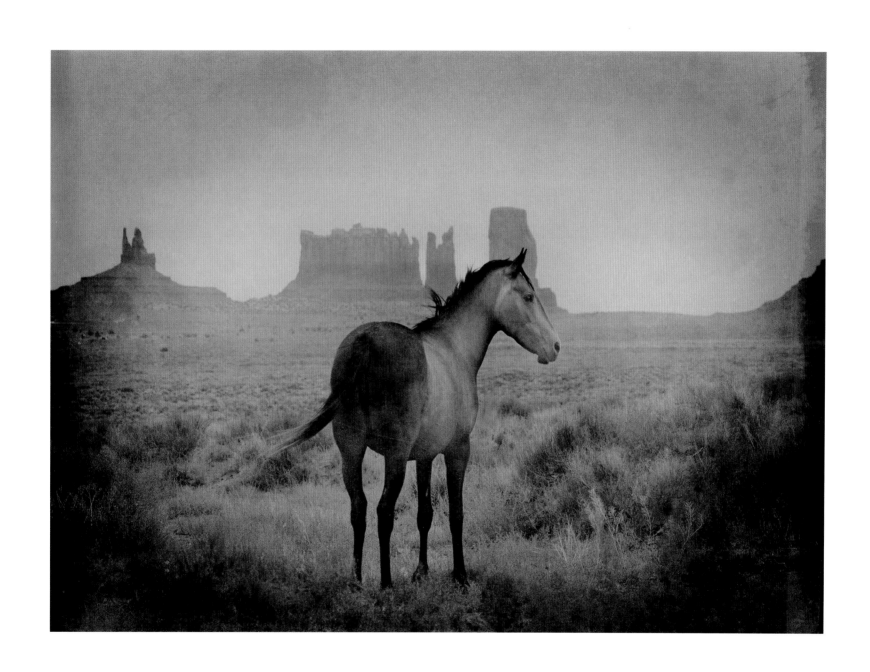

ABSTRACT STORM

2008, Utah

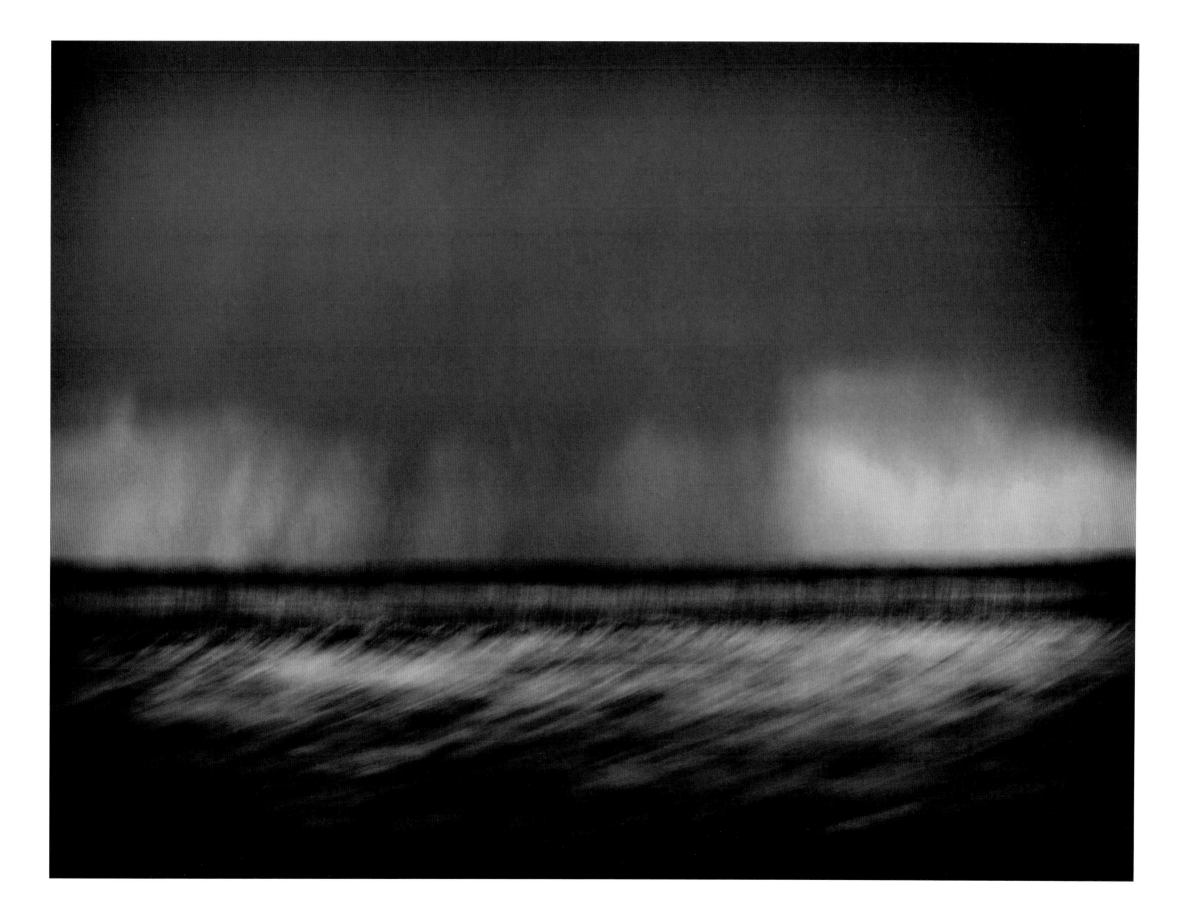

SALT LAKE

2014, Utah

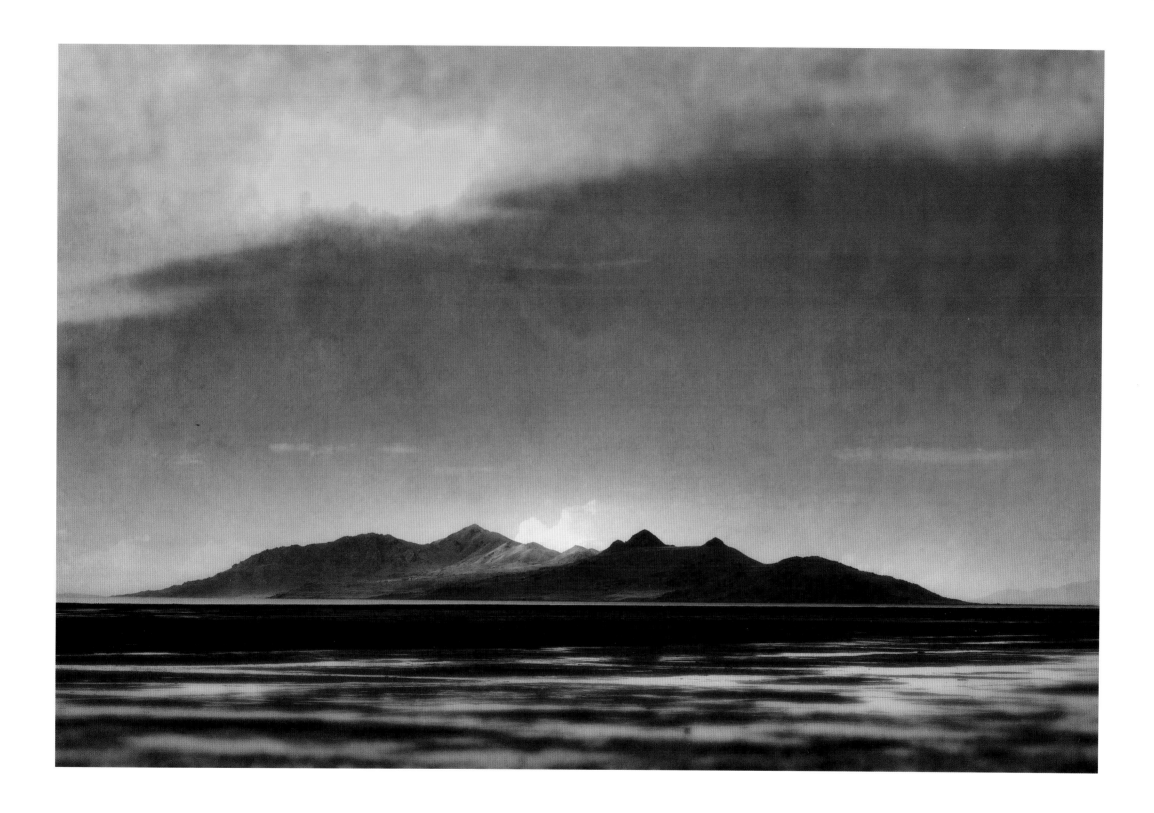

ROUTE 66

2014, Ash Grove, Arizona

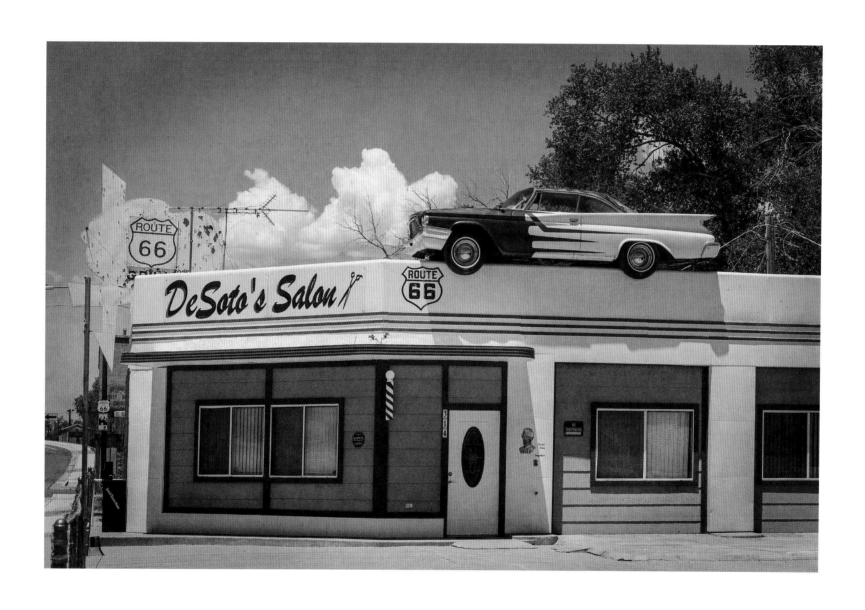

SNOW PONIES

2007, Truchas, New Mexico

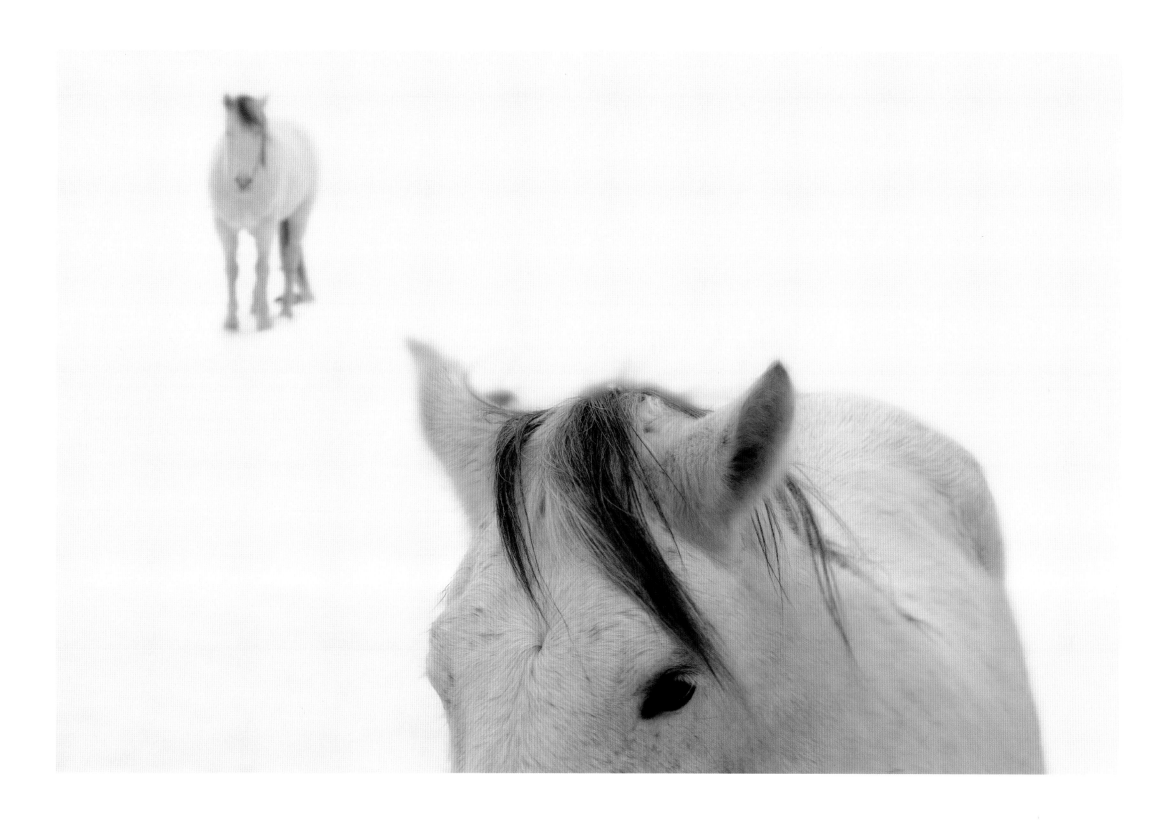

TRUCHAS IN SNOW

2007, Truchas, New Mexico

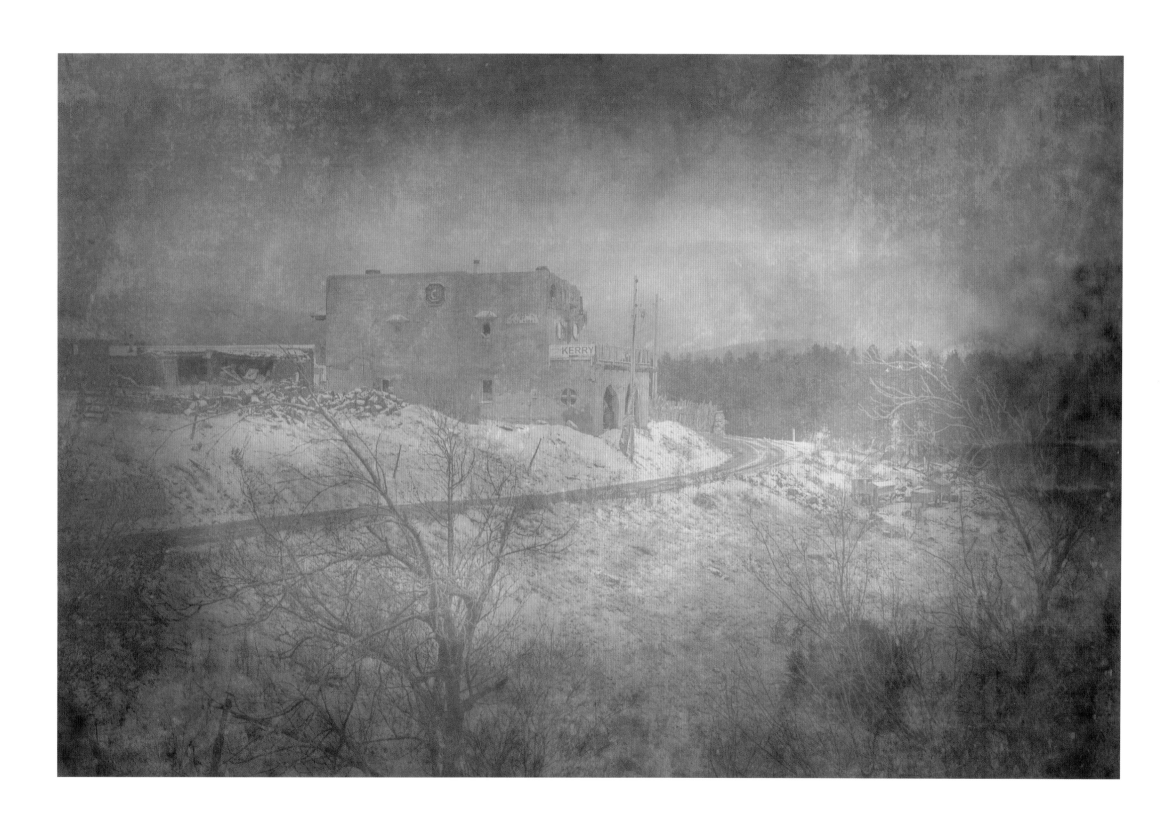

TAOS GORGE

2007, Taos, New Mexico

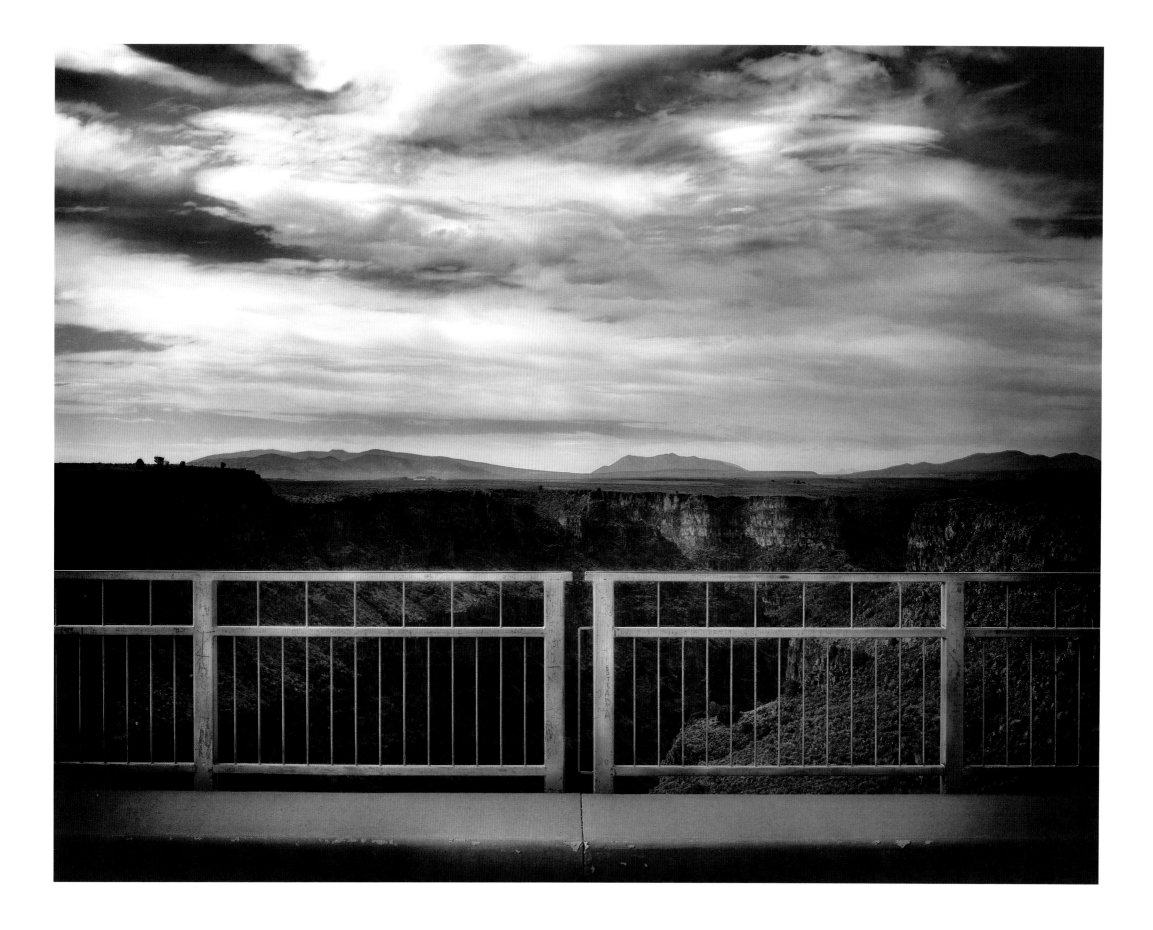

RED CHURCH

2006, New Mexico

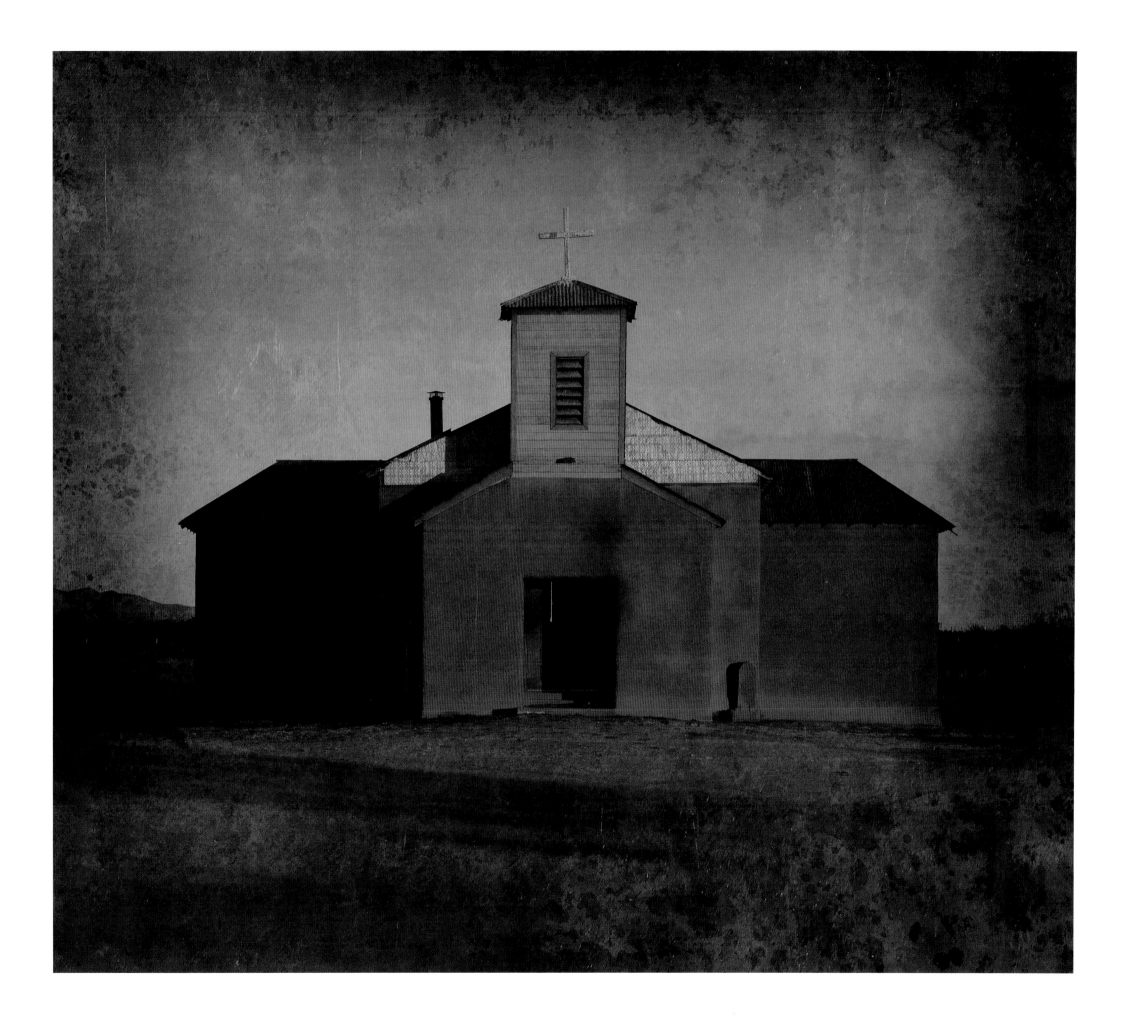

BUFFALO

2004, New Mexico

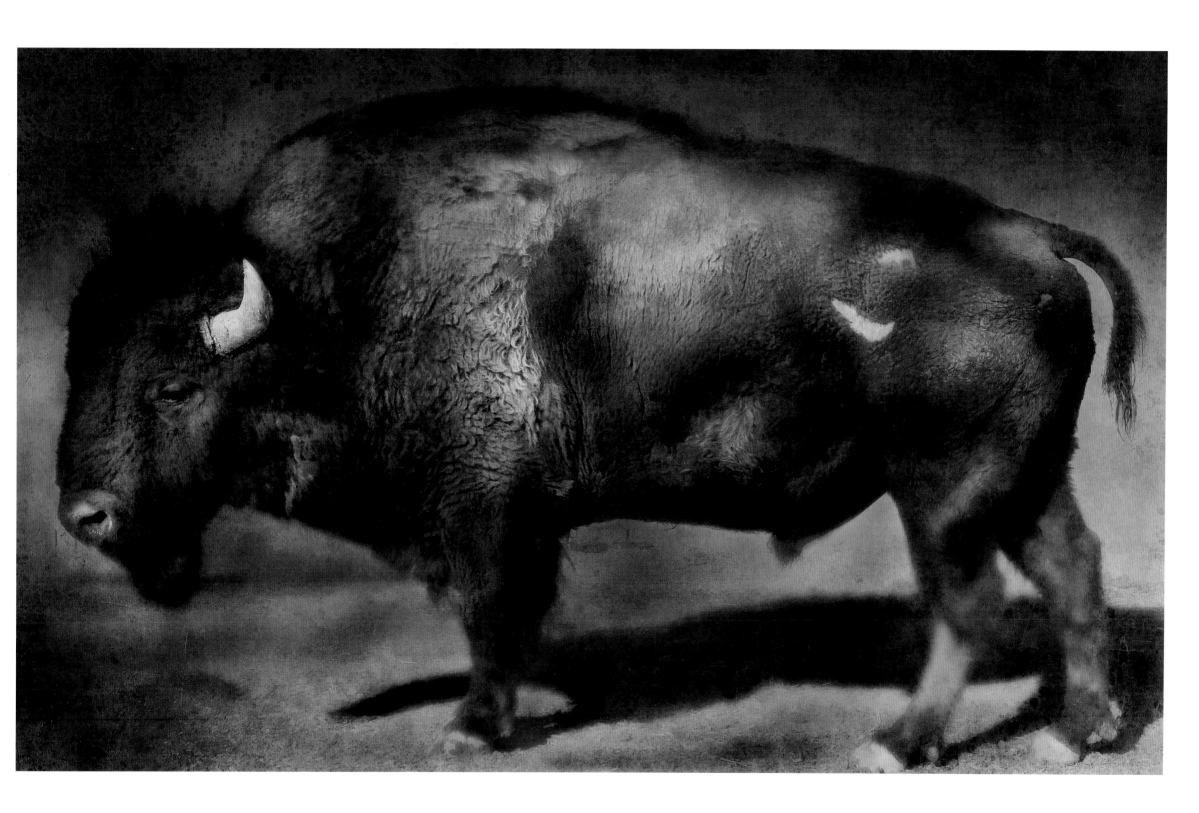

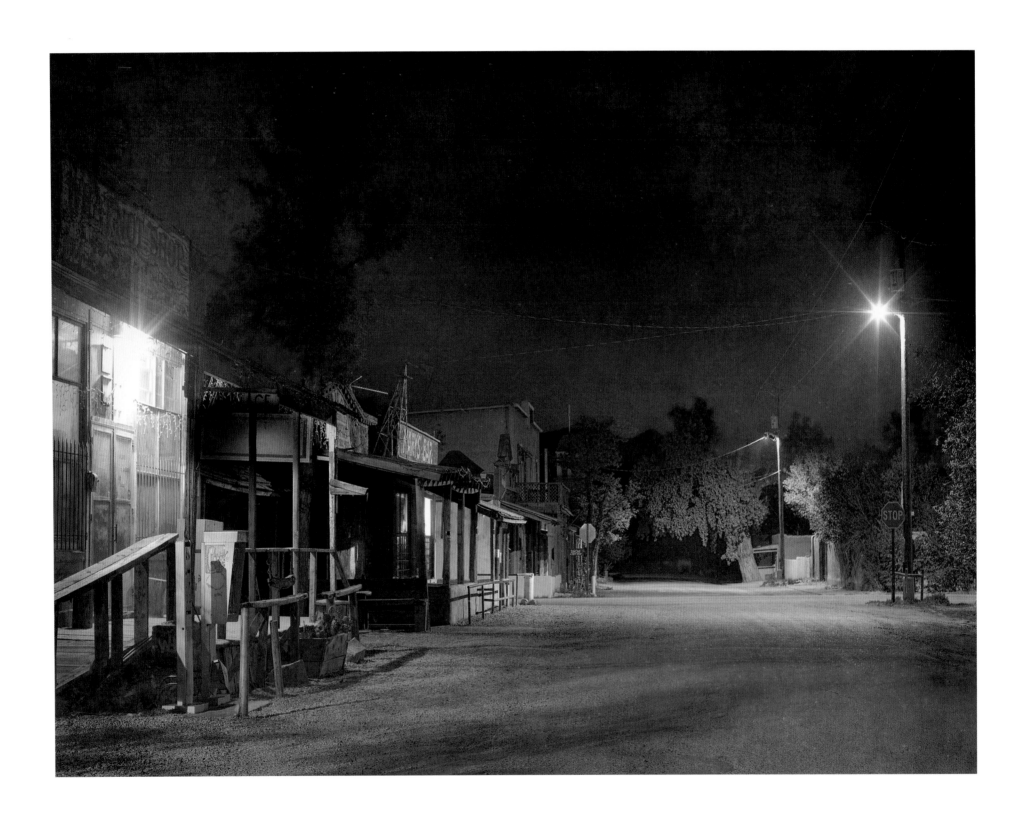

CERILLOS NIGHT

2007, Cerillos, Mew Mexico

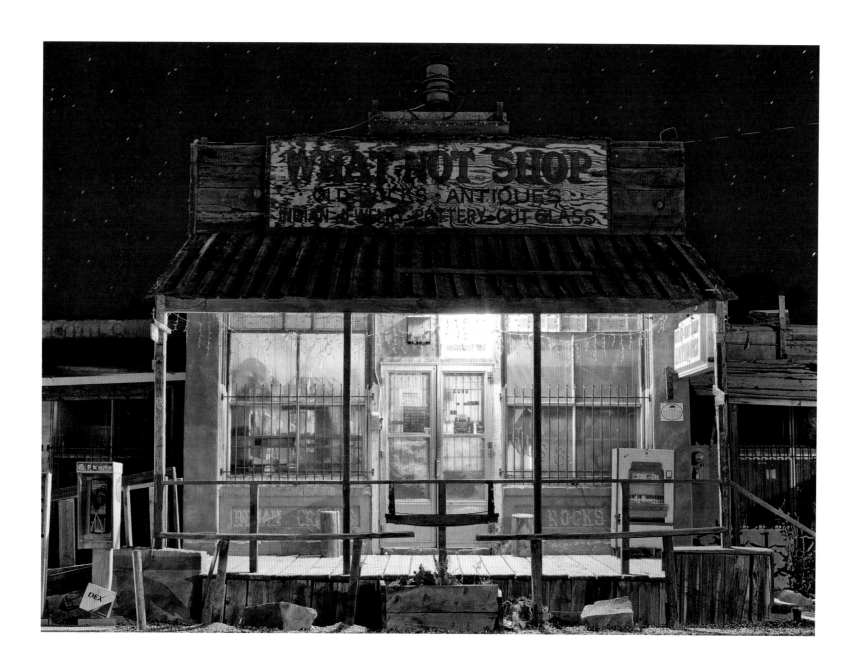

WHAT NOT SHOP

2007, Cerillos, New Mexico

WHITE SANDS

2014, Alamogordo, New Mexico

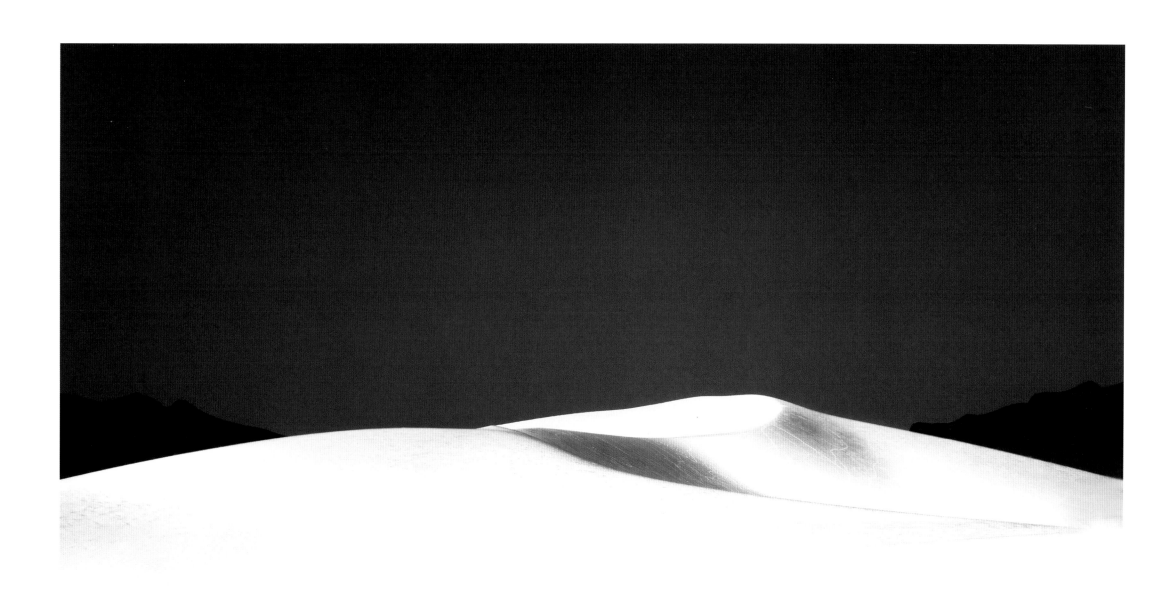

SCHOOL / BARN

2014, Corral, Idaho

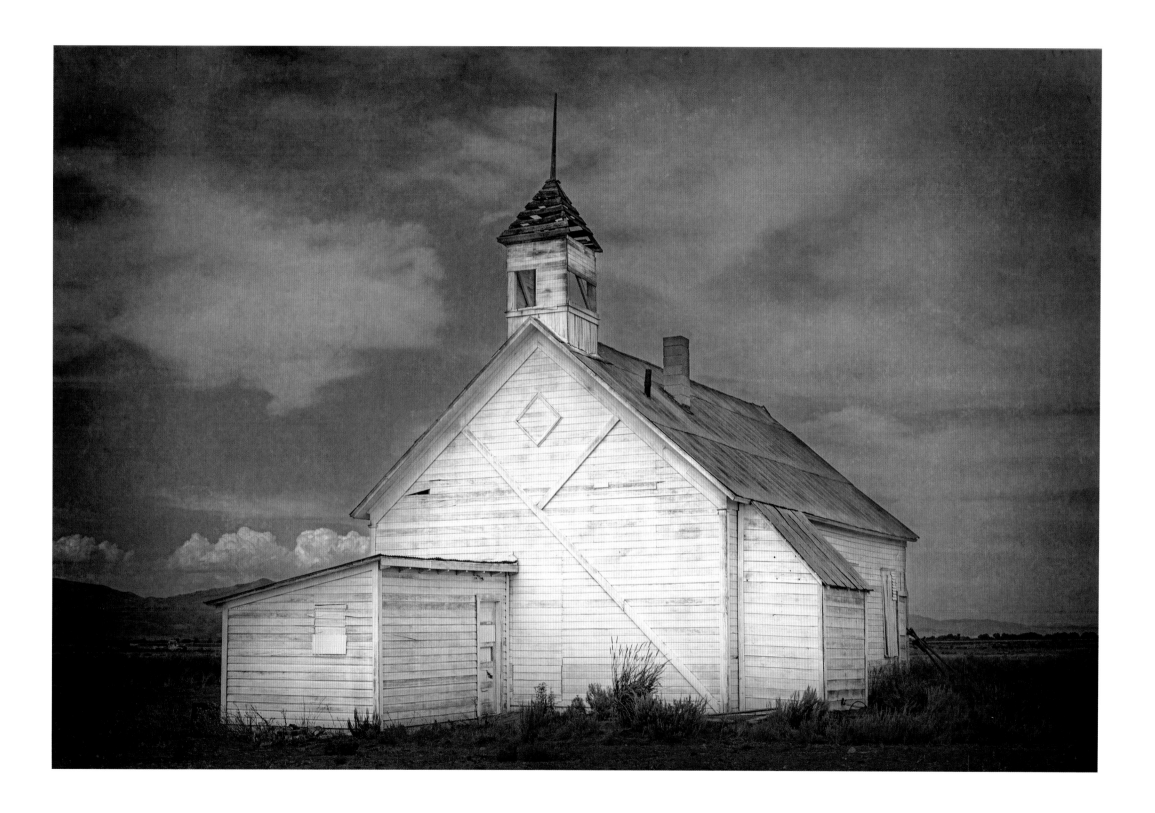

CORRAL, IDAHO

2014, Corral, Idaho

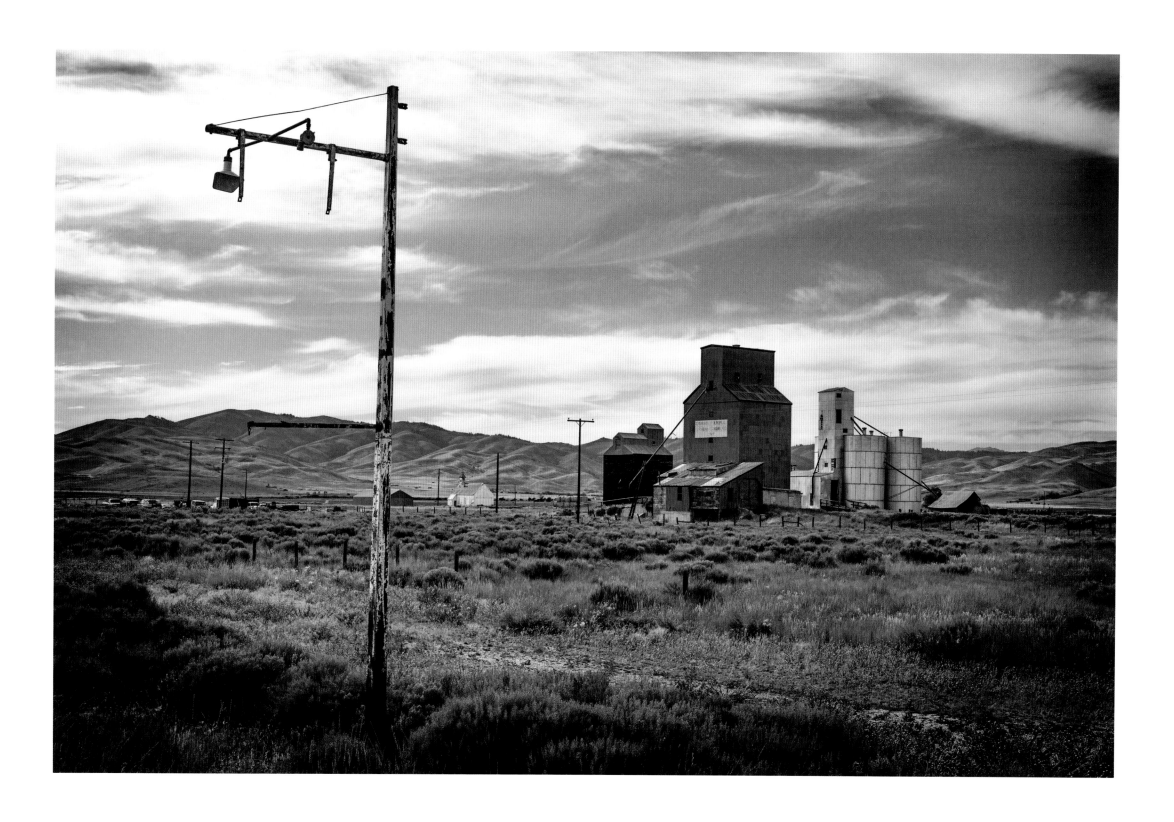

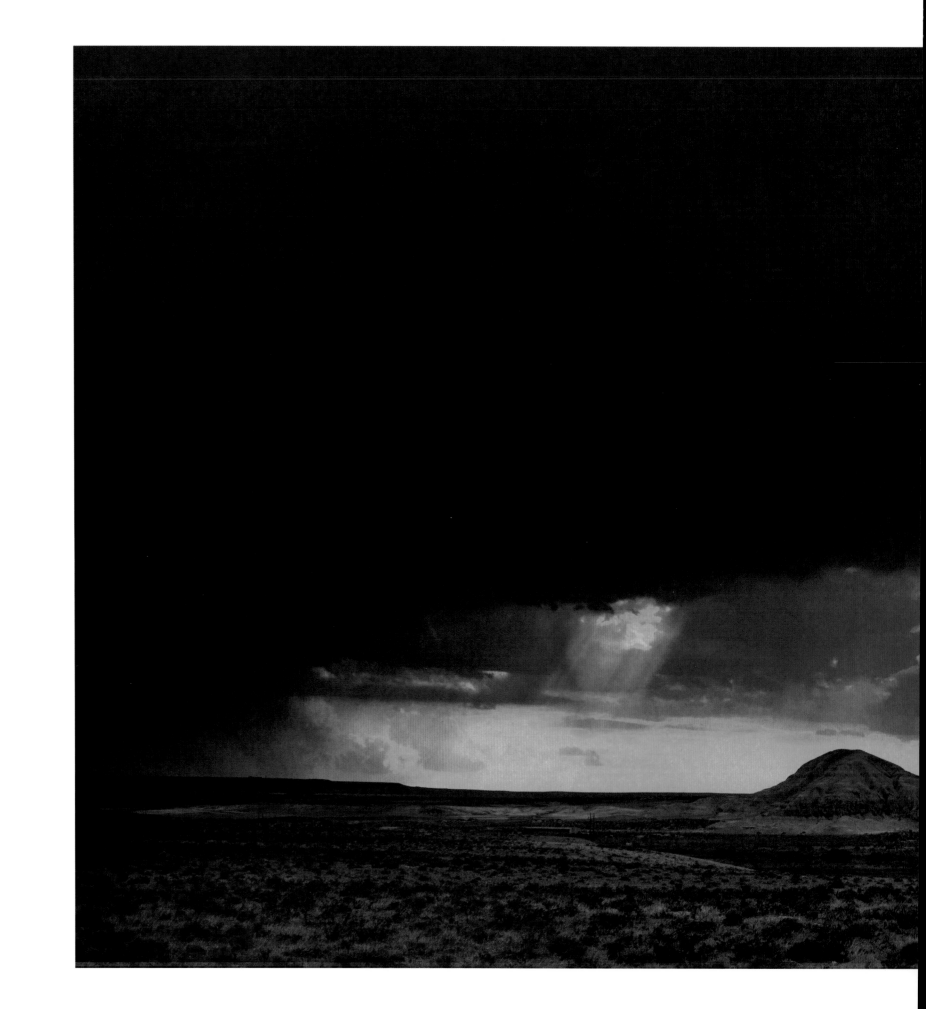

STORM CLOUDS

2014, Wyoming

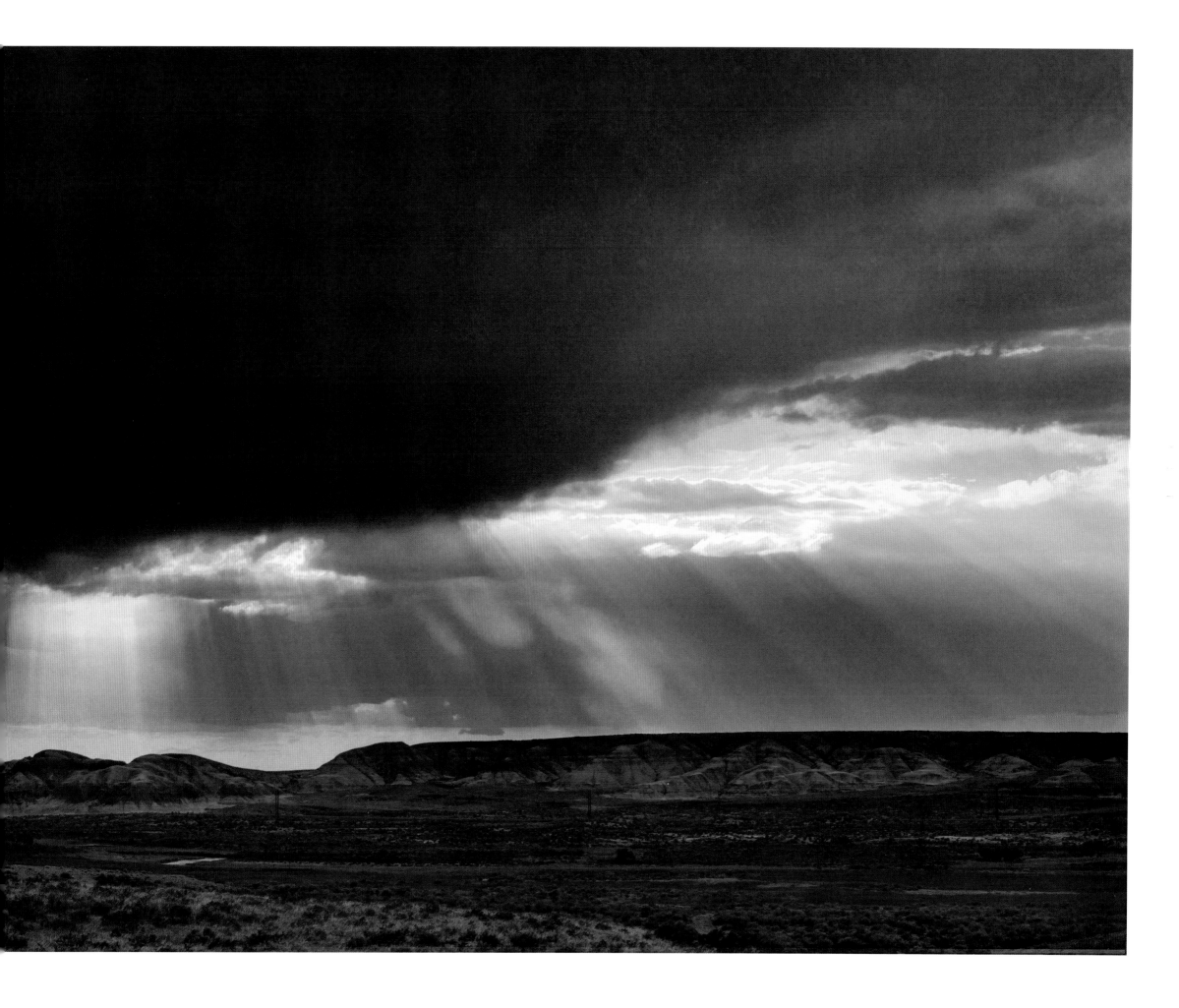

BUFFALO / TETONS

2008, Wyoming

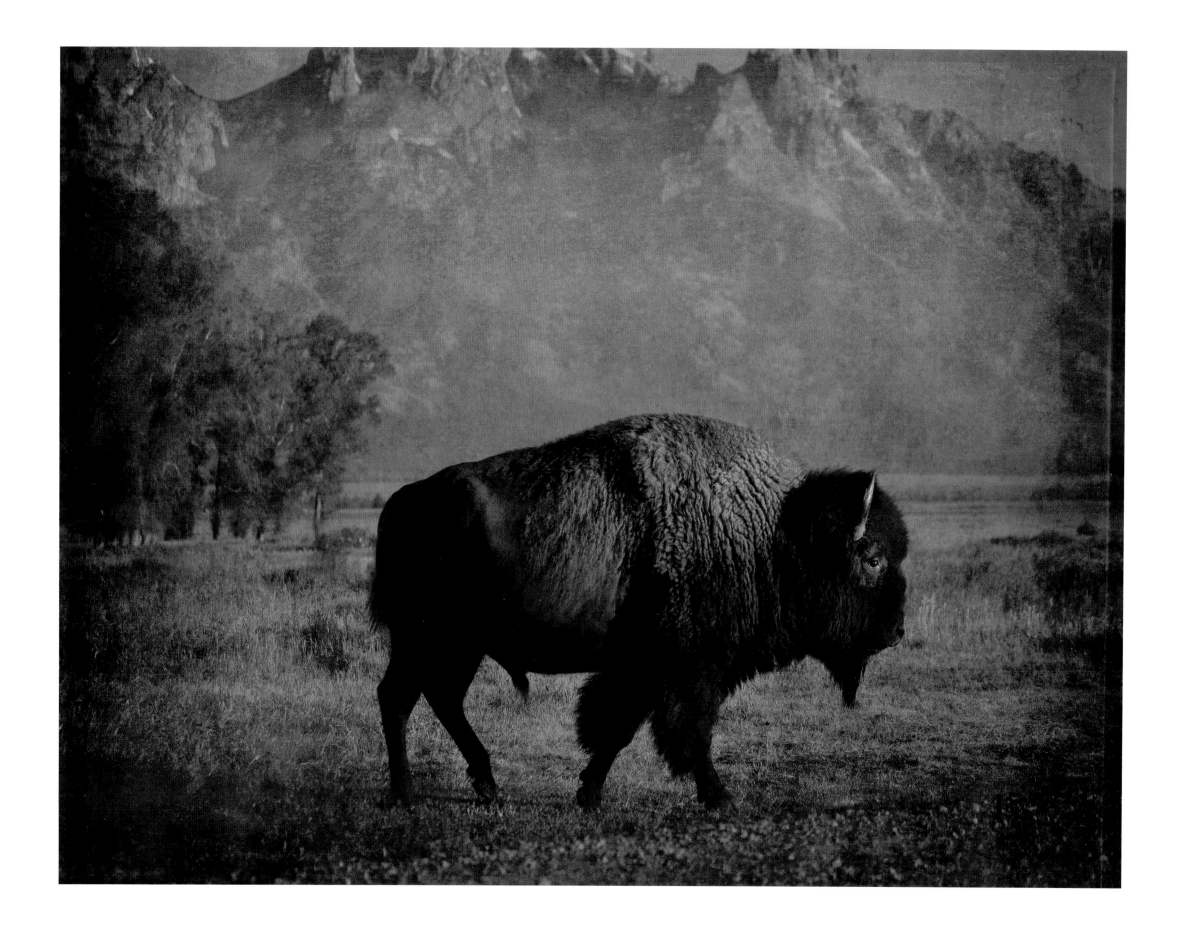

CLOUD / ROAD

2008, Wyoming

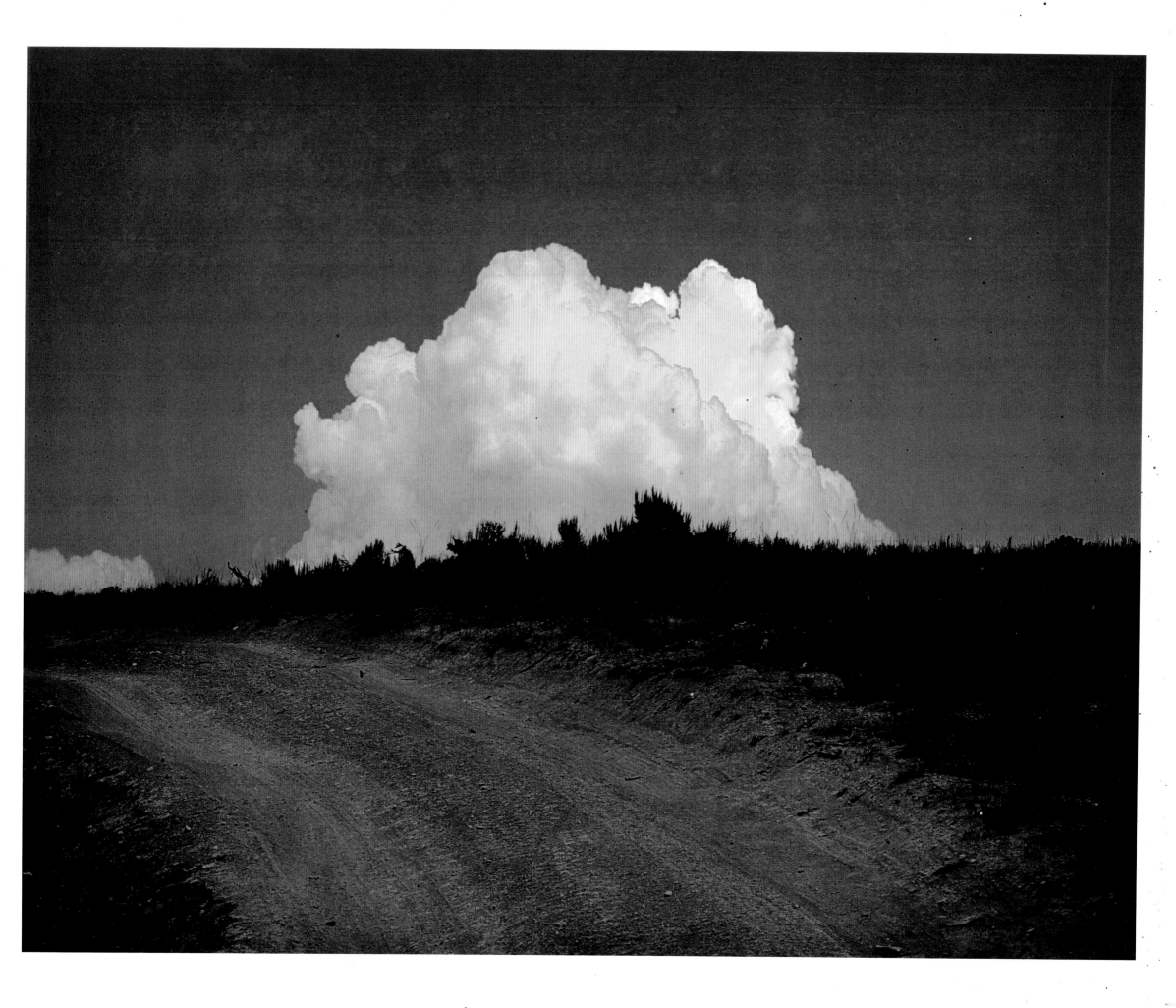

SNAKE RIVER REFLECTION

2005, Wyoming

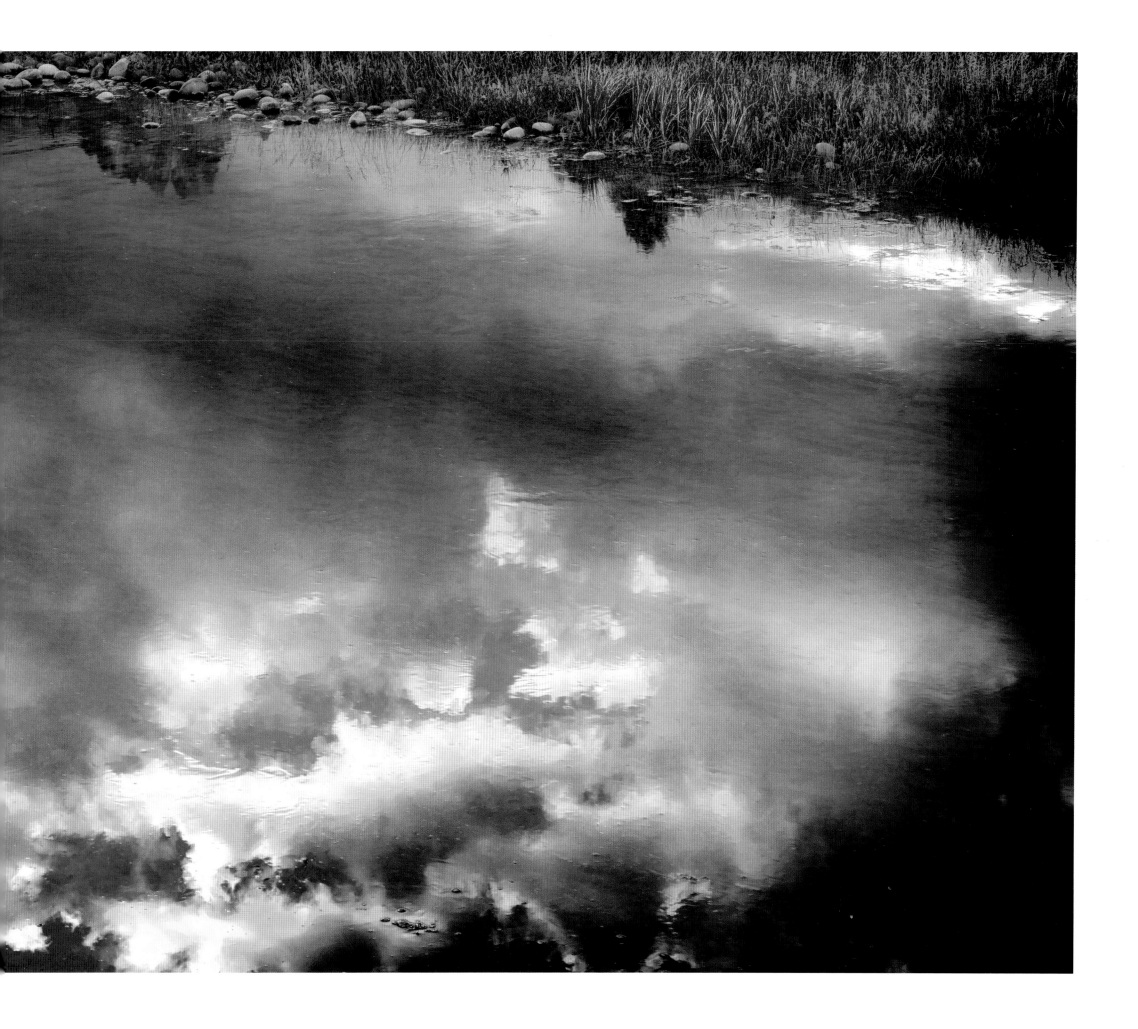

DARK HORSE

2005, Wyoming

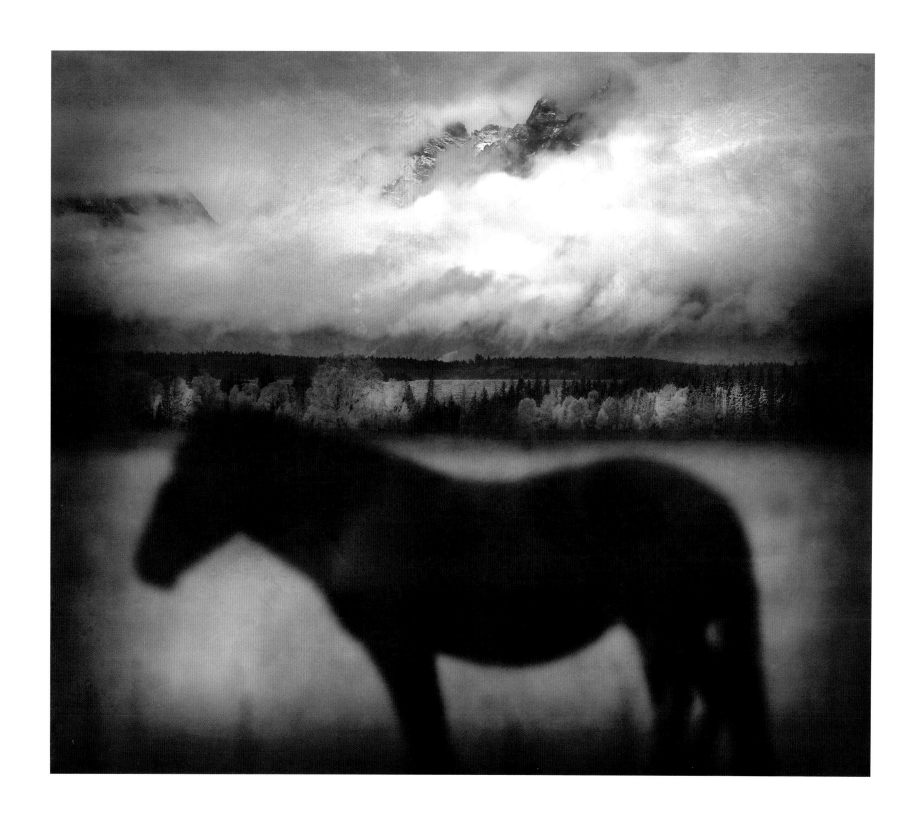

4TH OF JULY

2008, Sheridan, Wyoming

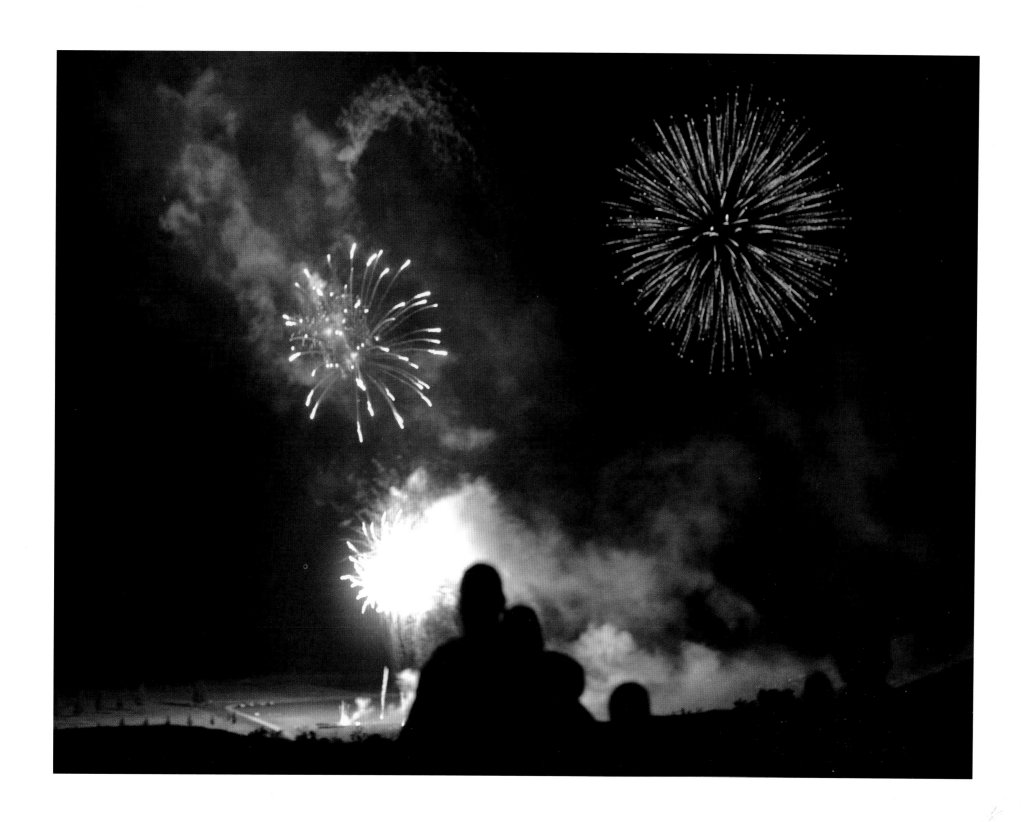

TETONS IN FOG

2005, Jackson, Wyoming

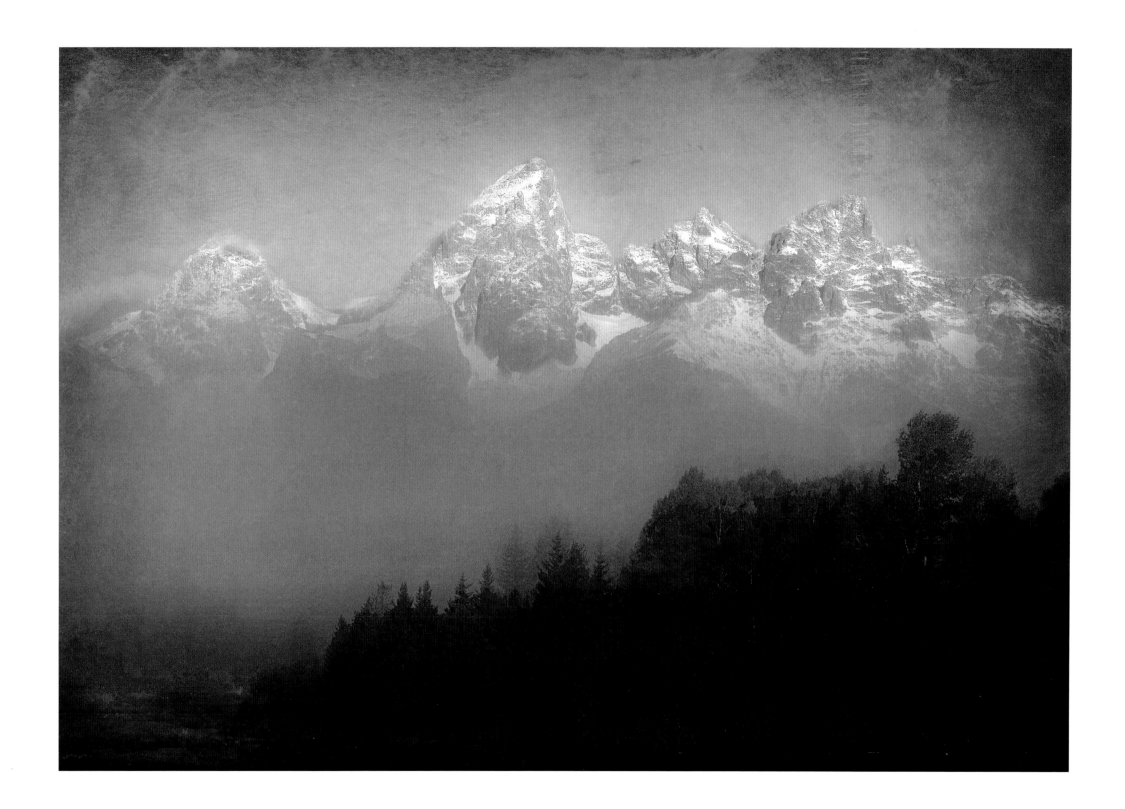

YELLOWSTONE RIVER

2005, Montana

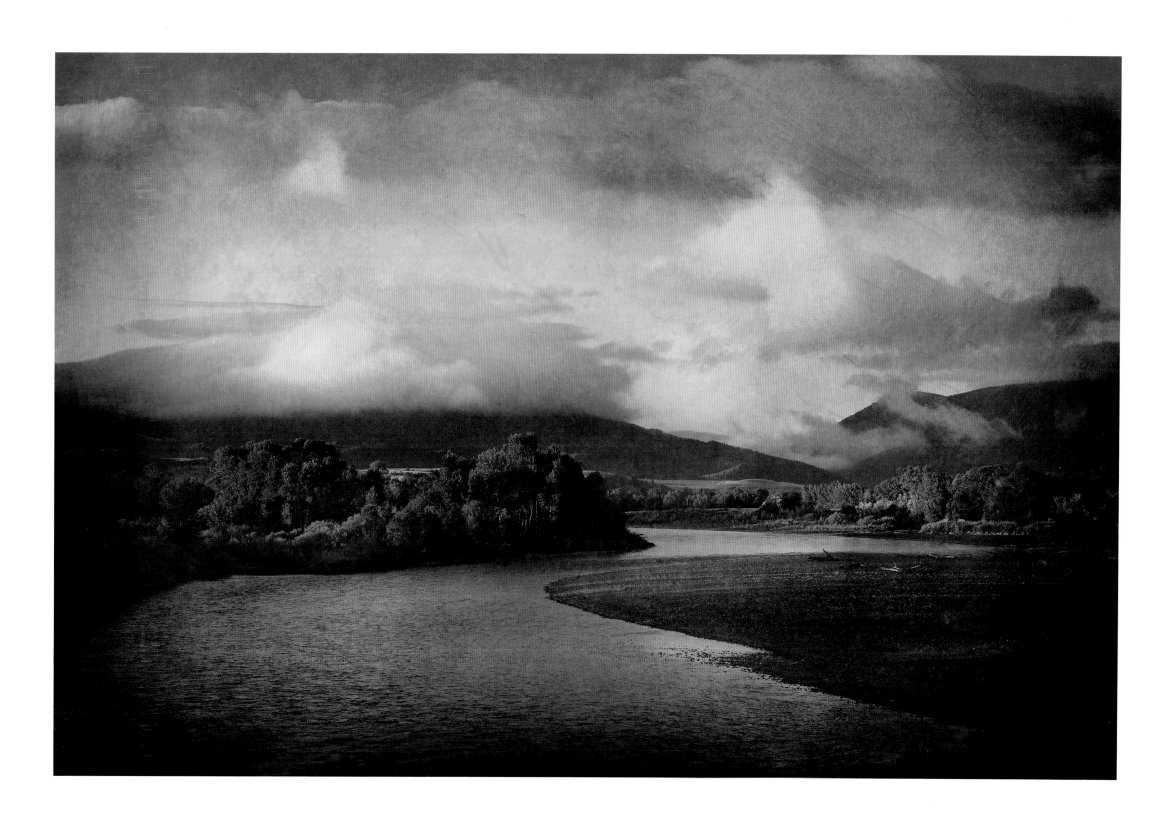

5 HORSES

2005, Montana

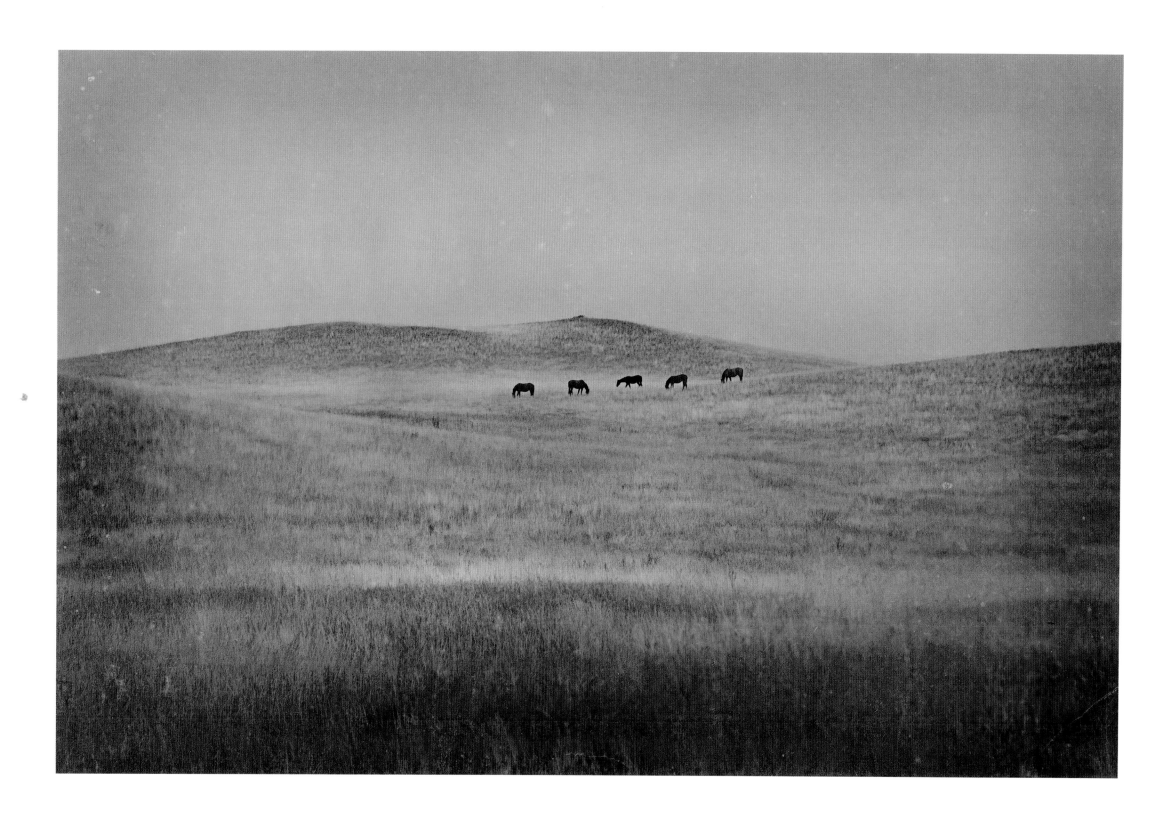

RATTLESNAKE CHURCH

2003, Northern Montana

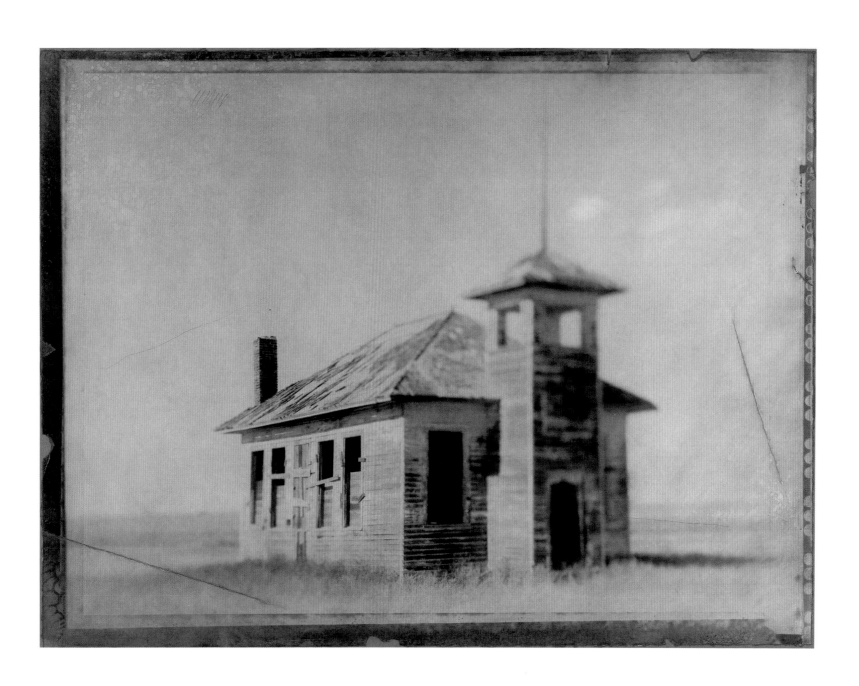

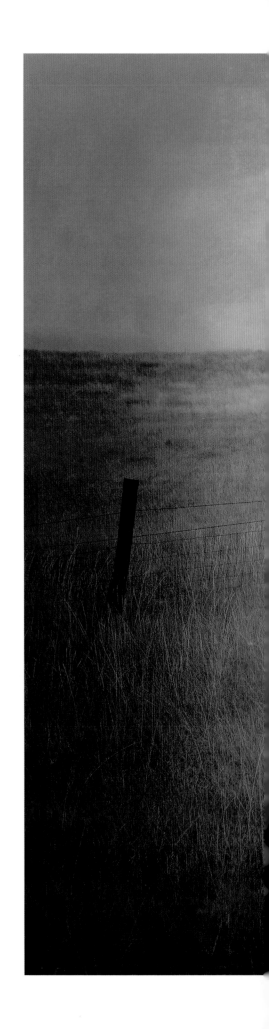

FENCE LINE

2005, Montana

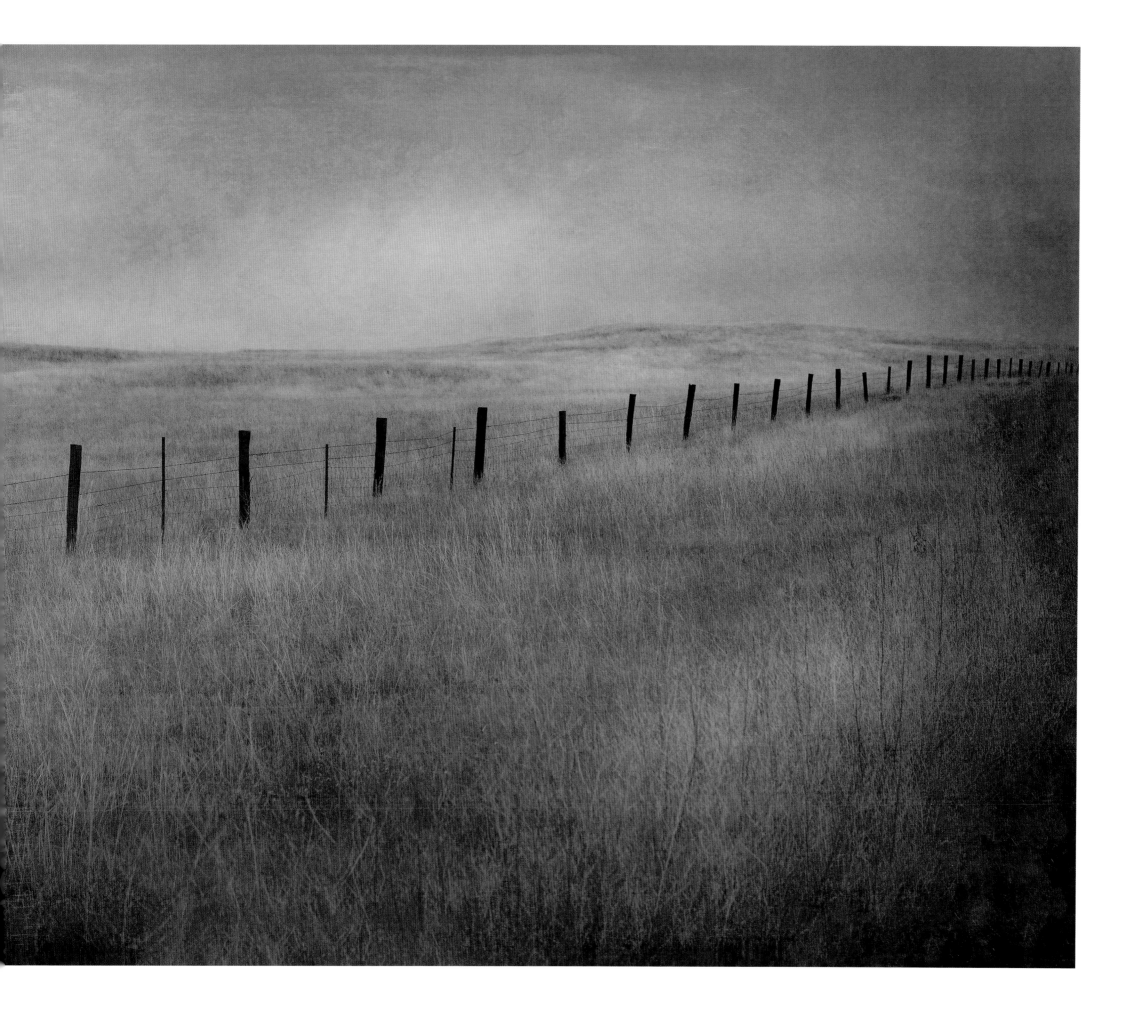

HORSES / FOG / ROAD

2008, Montana

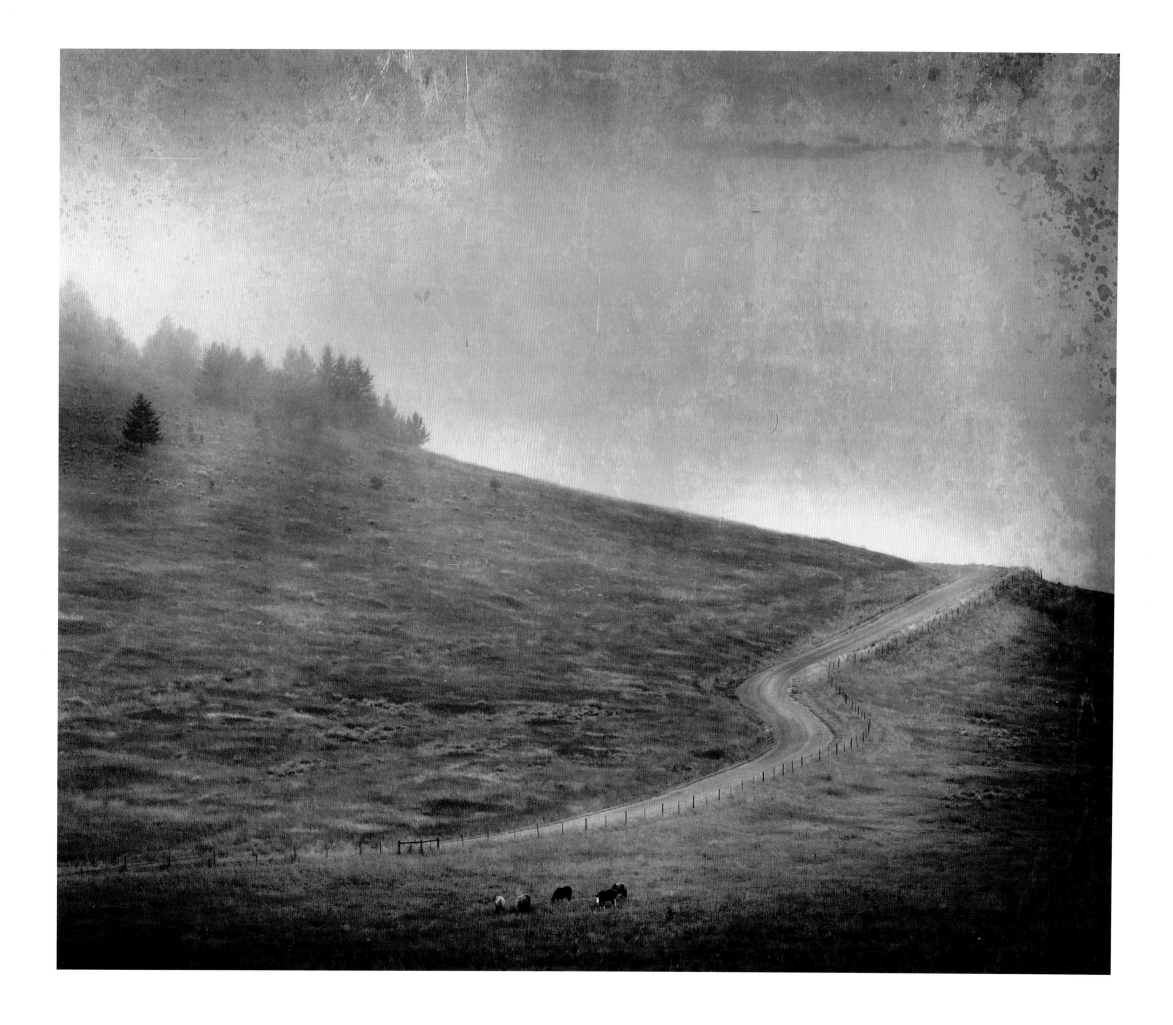

MONTANA DRAW

2005, Montana

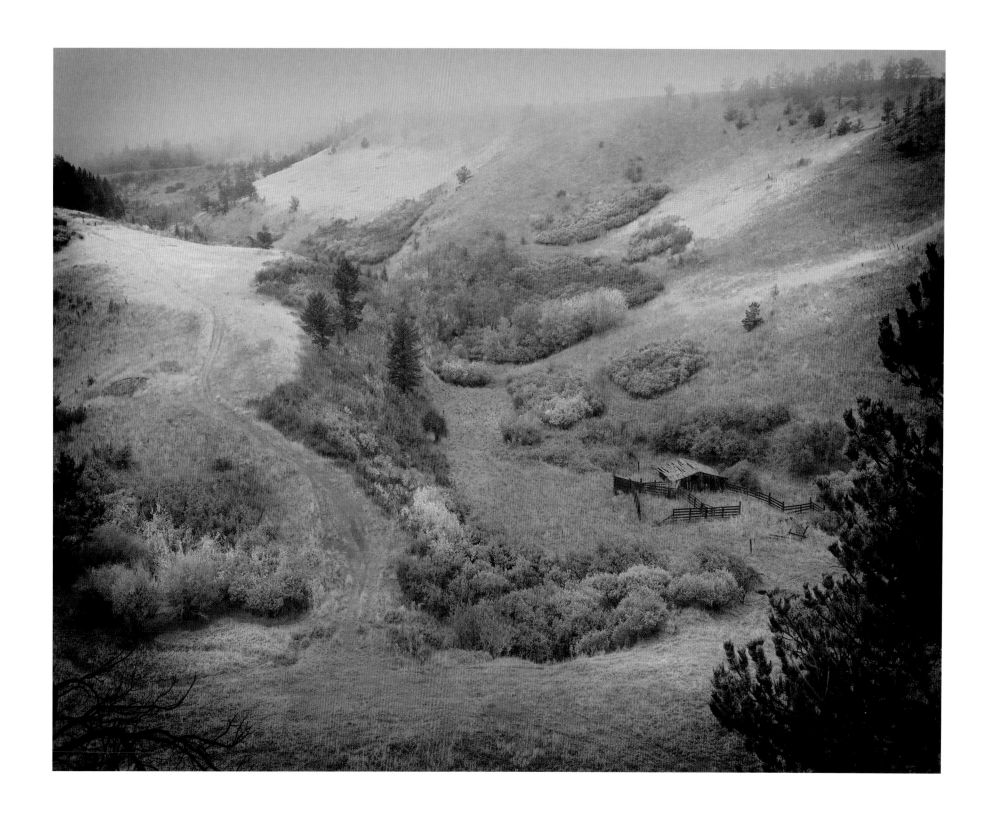

18 ANTELOPE

2005, Montana

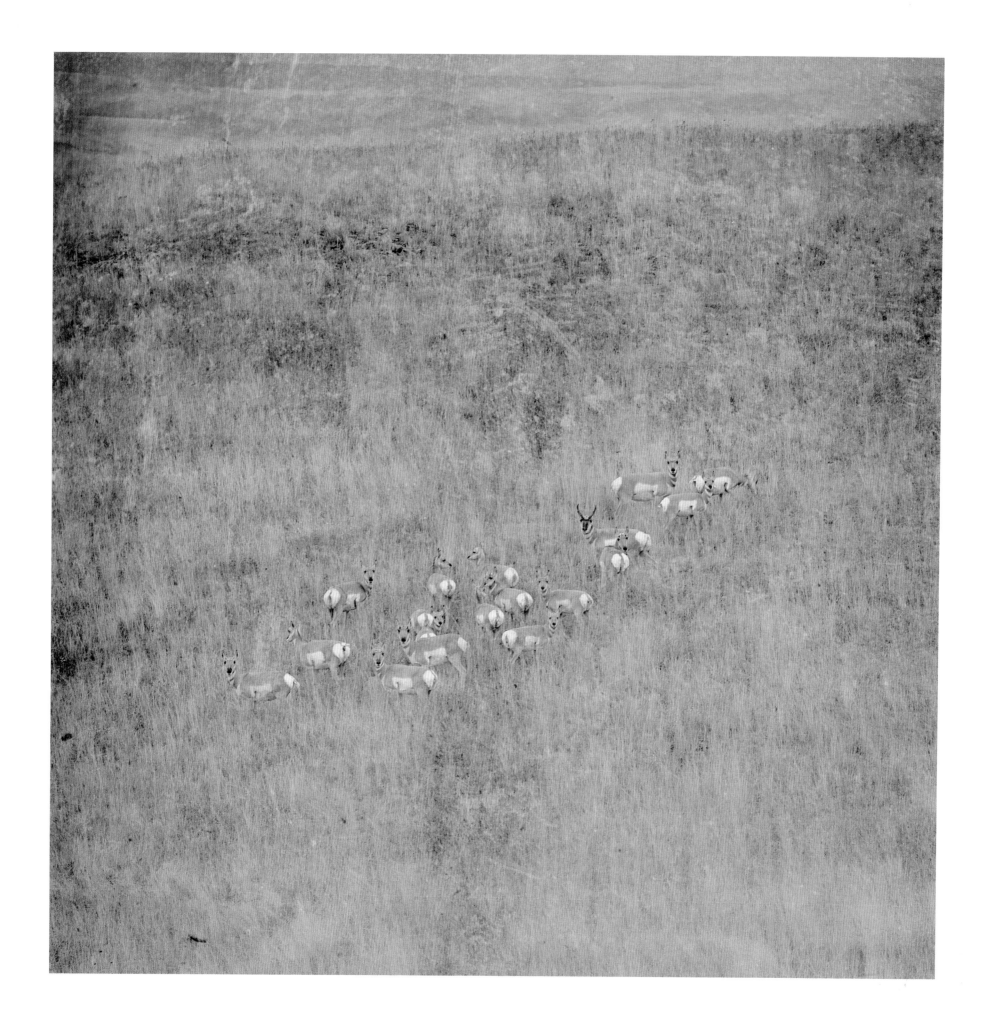

MURRAY HOTEL I

2005, Livingston, Montana

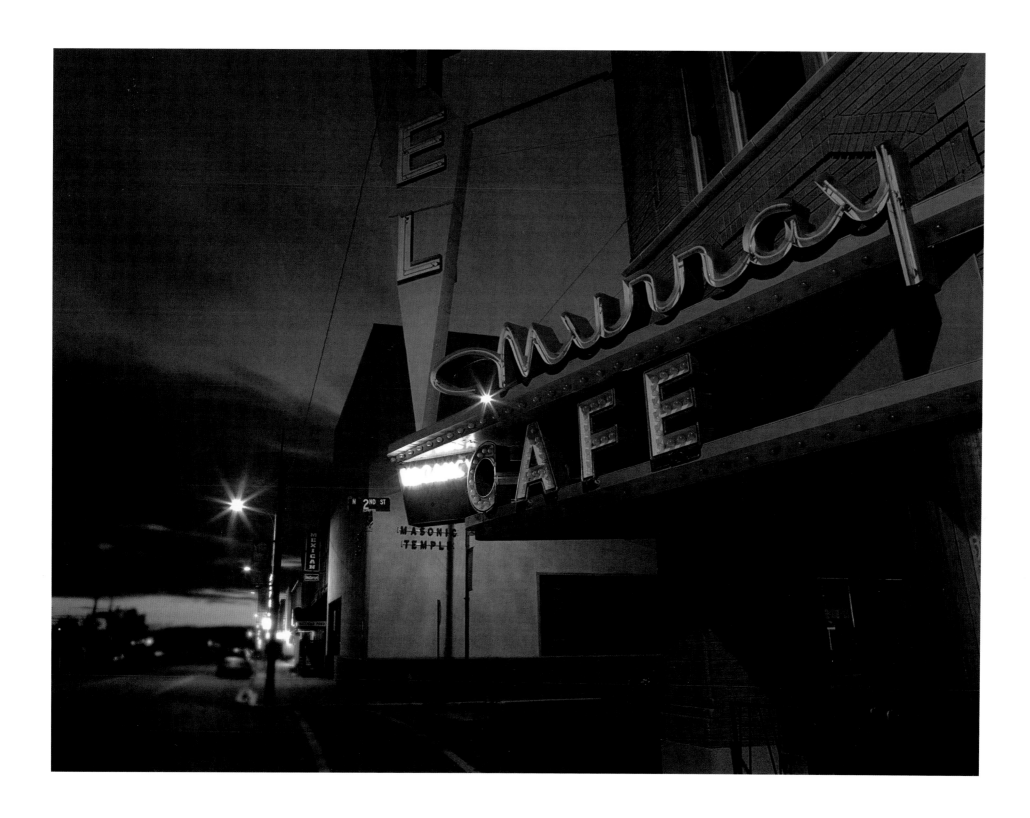

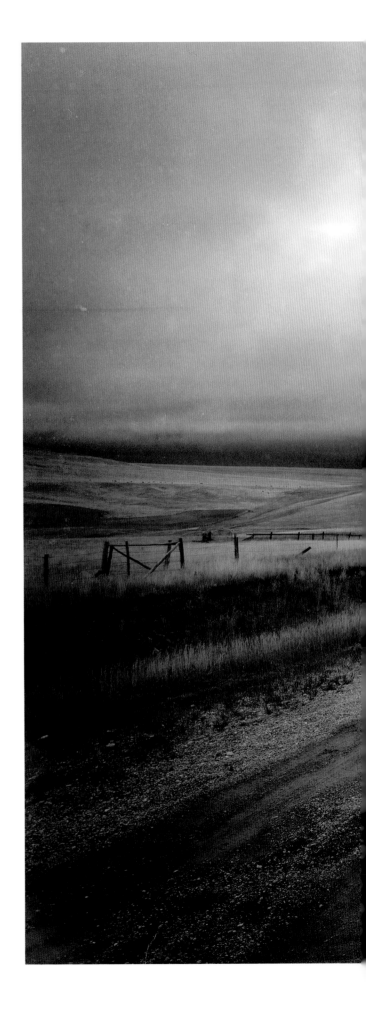

ROAD TO LIVINGSTON

2005, Montana

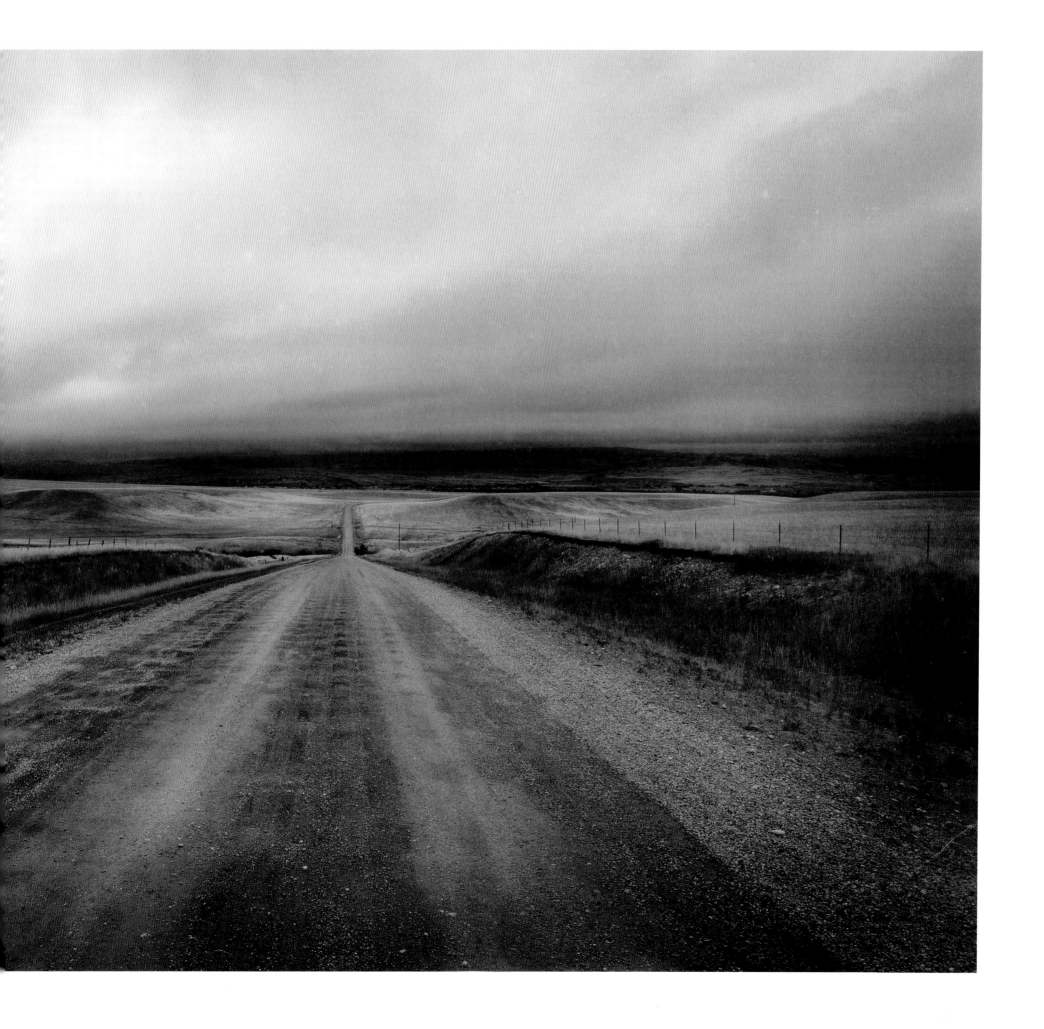

HORSES 15

2003, Badlands, South Dakota

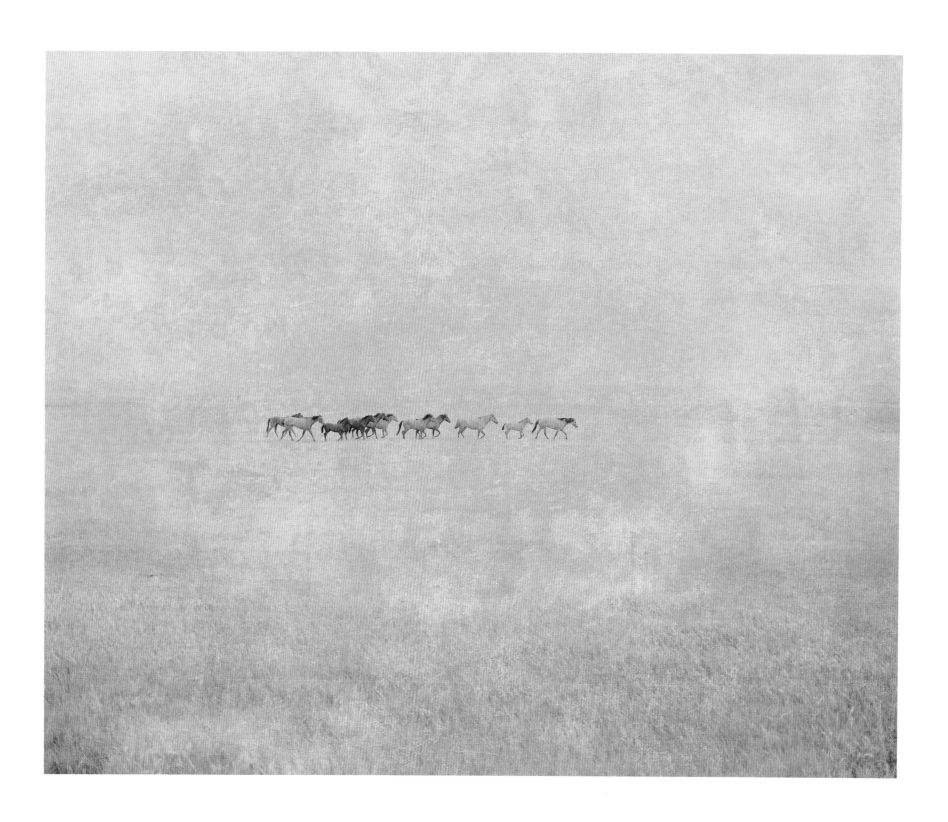

RING AROUND THE SUN

2005, Badlands, South Dakota

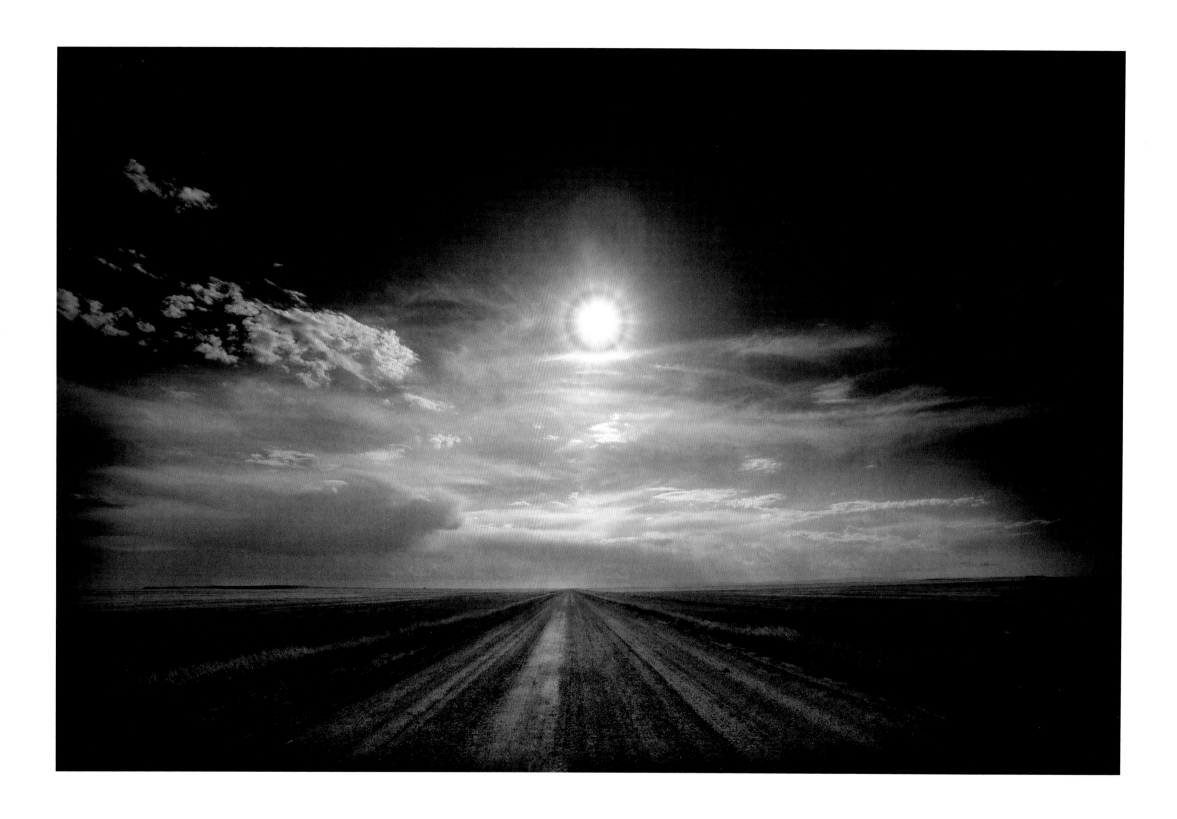

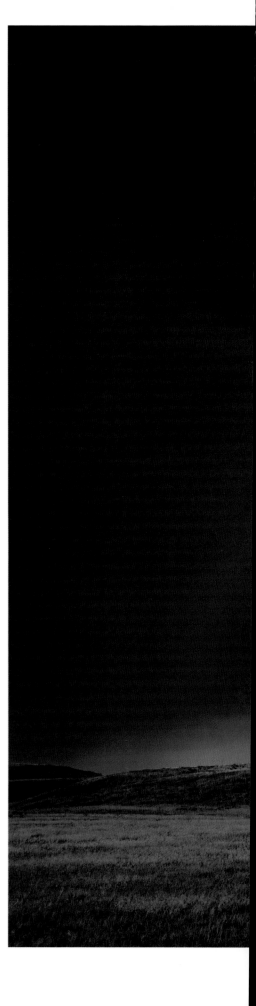

CLOUD / TREE

2008, South Dakota

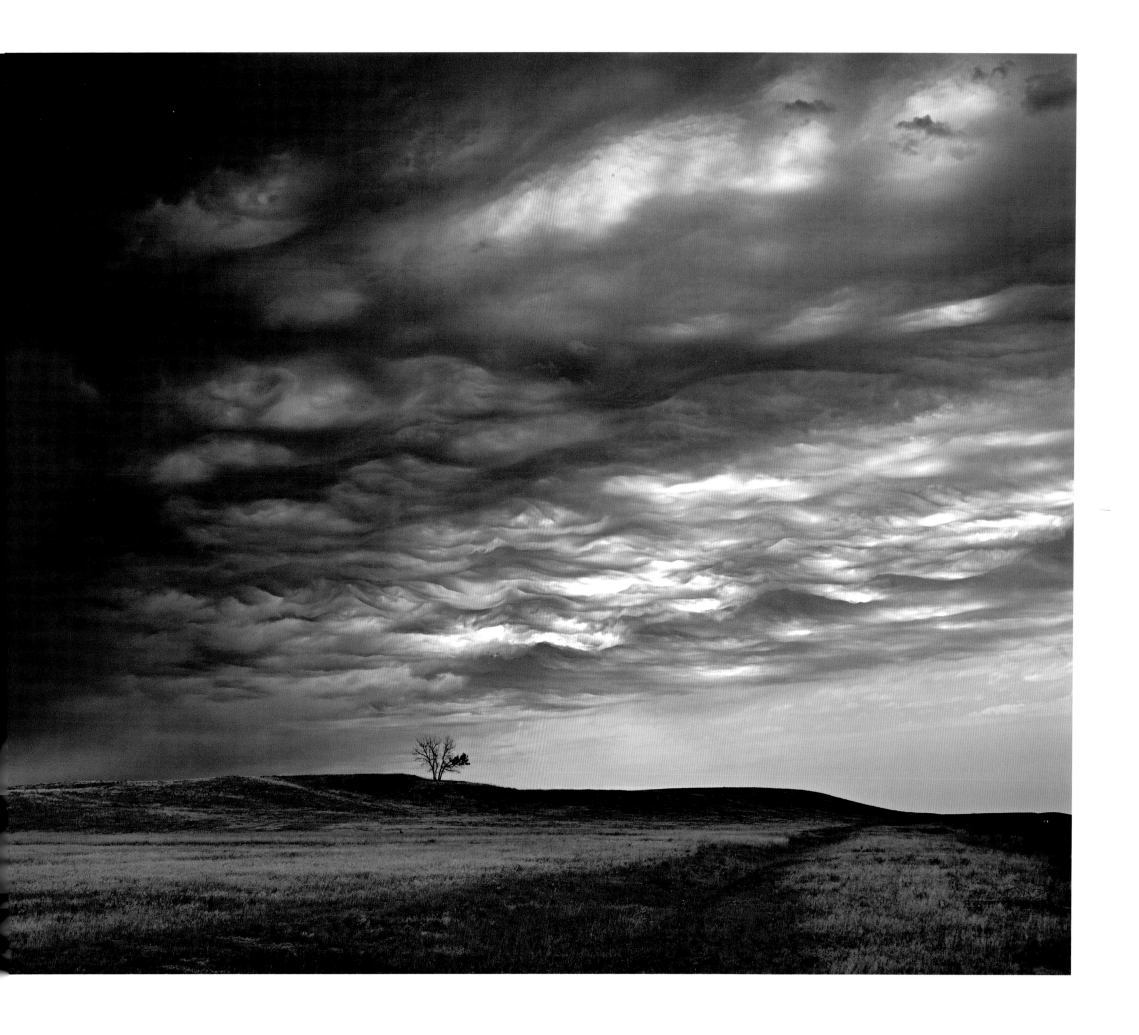

WOUNDED KNEE

2003, Wounded Knee, South Dakota

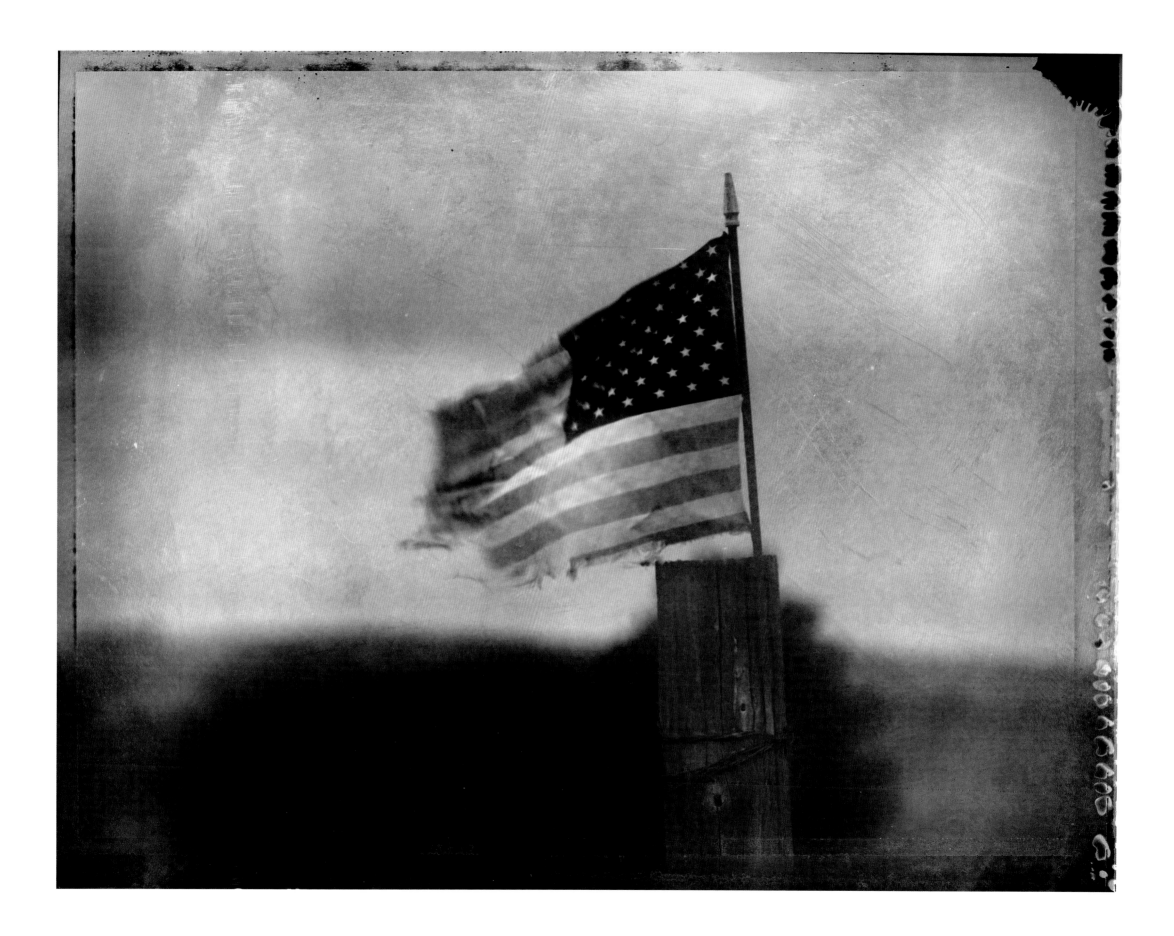

FOURTEEN TREES OF WOUNDED KNEE

2003, Pine Ridge, South Dakota

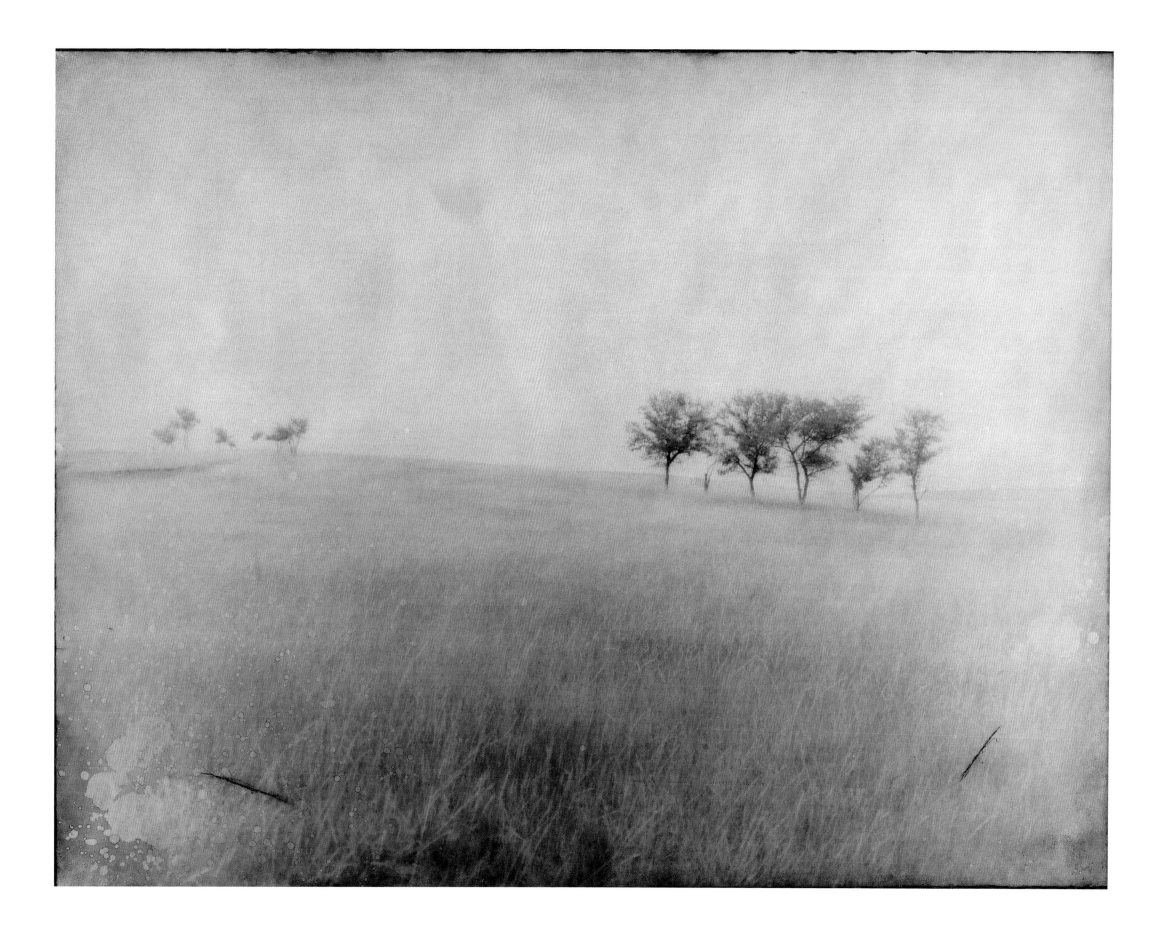

HORSES, BADLANDS

2003, Badlands, South Dakota

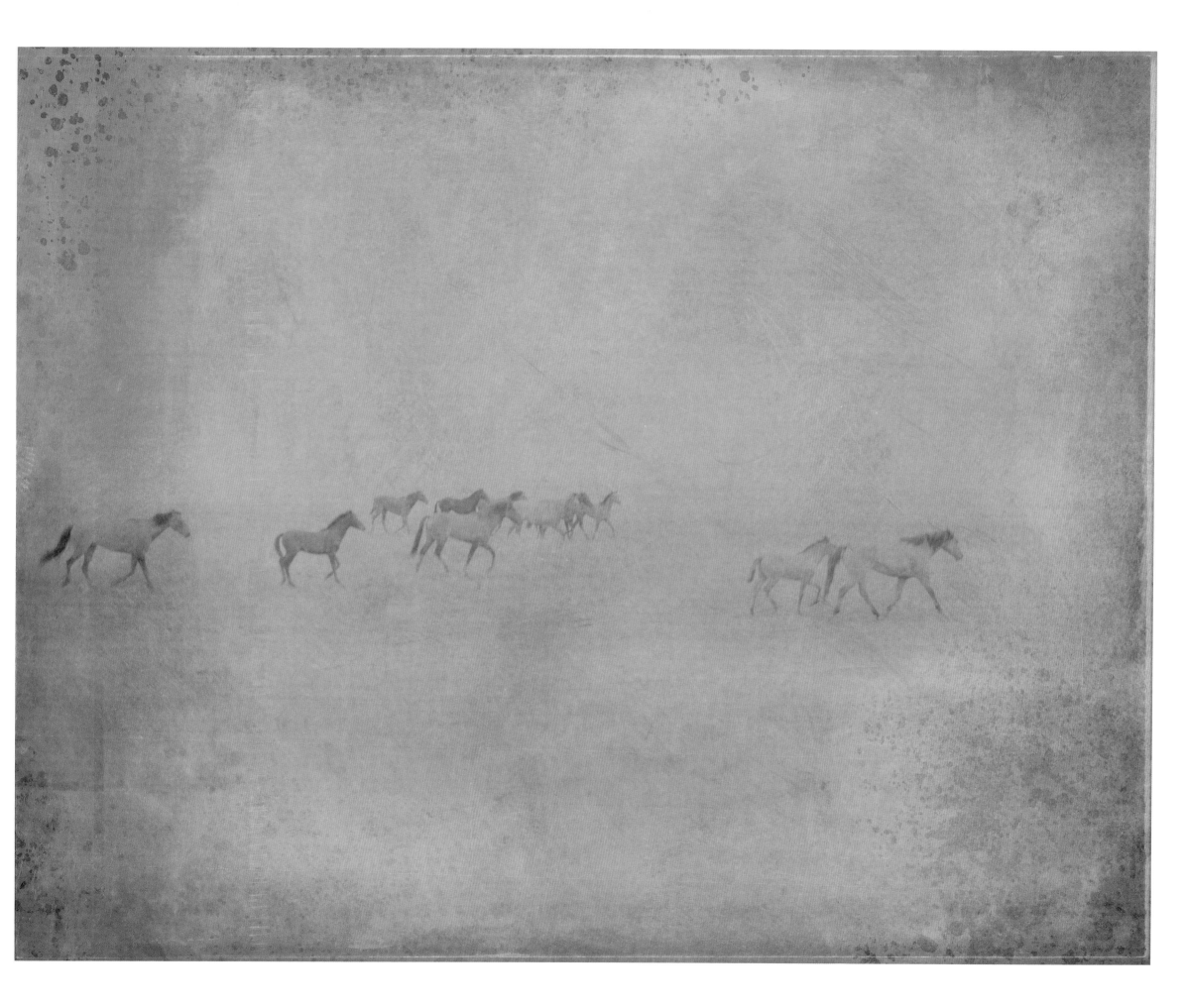

WEATHER

2008, South Dakota

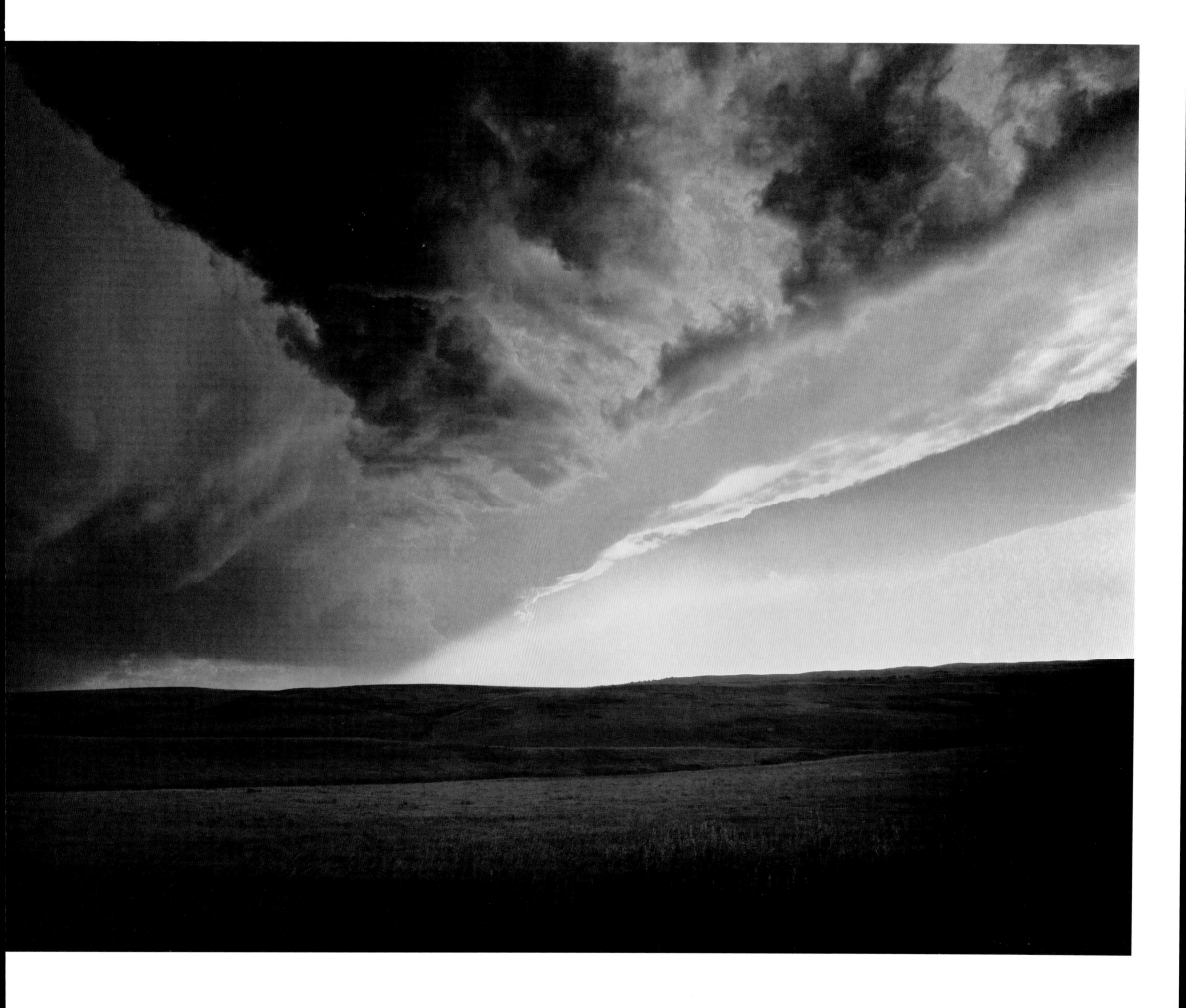

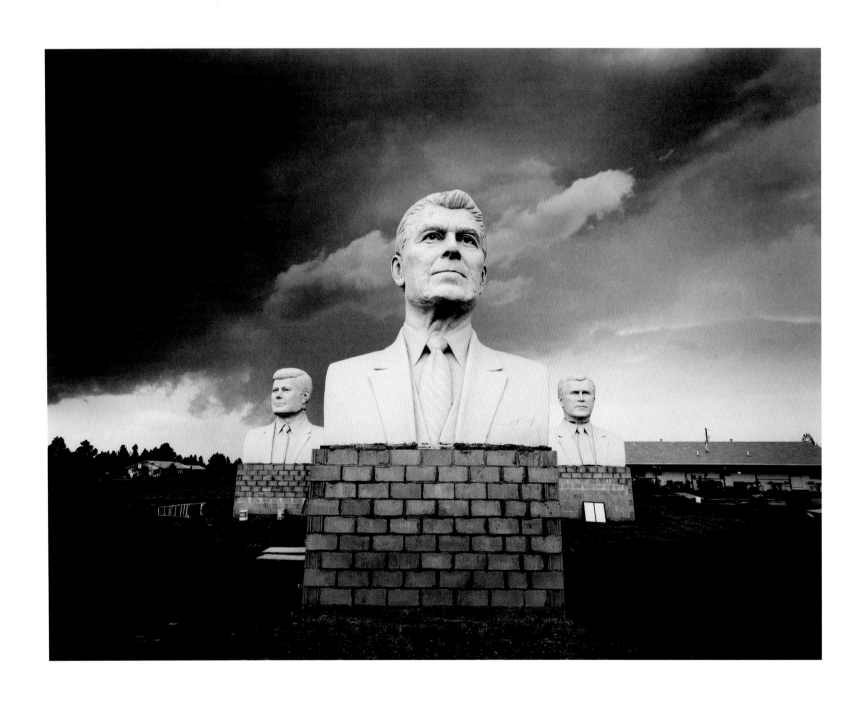

PRESIDENTS

2005, South Dakota

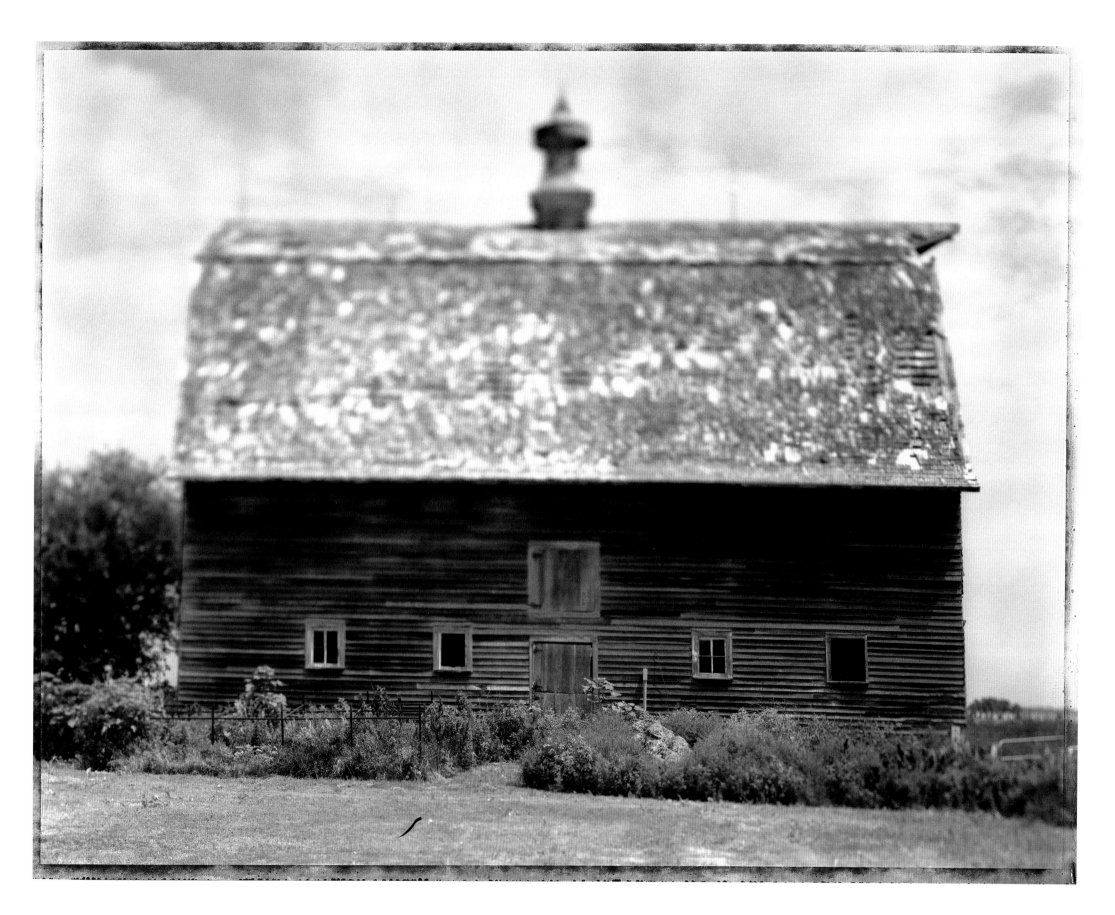

BARN / NEBRASKA

2003, Nebraska

NEBRASKA

2007, Nebraska

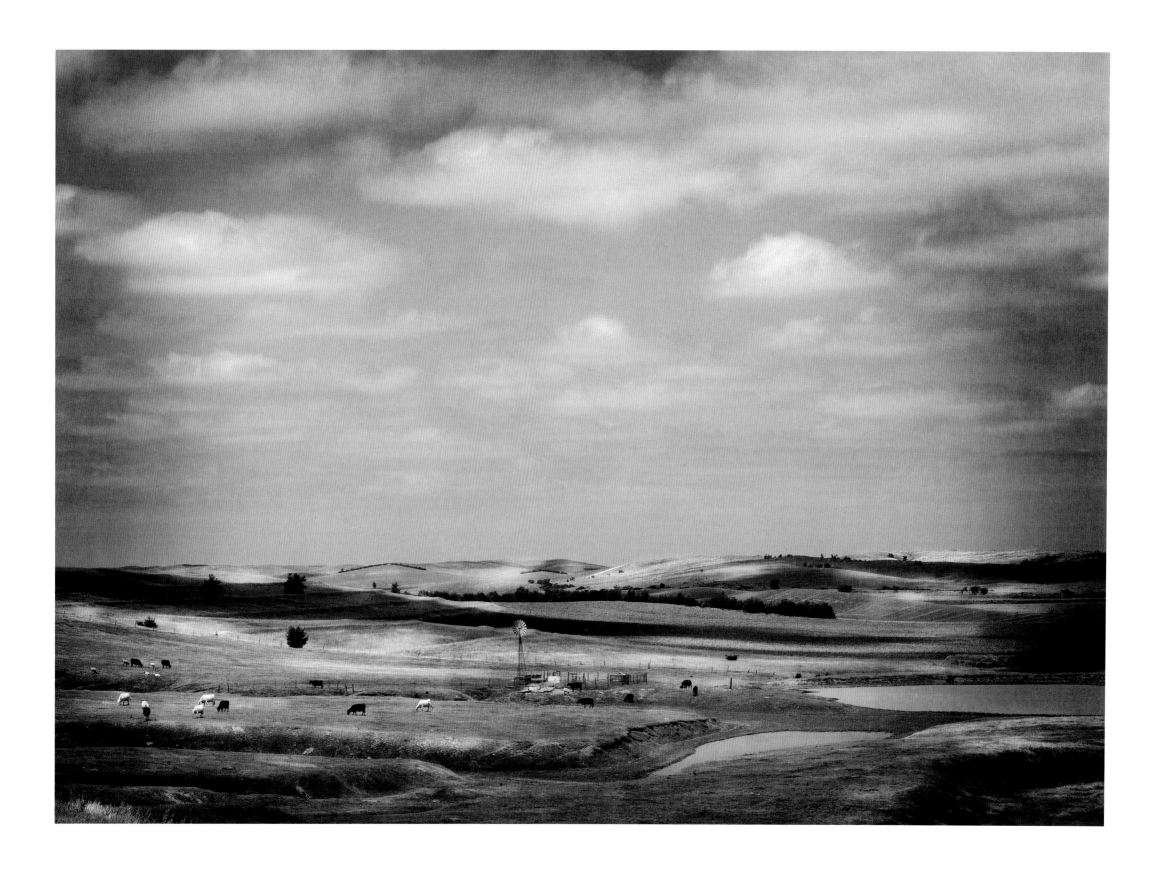

AN AMERICAN HOUSE

2003, Nebraska

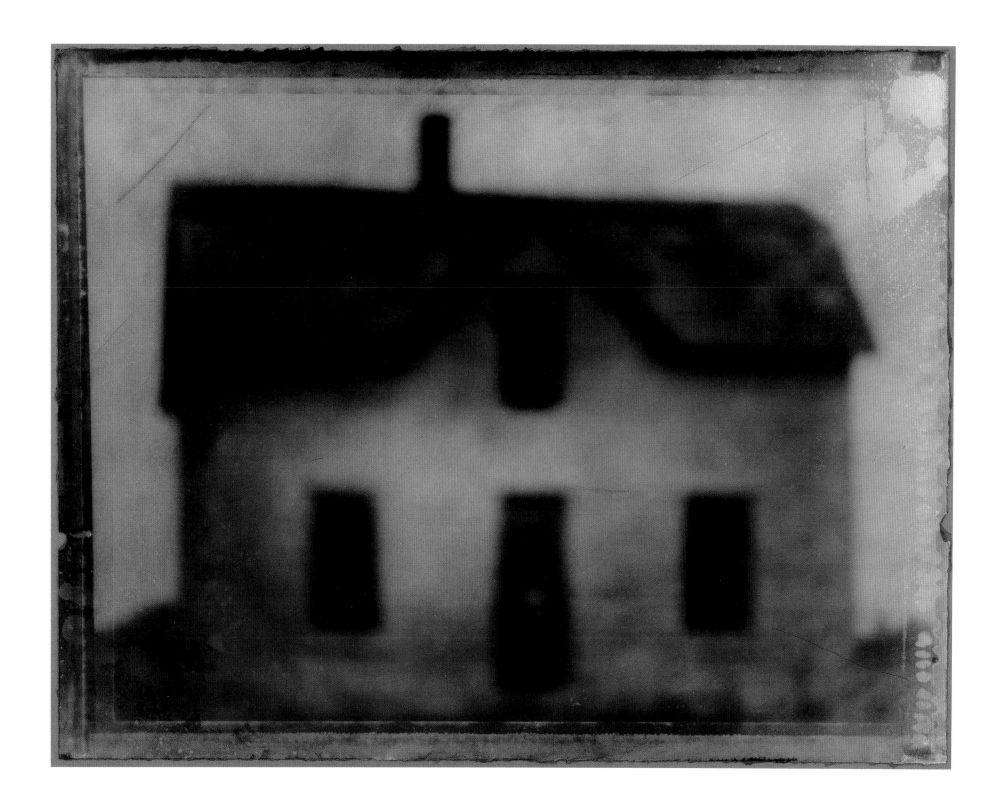

ROAD II

2005, Nebraska

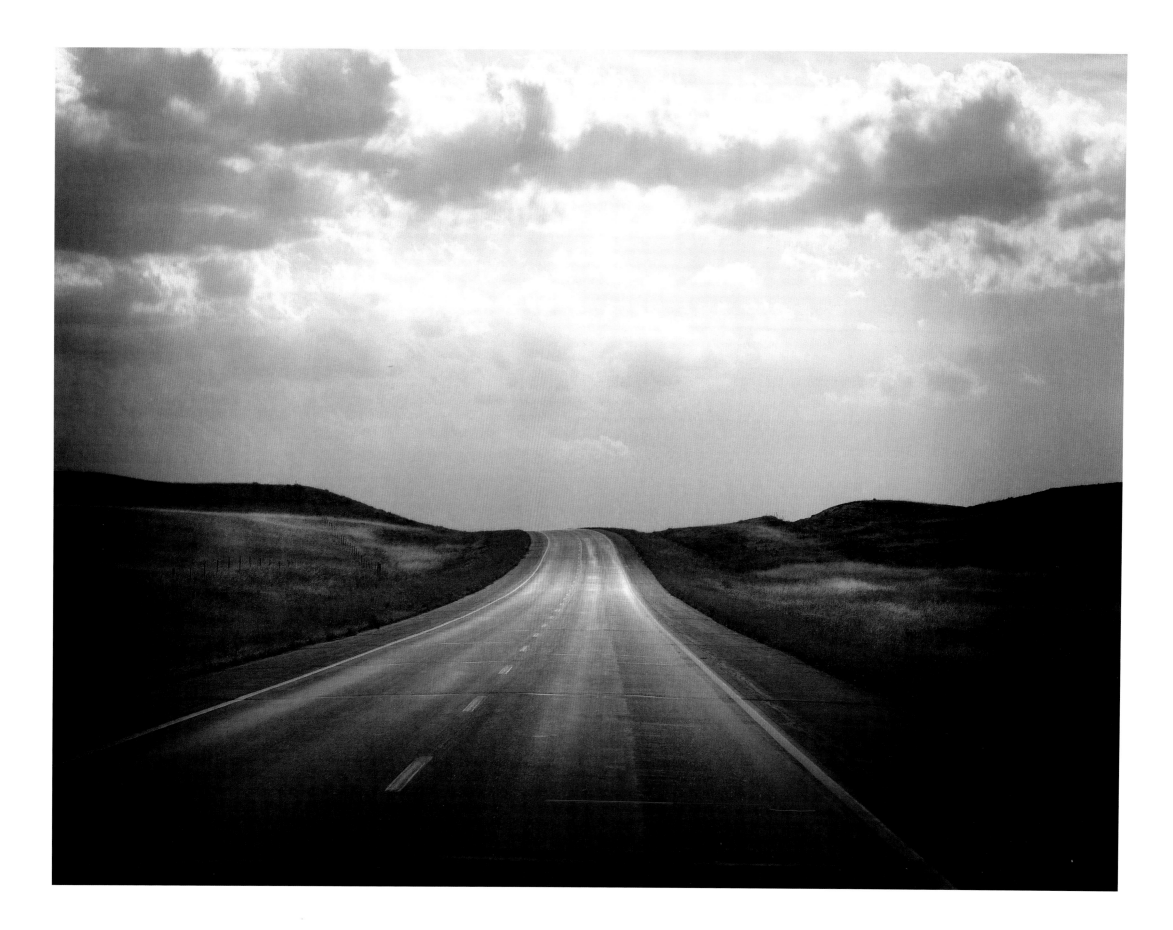

SILVER CLOUDS

2007, Nebraska

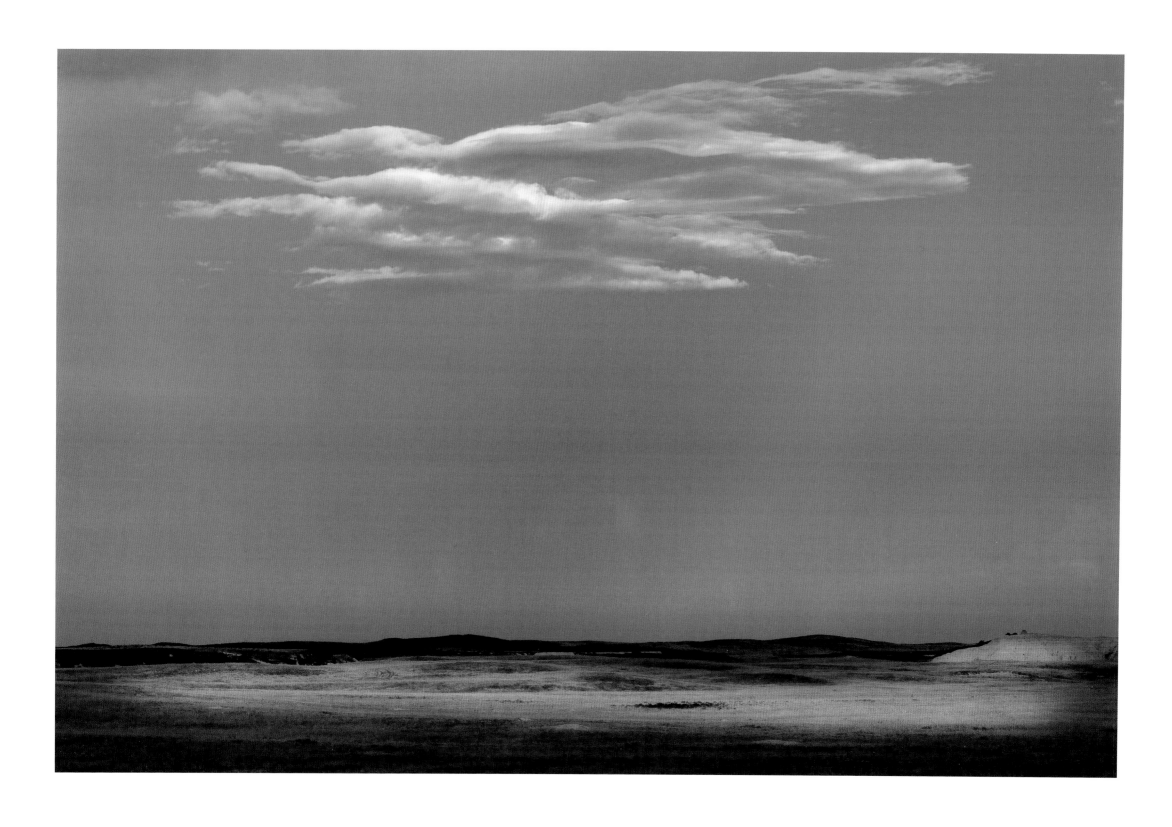

4 SILOS

2007, Iowa

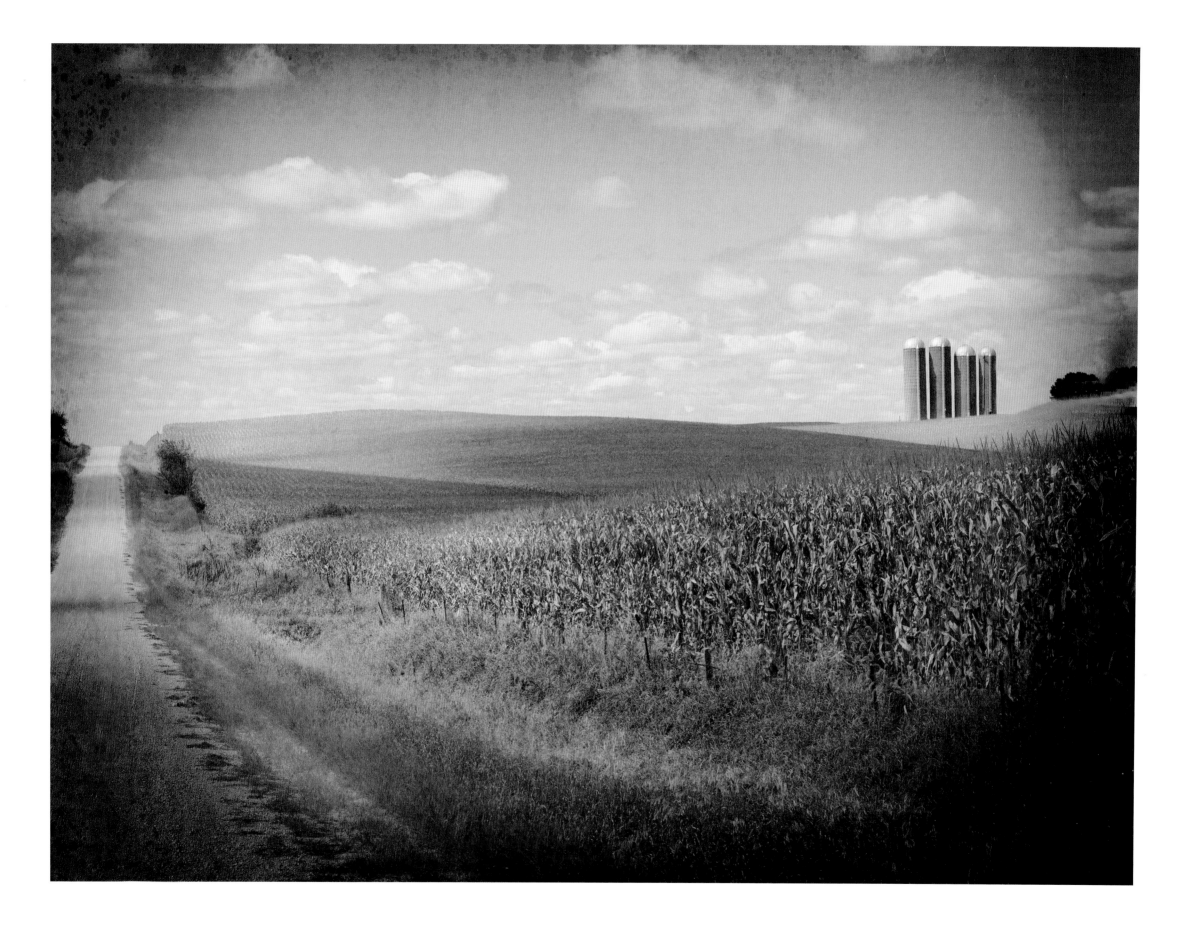

IOWA

2007, Iowa

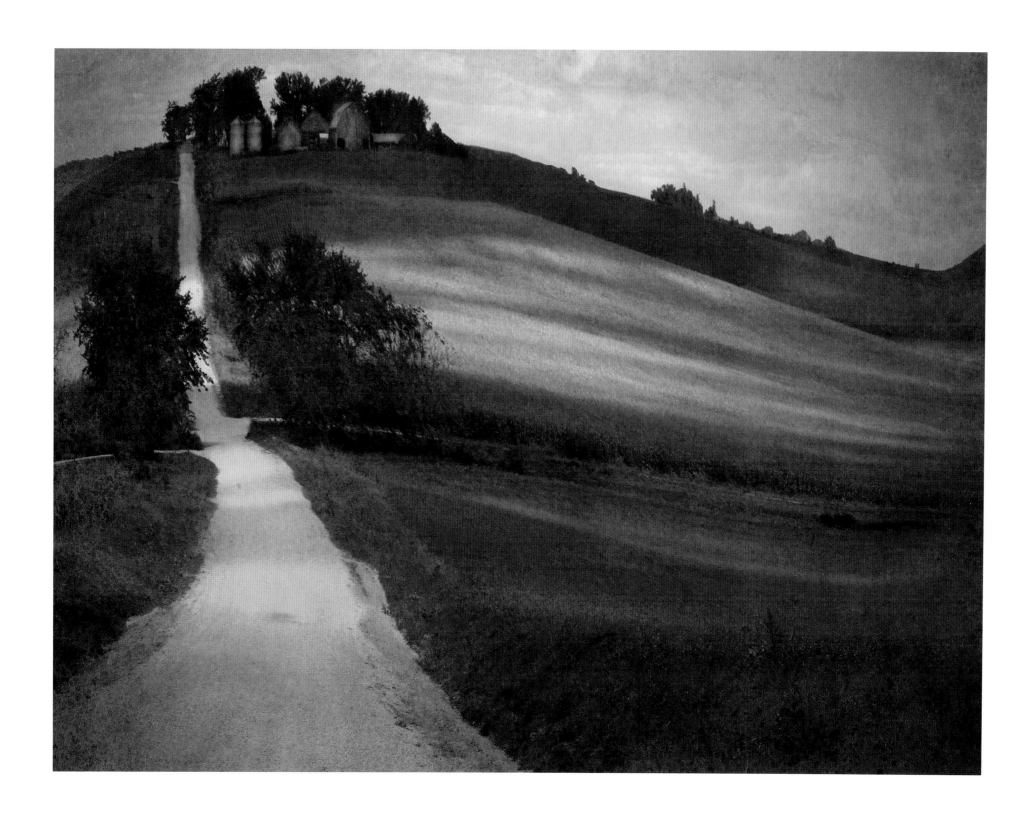

LOST NATION, IOWA

2008, Lost Nation, Iowa

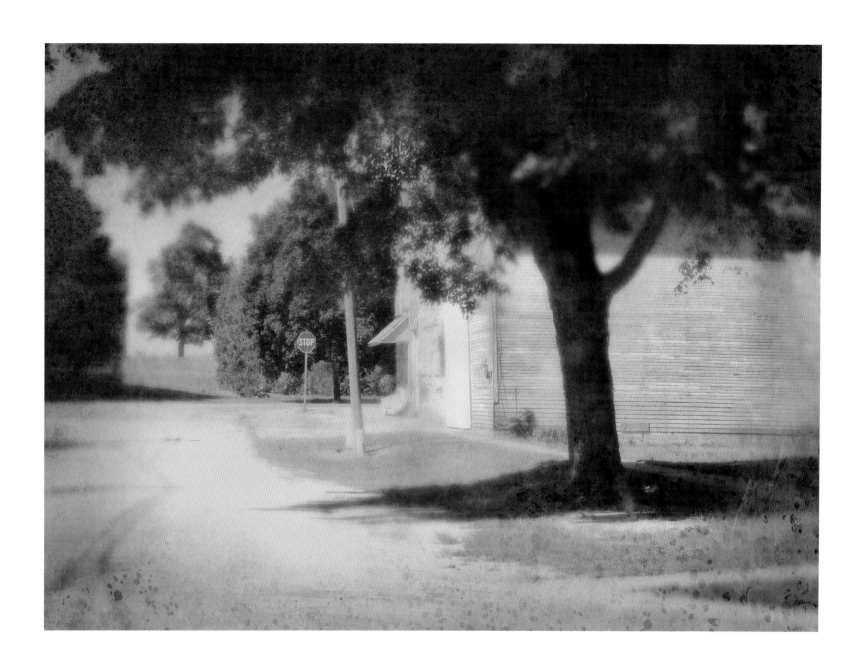

BIRDS 22

2007, Iowa

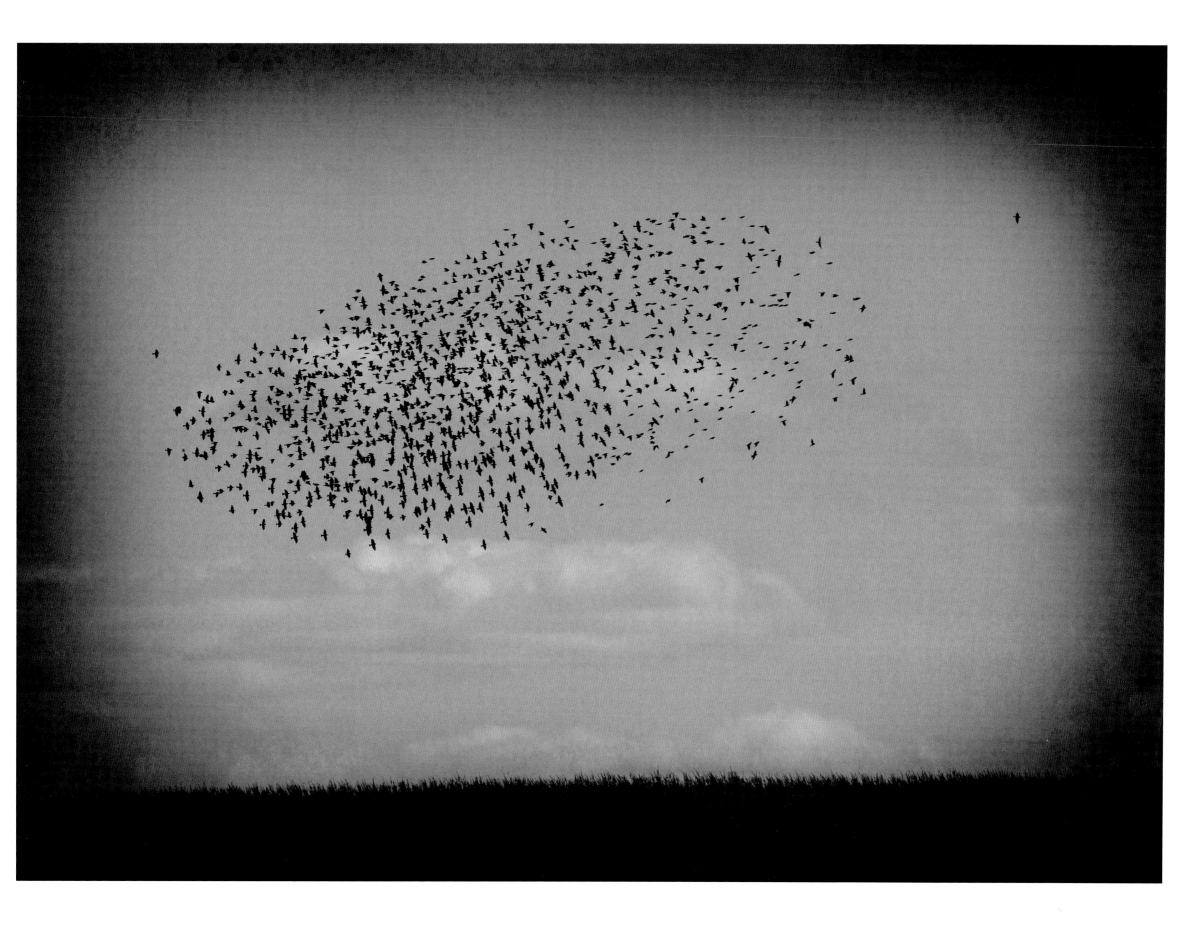

MISCANTHUS

2007, Iowa

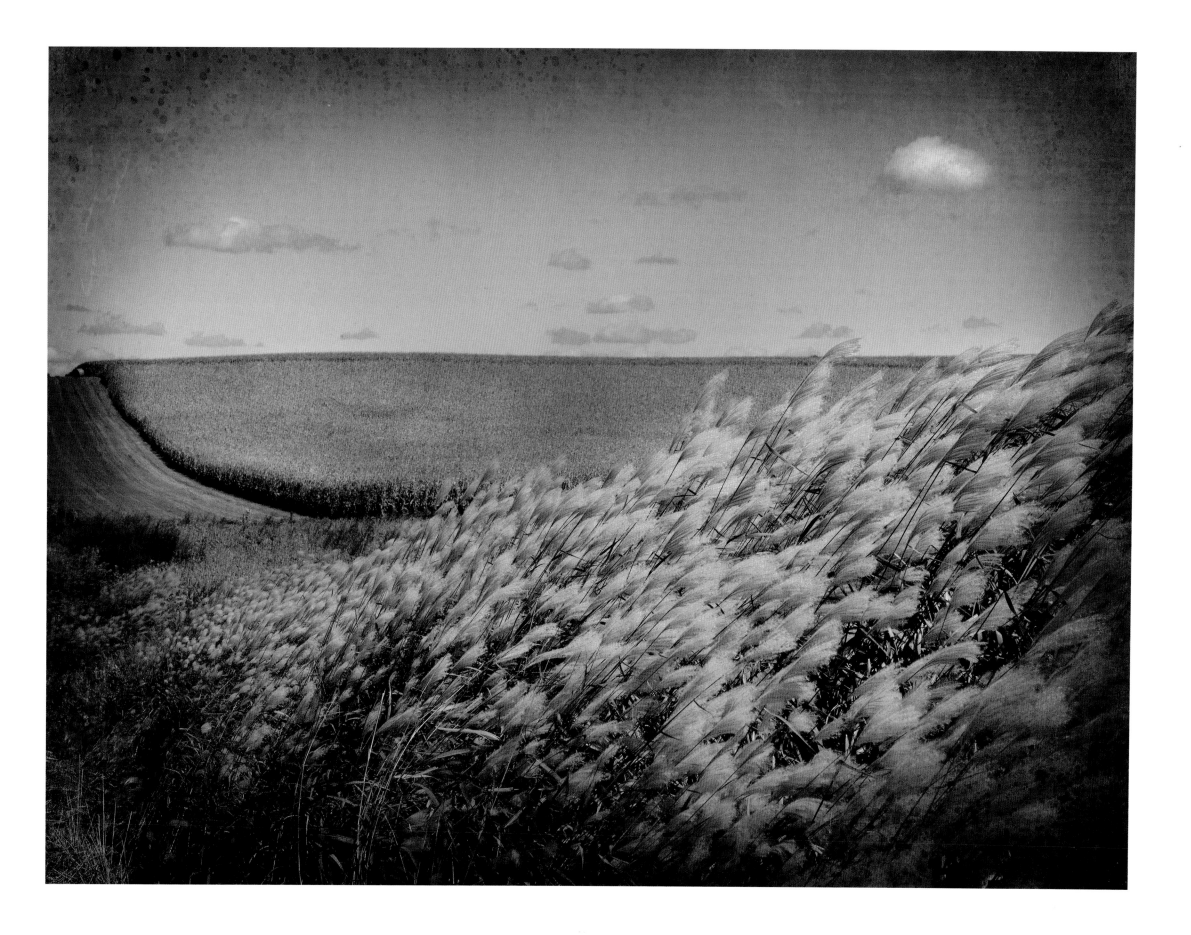

SUMMER IN XENIA, ILLINOIS

2010

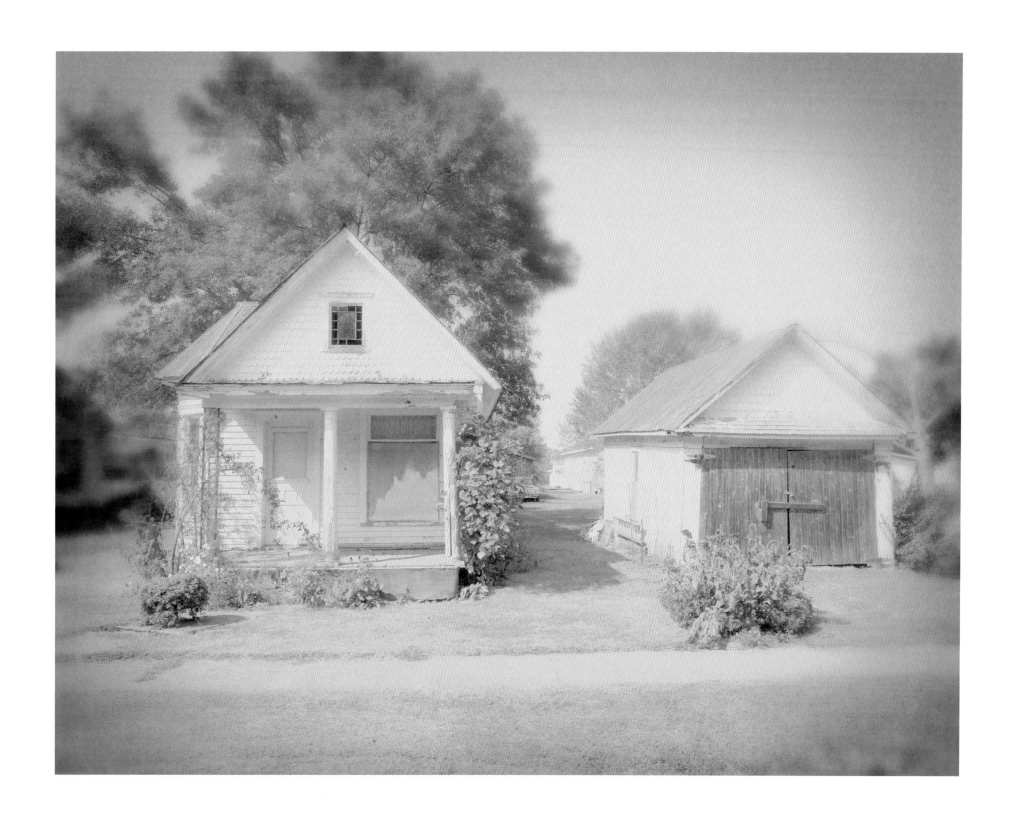

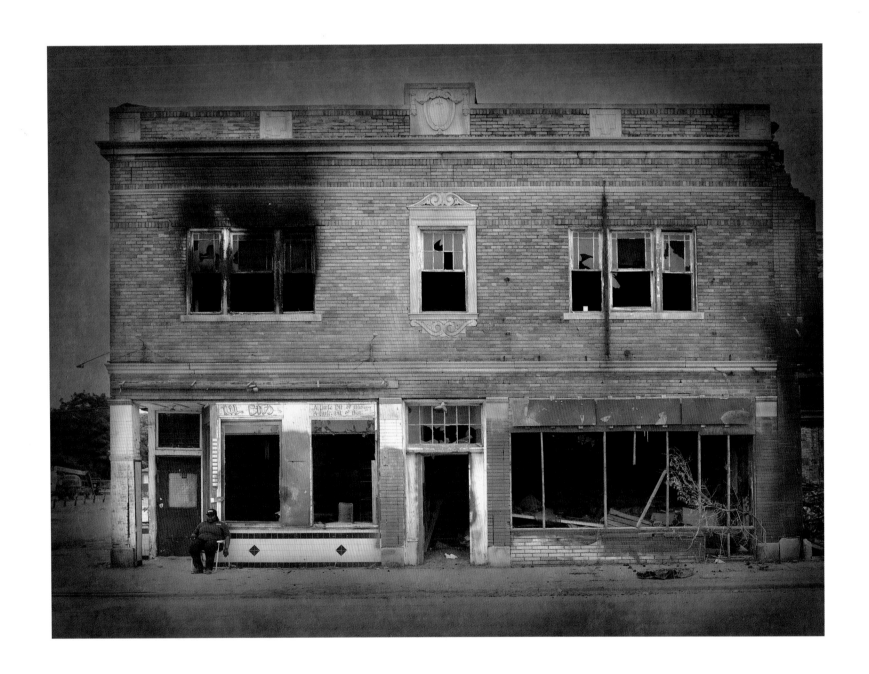

DETROIT

2016, Detroit, Michigan

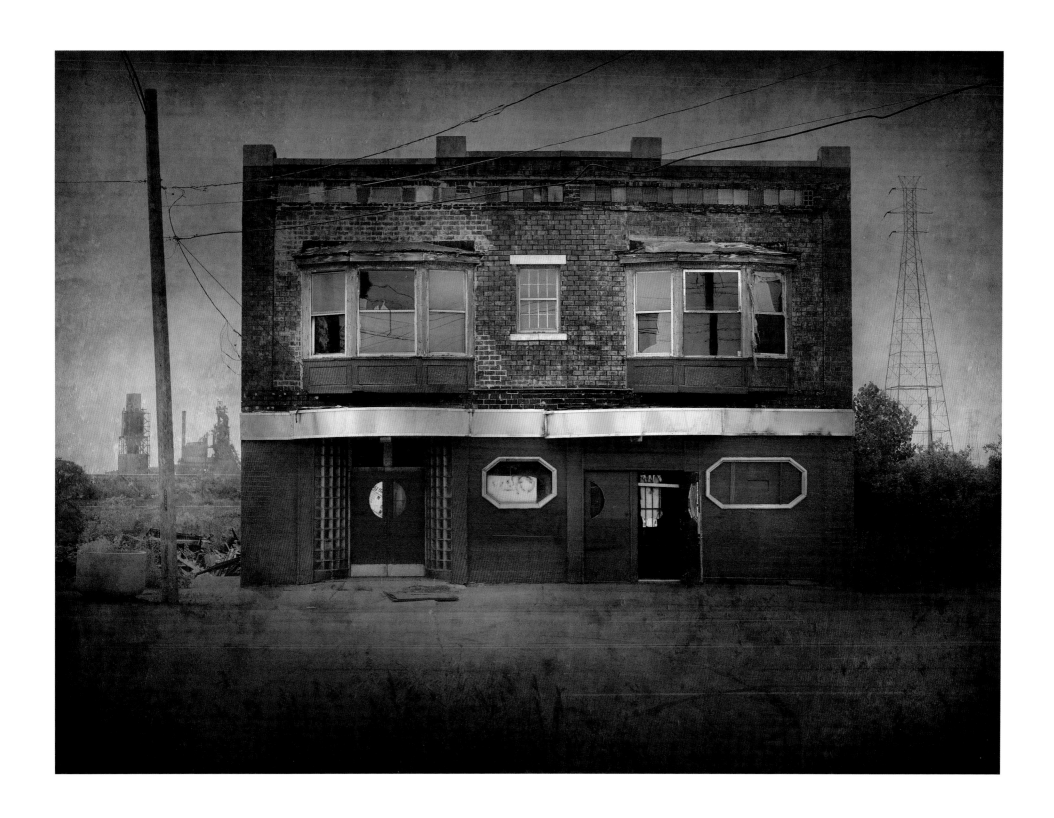

DEARBORN BAR

2016, Dearborn, Michigan

THE RIVER ROUGE

2016, Dearborn, Michigan

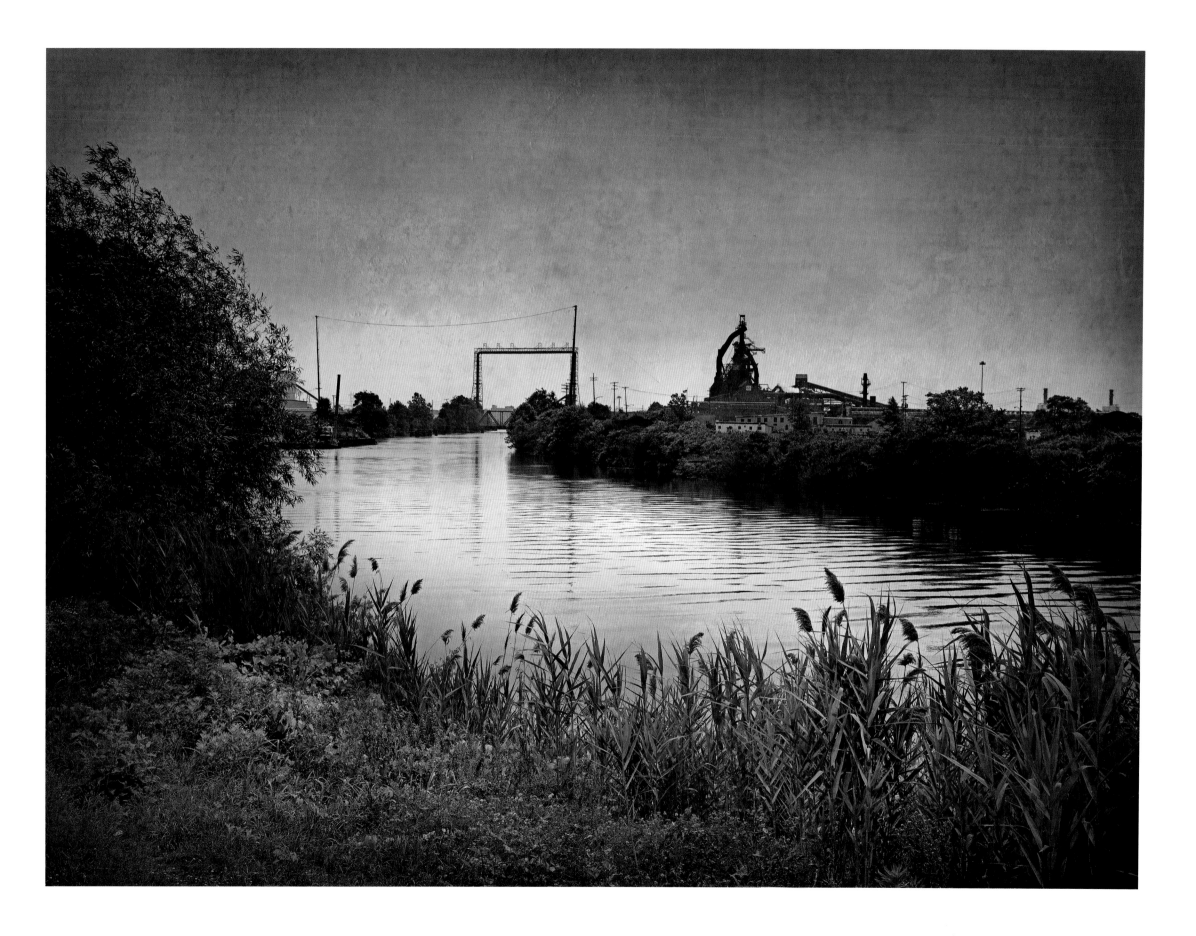

RIVER ROUGE PLANT

2016, Dearborn, Michigan

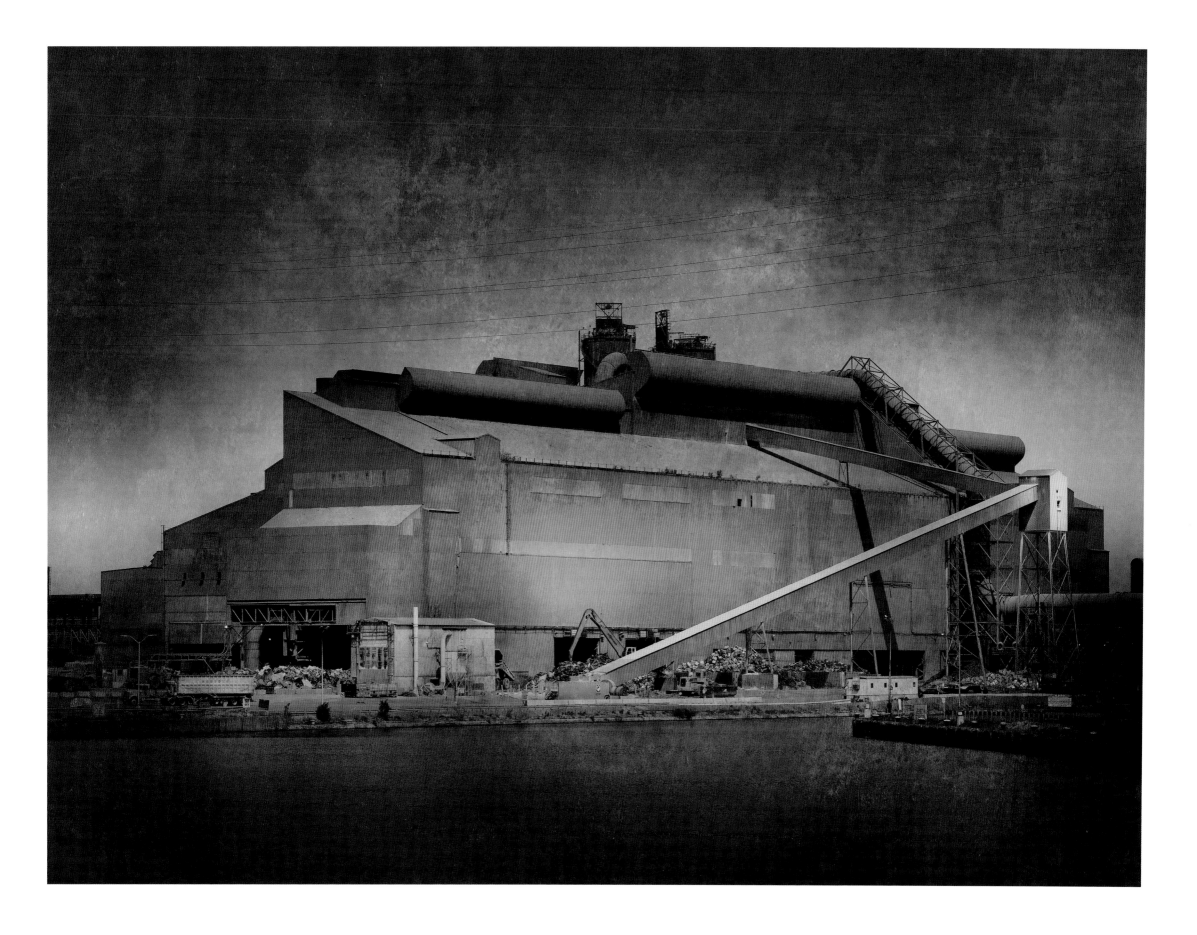

HOTEL ROYAL

2016, Toledo, Ohio

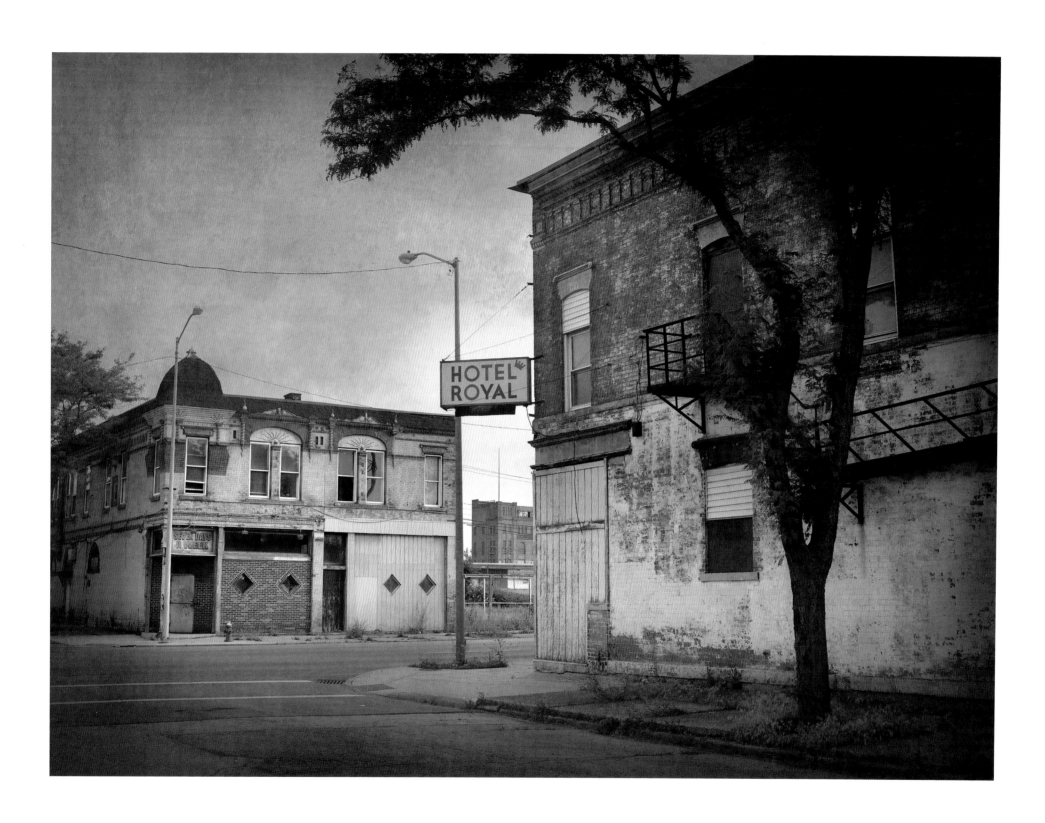

STILL DREAMING

2016, Toledo, Ohio

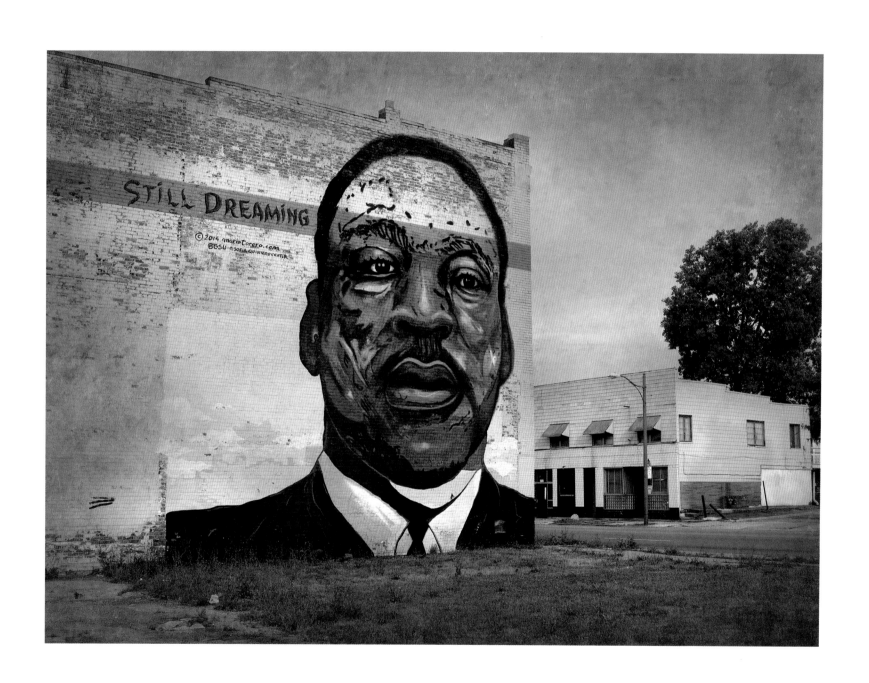

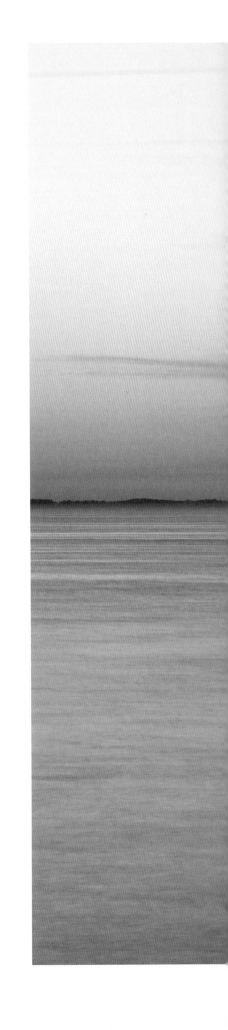

LAKE ERIE

2016, Toledo, Ohio

144

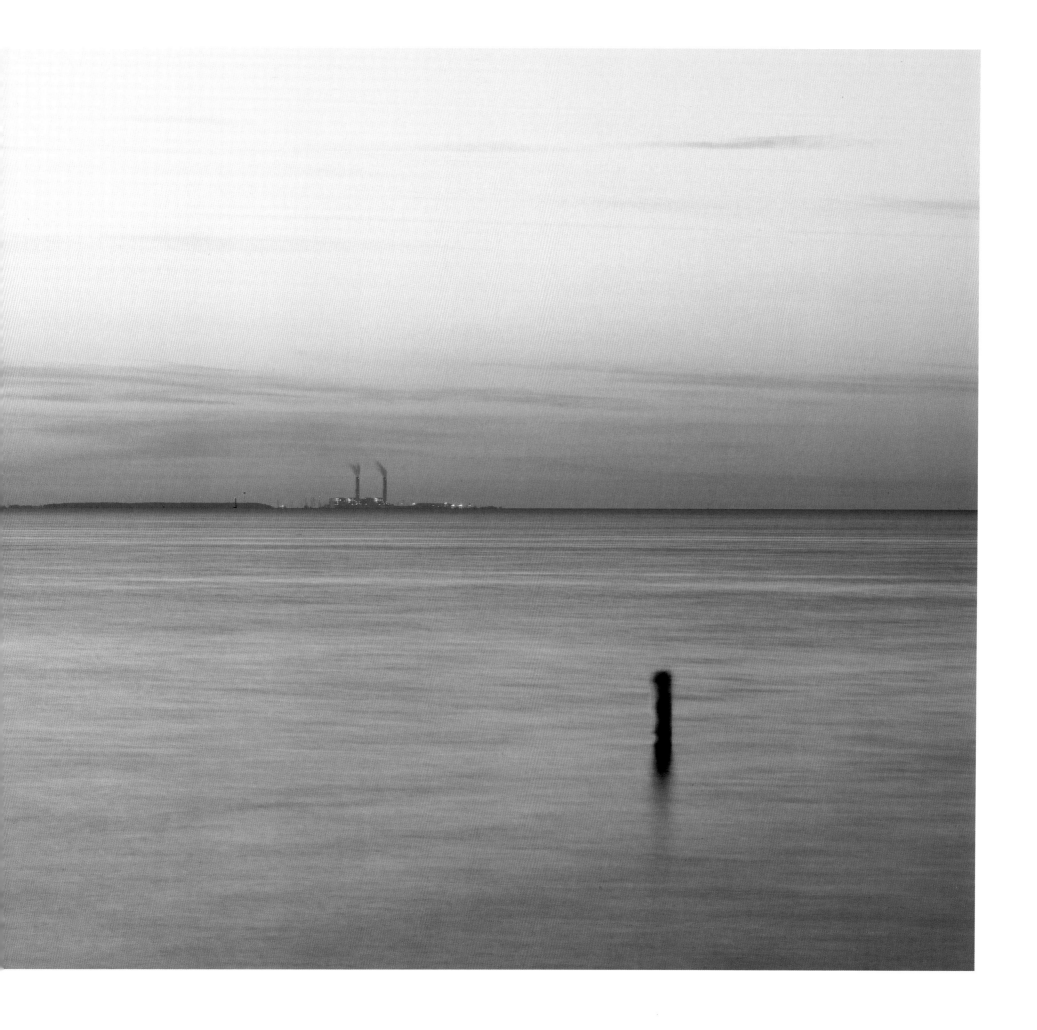

HOLY TRINITY BYZANTINE CHURCH

2016, Youngstown, Ohio

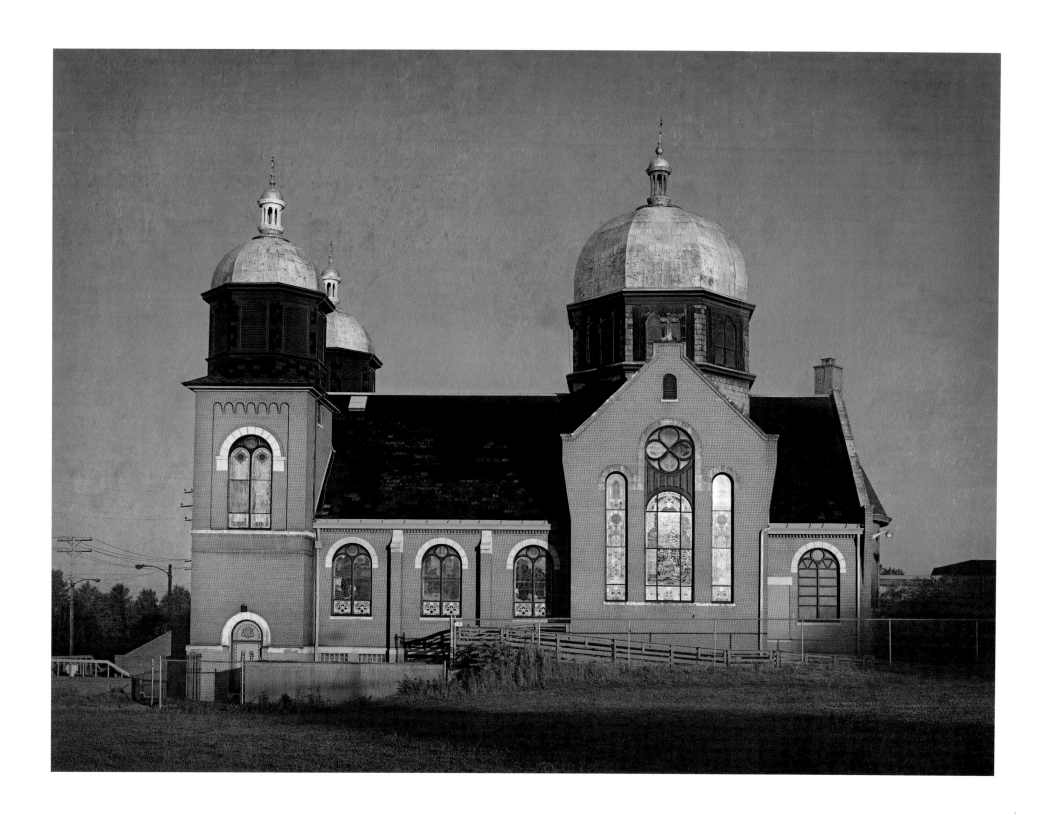

DEL-RIO BAR

2014, Pecos, Texas

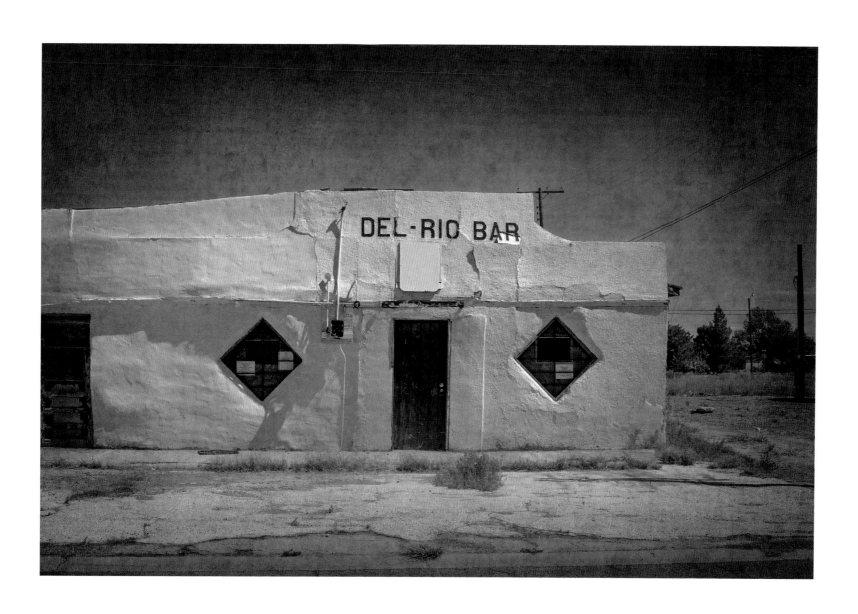

WEST TEXAS SPRING

2004, Texas

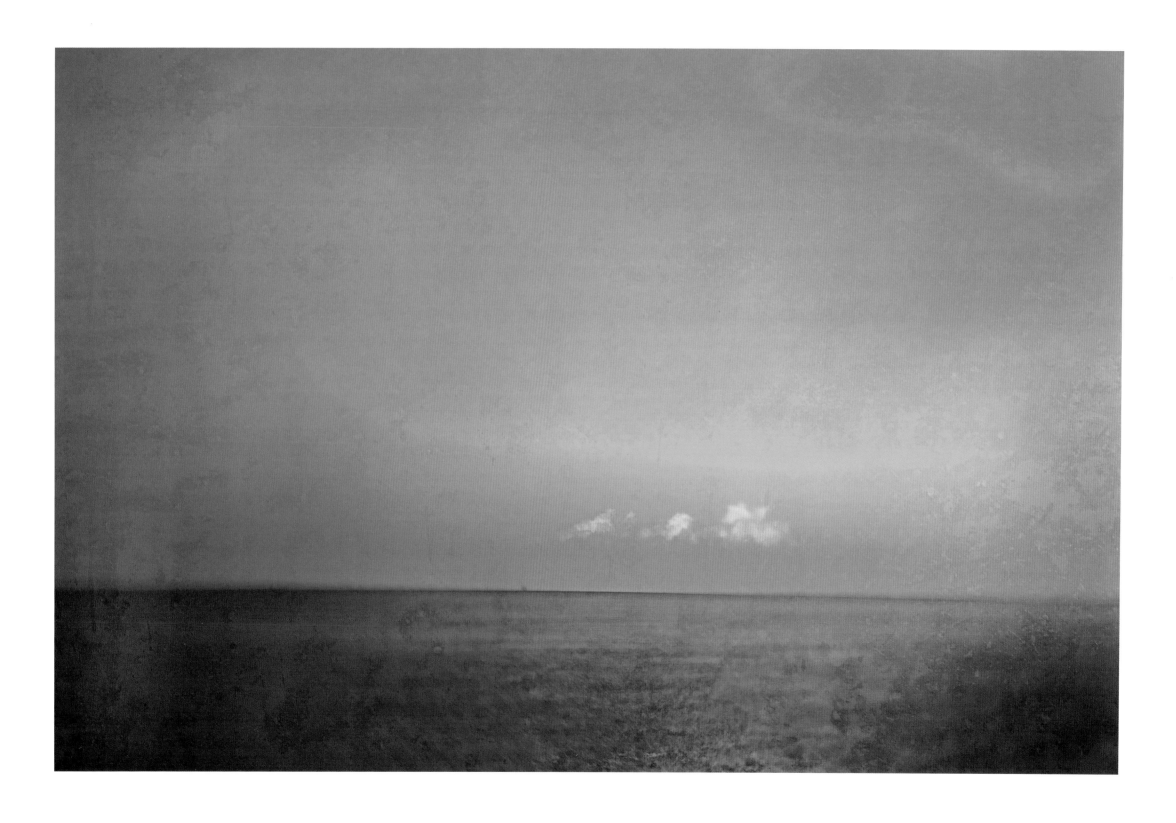

WEST TEXAS STORE

2004, Texas

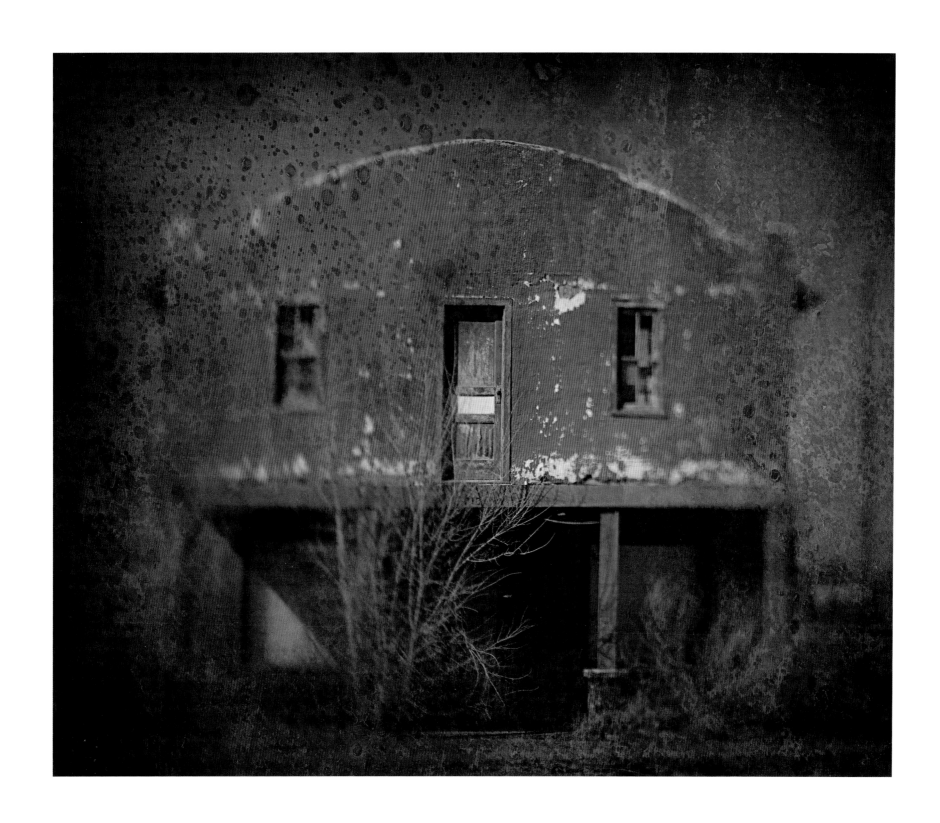

WEST TEXAS DRIVE-IN

2009, Texas

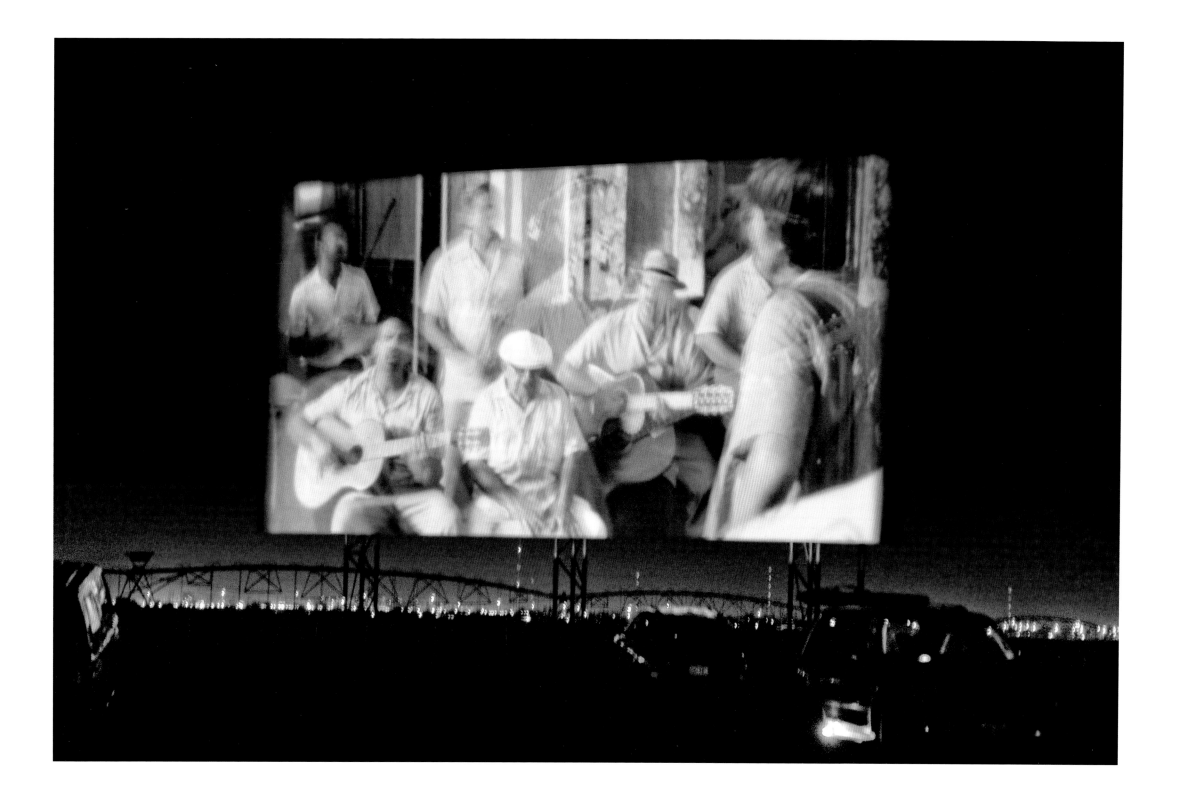

WEST TEXAS ROAD

2004, Texas

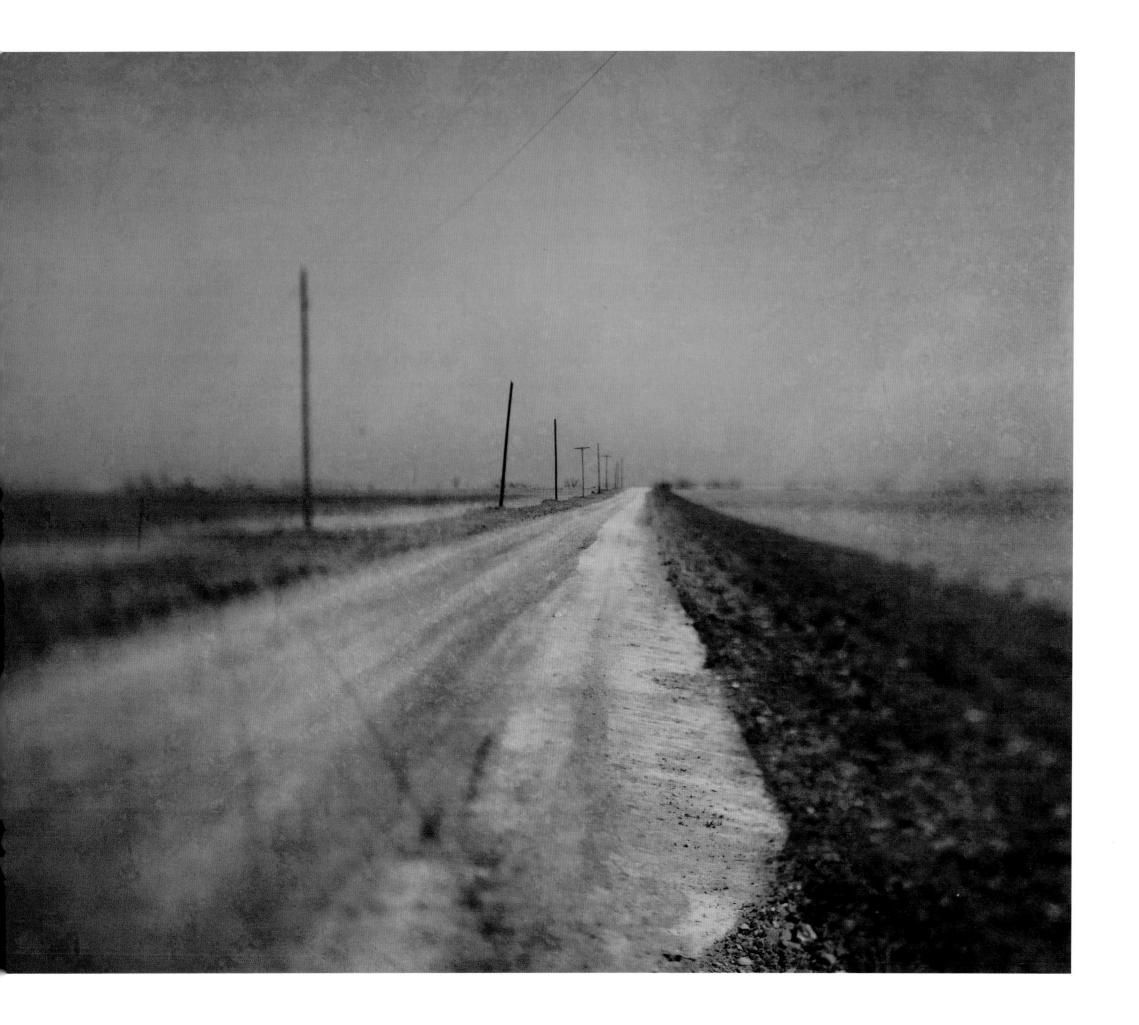

ABANDONED SCHOOL BUS

2014, Pecos, Texas

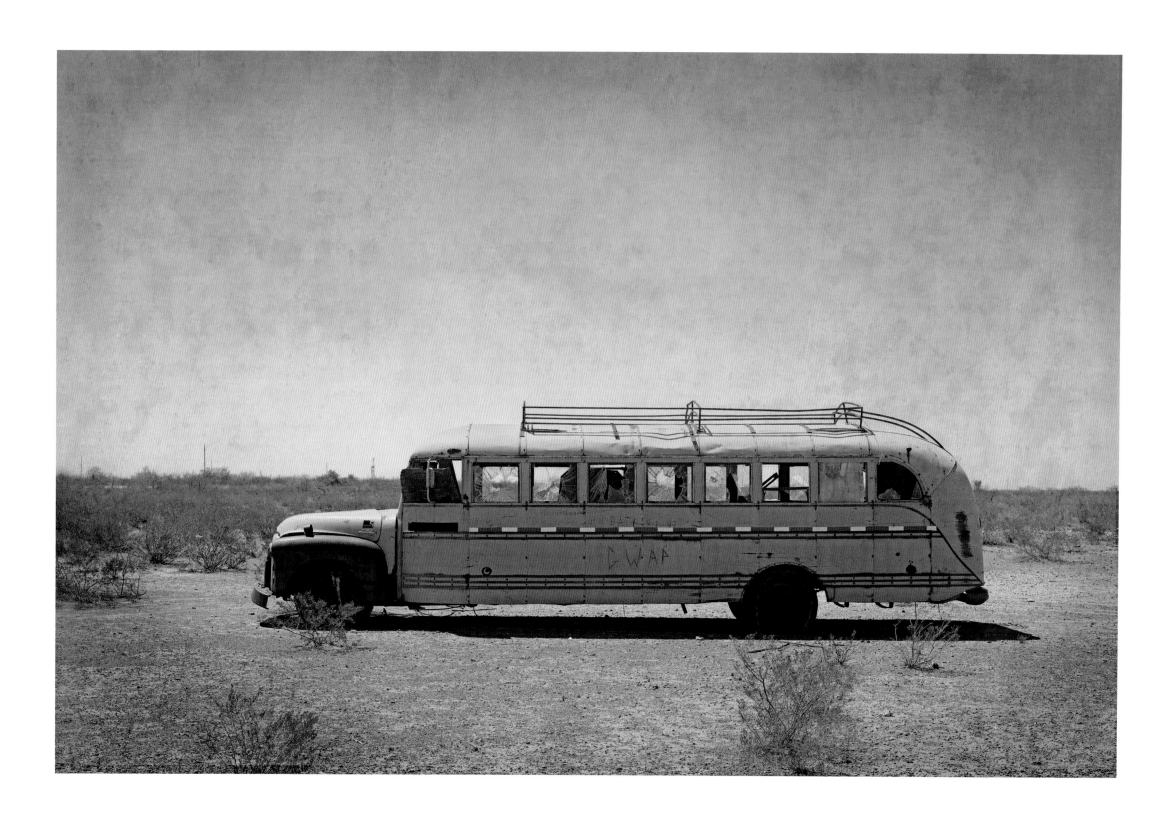

BANK

2014, Barstow, Texas

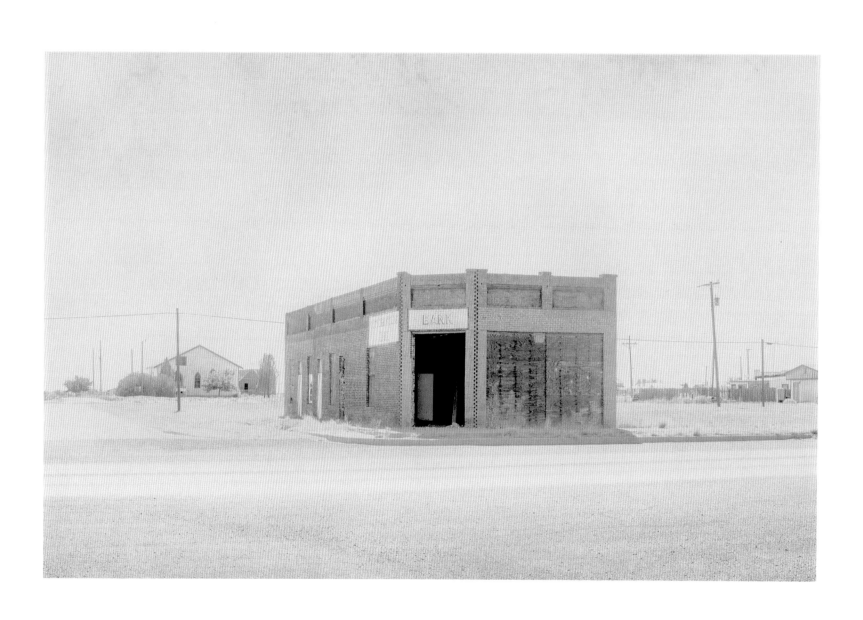

WADERS

2014, Mandeville, Louisiana

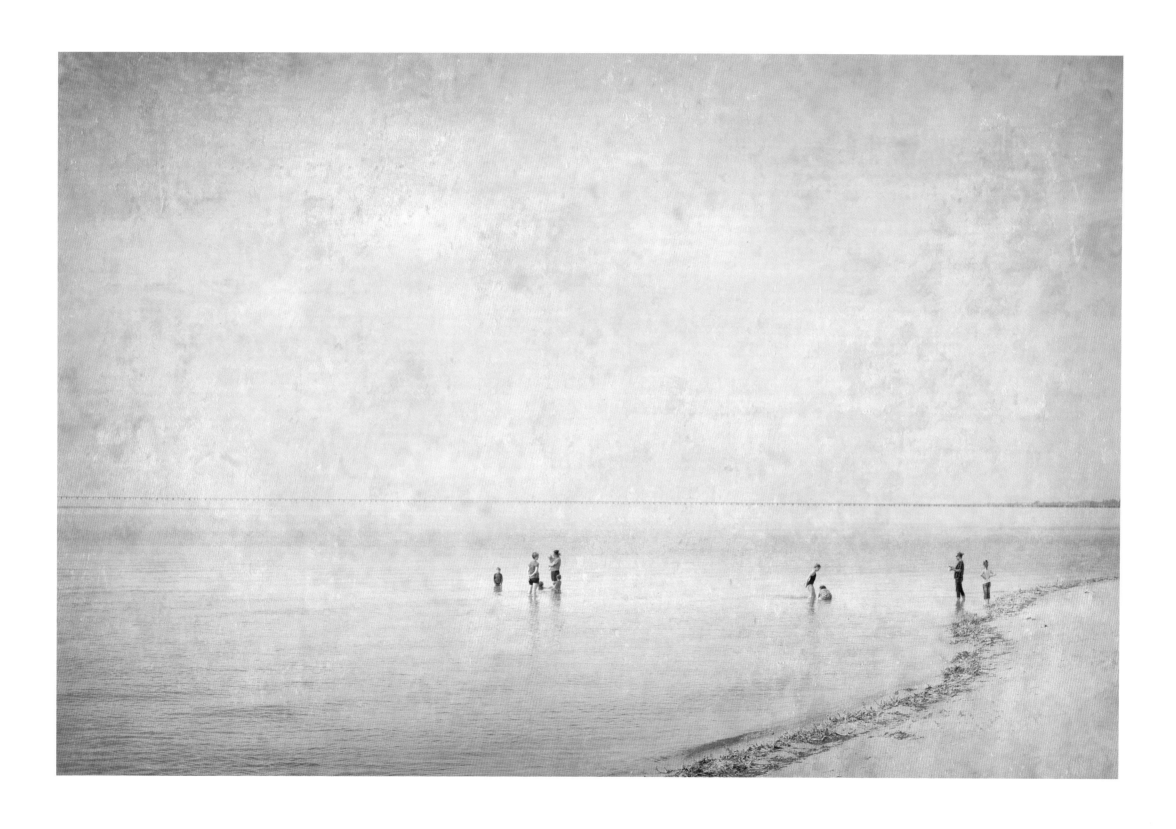

CHURCH I

2005, Frogtown, Louisiana

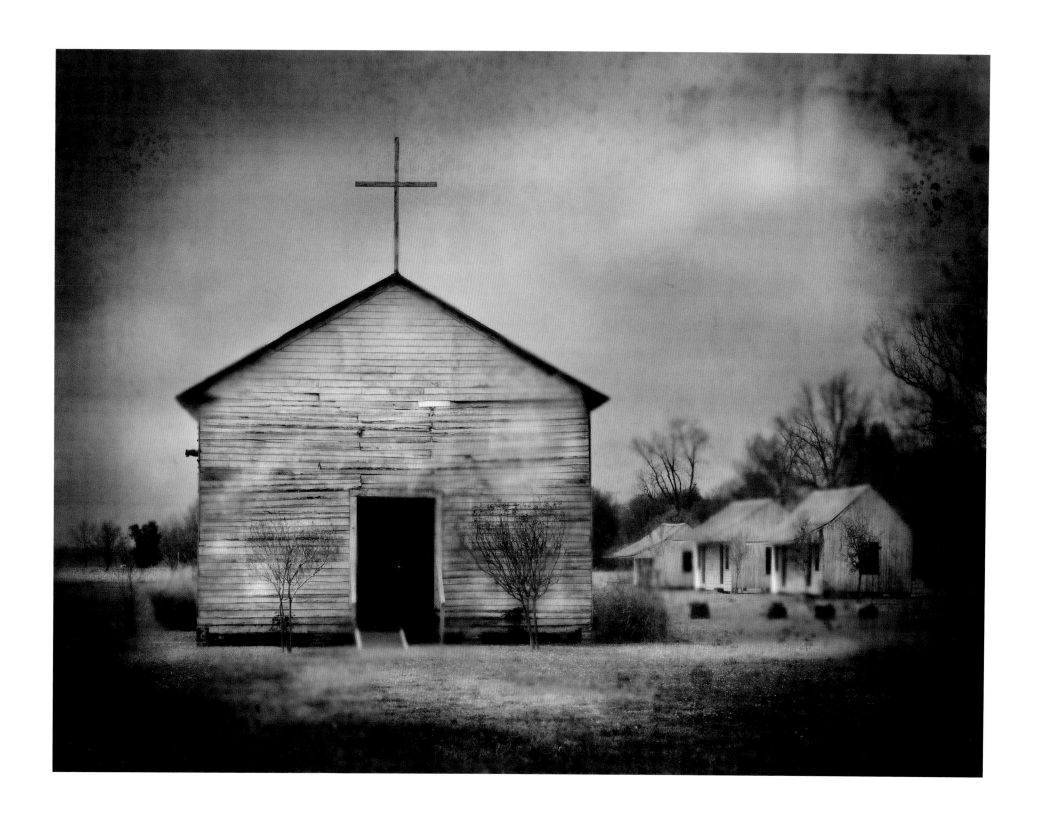

LIVY WAS HERE

2014, Transylvania, Louisiana

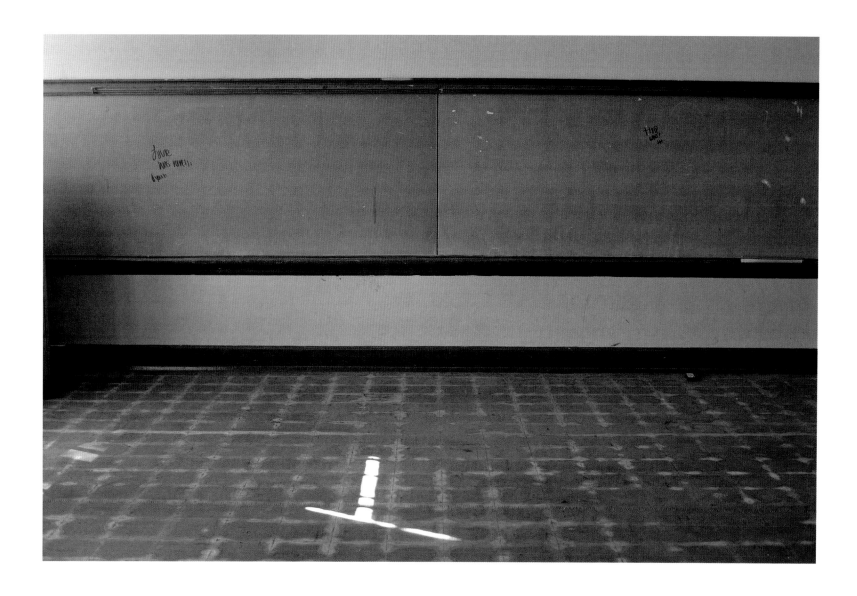

WHITE DEER

2004, Louisiana

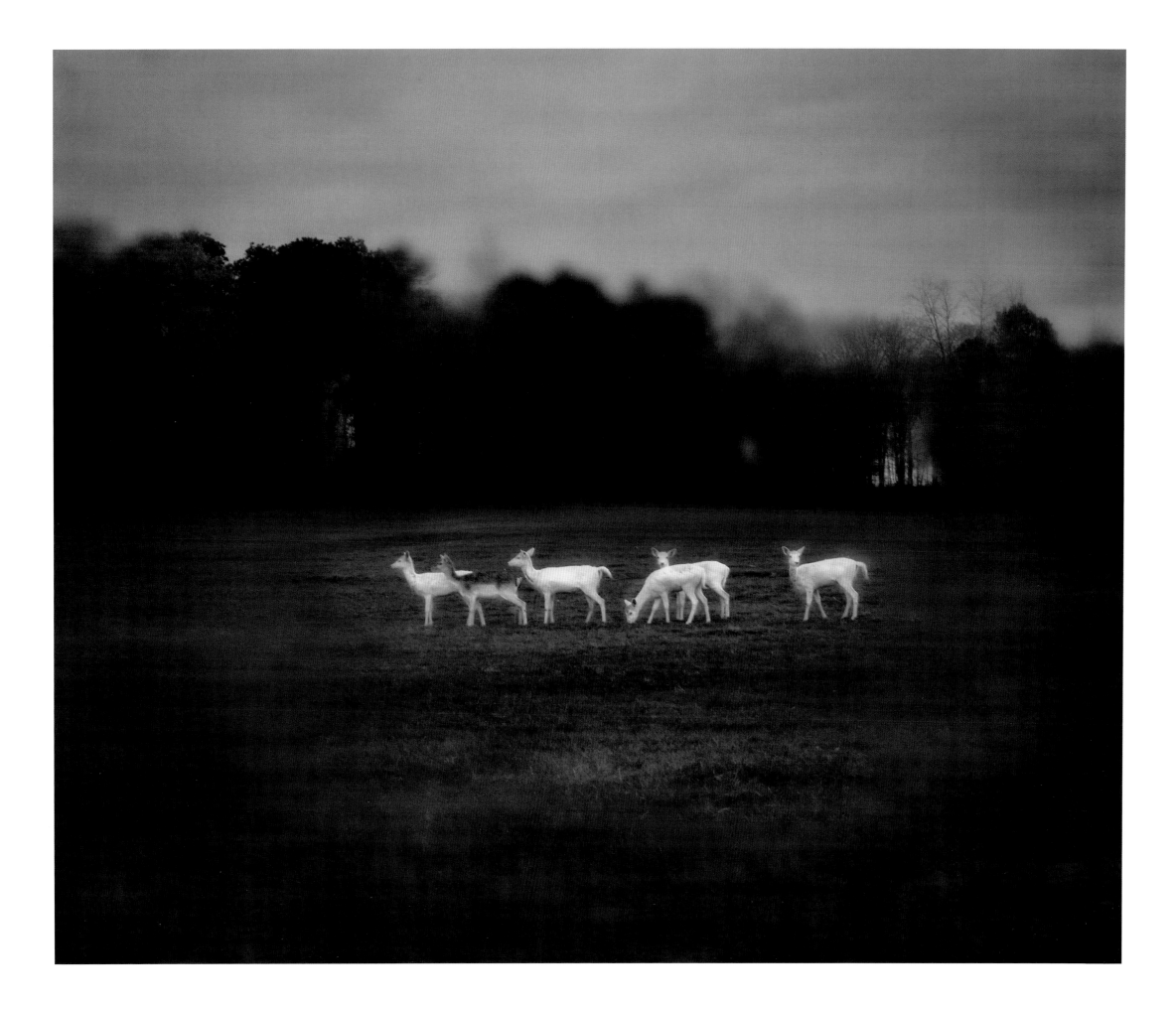

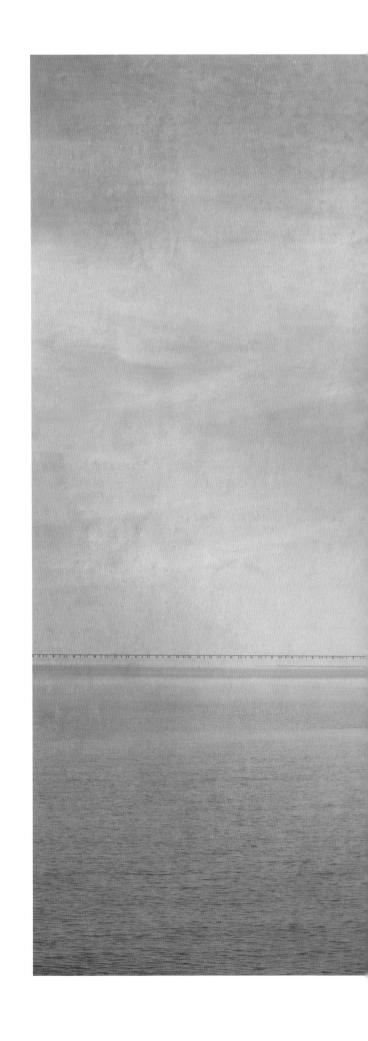

PONTCHARTRAIN

2014, Mandeville, Louisiana

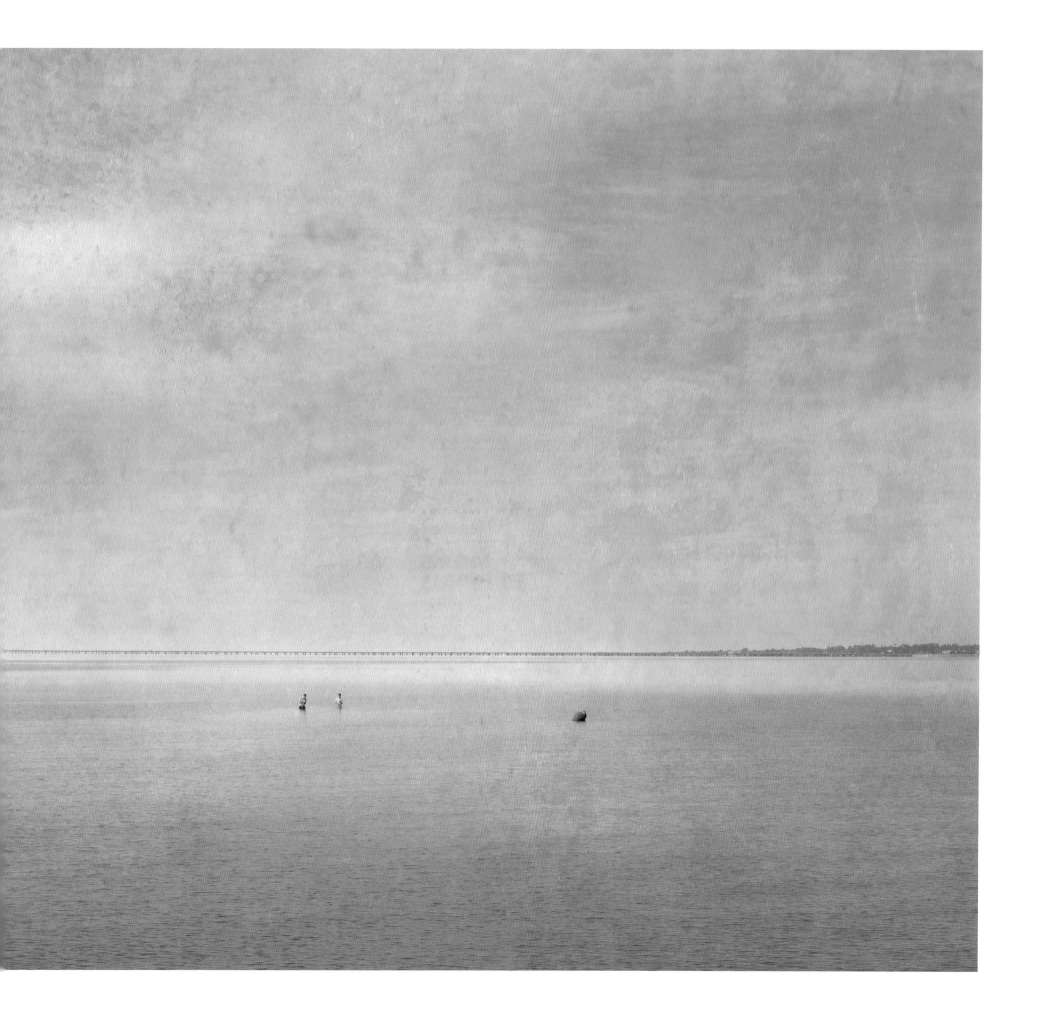

GIN HOUSE

2013, Panther Burn, Mississippi

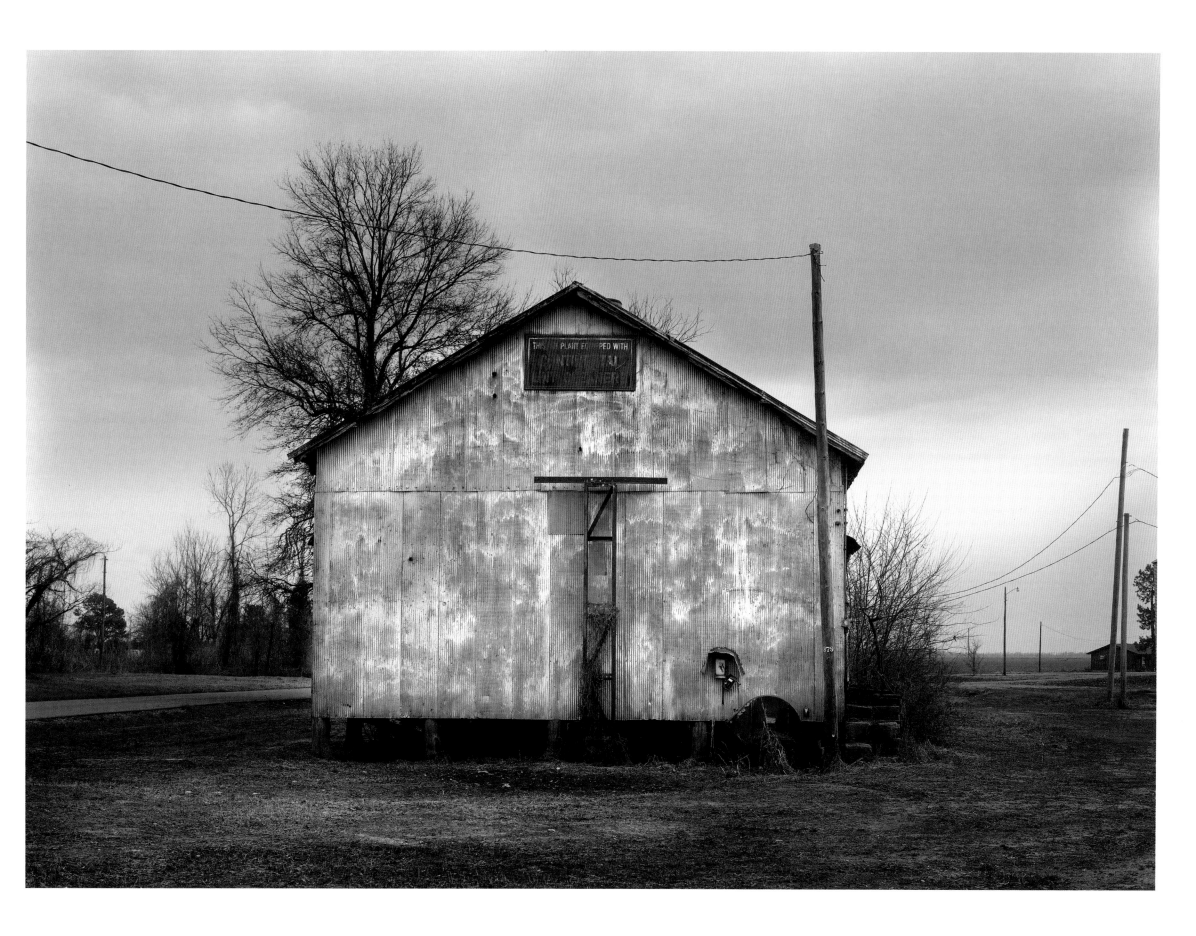

M & E SERVICE

2014, Greenville, Mississippi

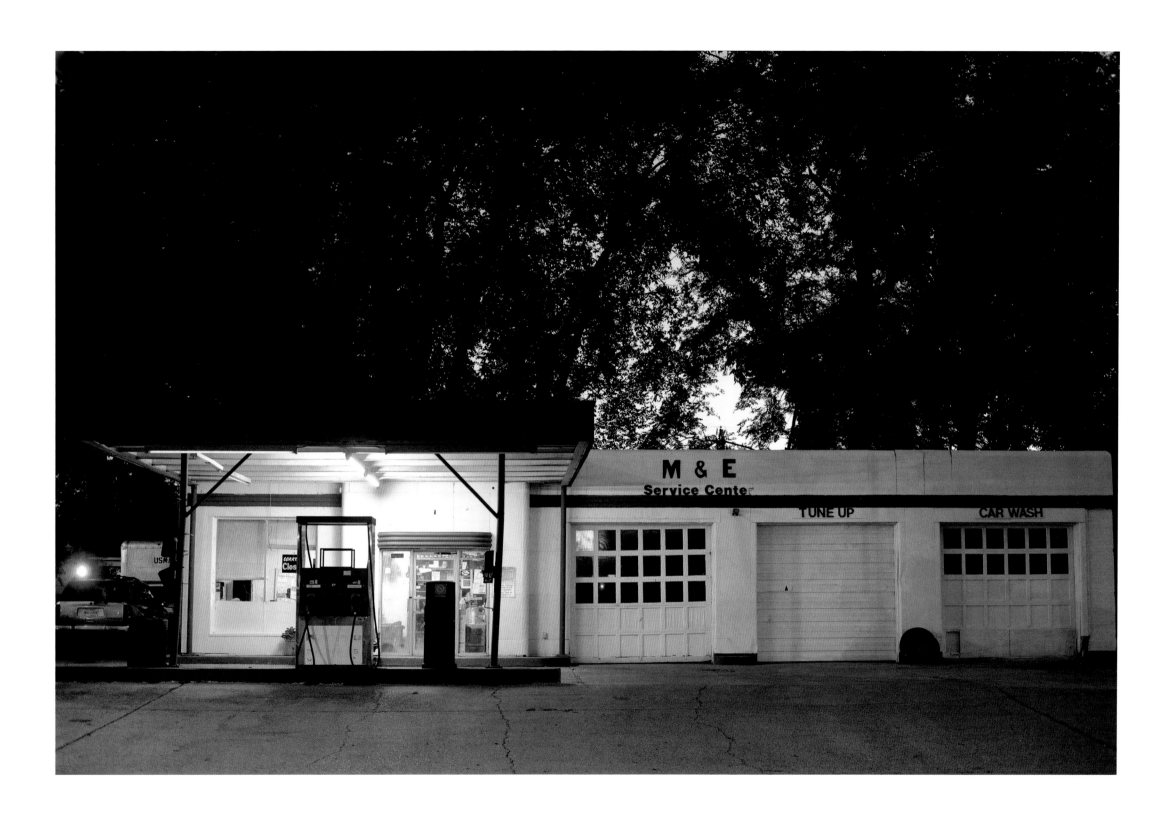

CYPRESS

2003, Coahoma County, Mississippi

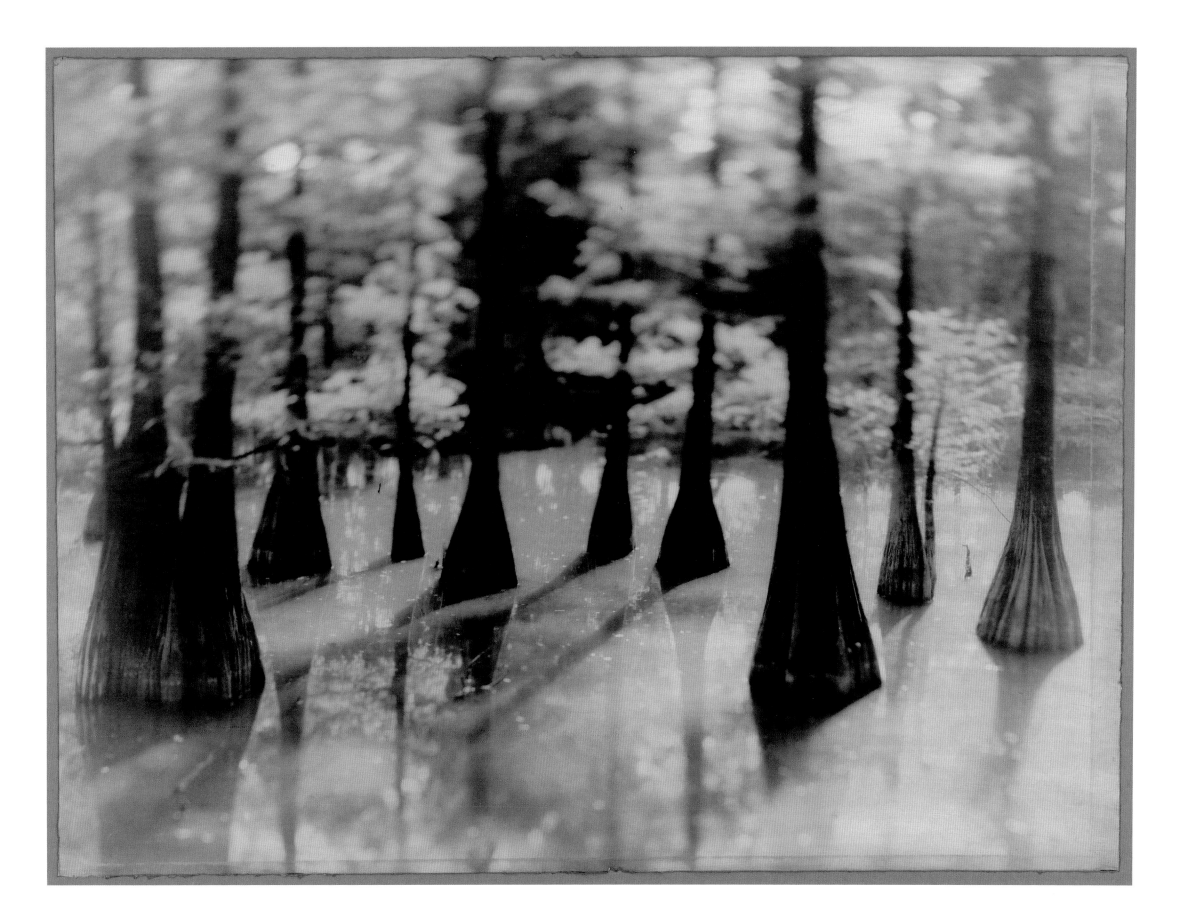

DELTA ROAD

2014, Mississippi

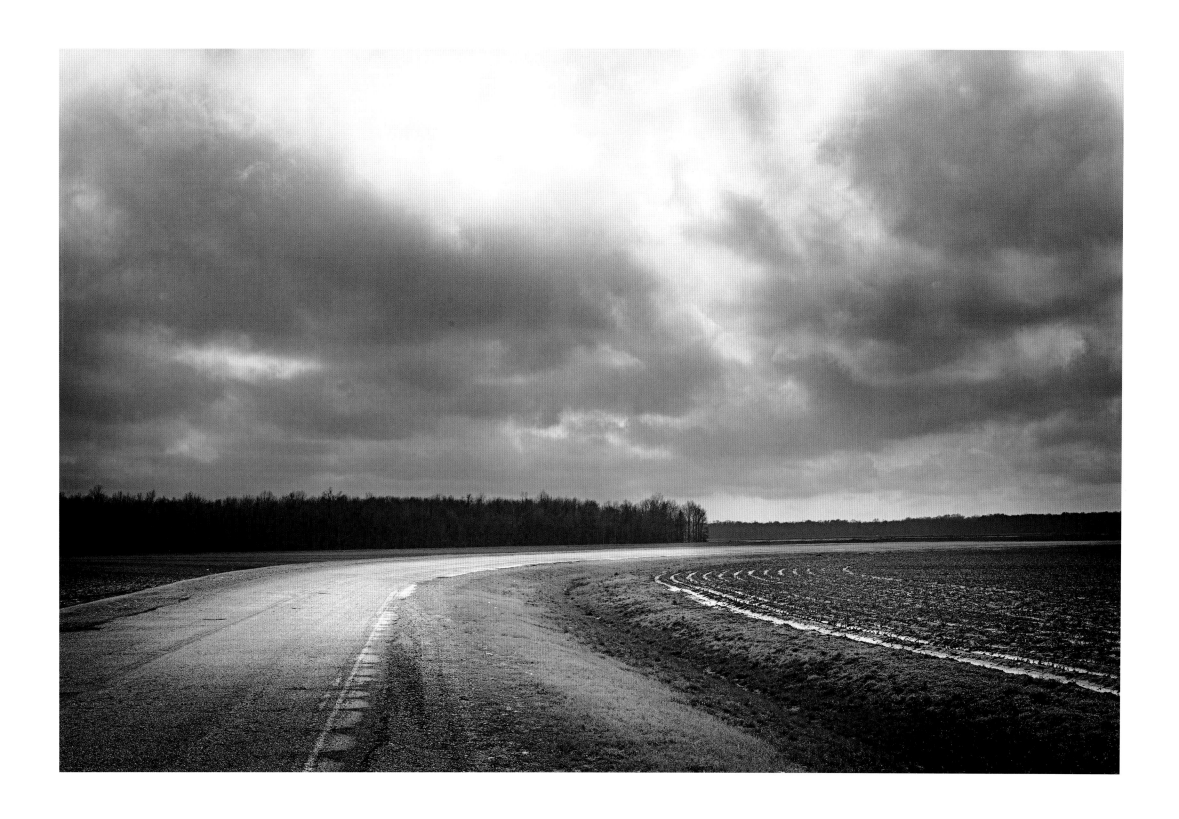

JAILHOUSE

2013, Itta Bena, Mississippi

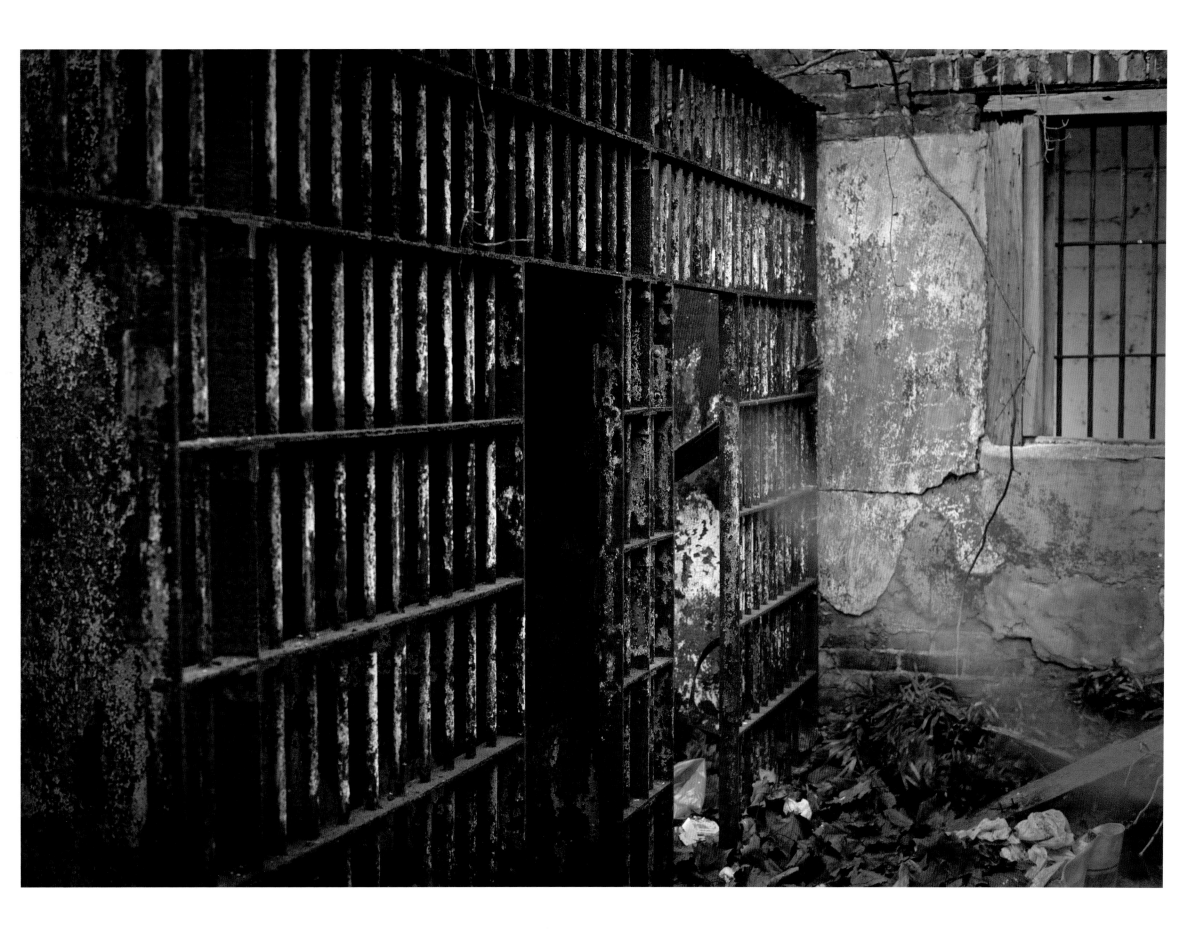

ROLLING FORK

2014, Rolling Fork, Mississippi

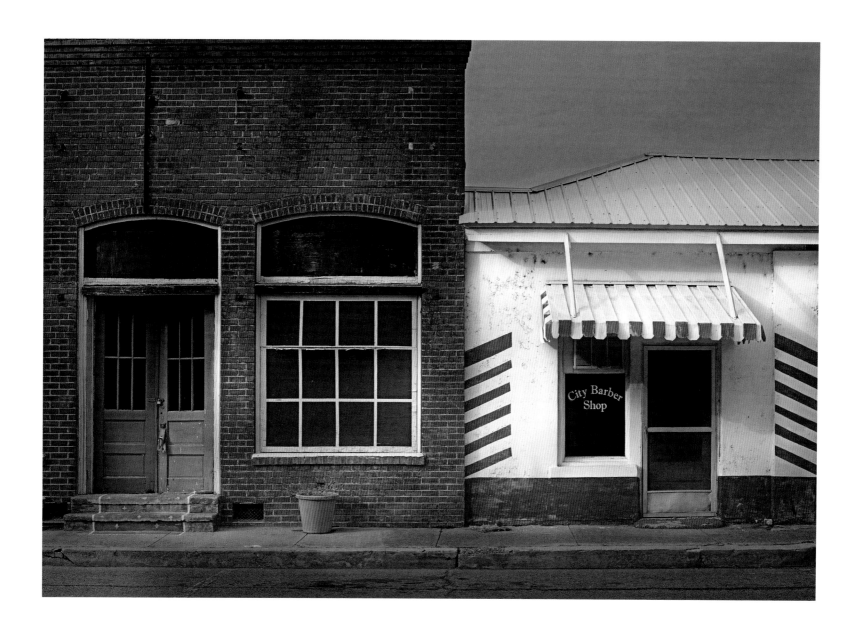

HOUSE BURNING

1998, Como, Mississippi

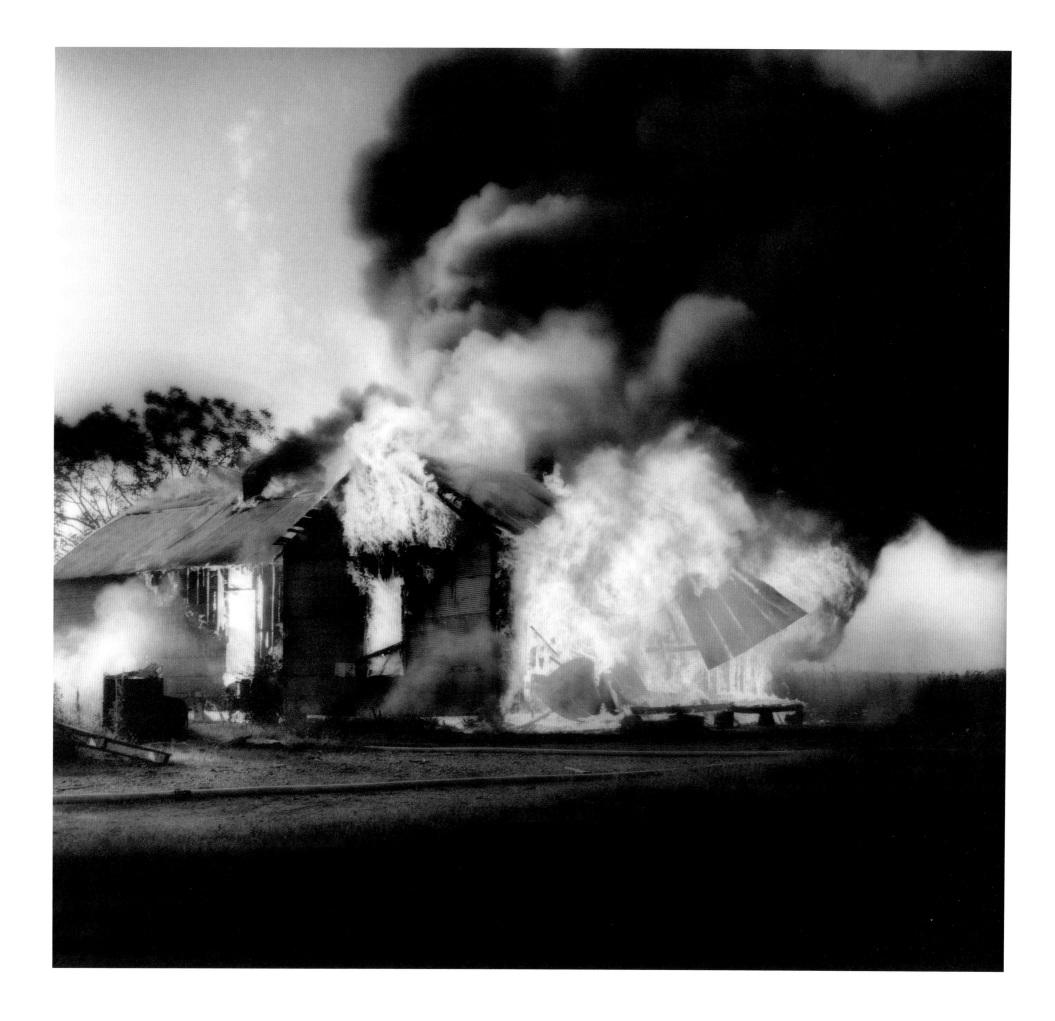

GRAND GULF NUCLEAR PLANT

2014, Port Gibson, Mississippi

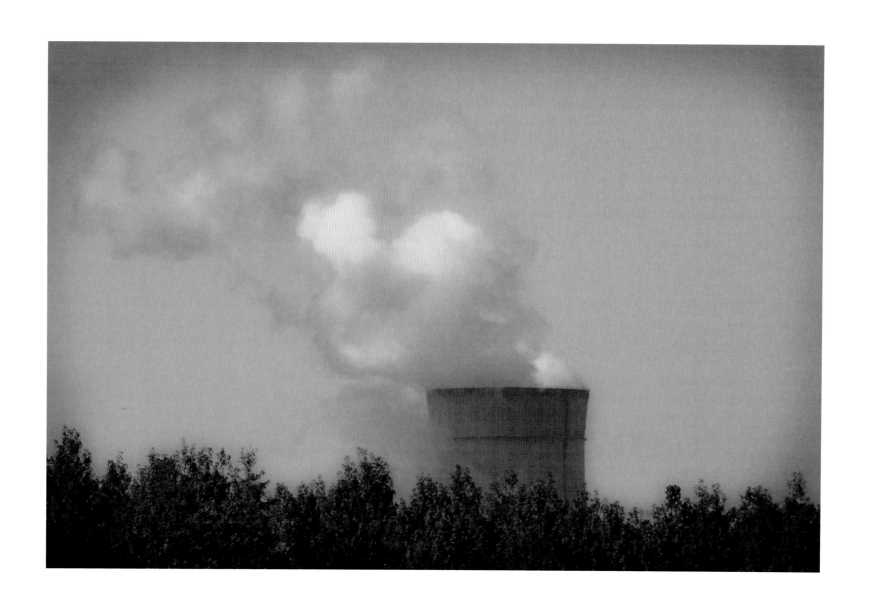

ONE TREE

2014, Itta Bena, Mississippi

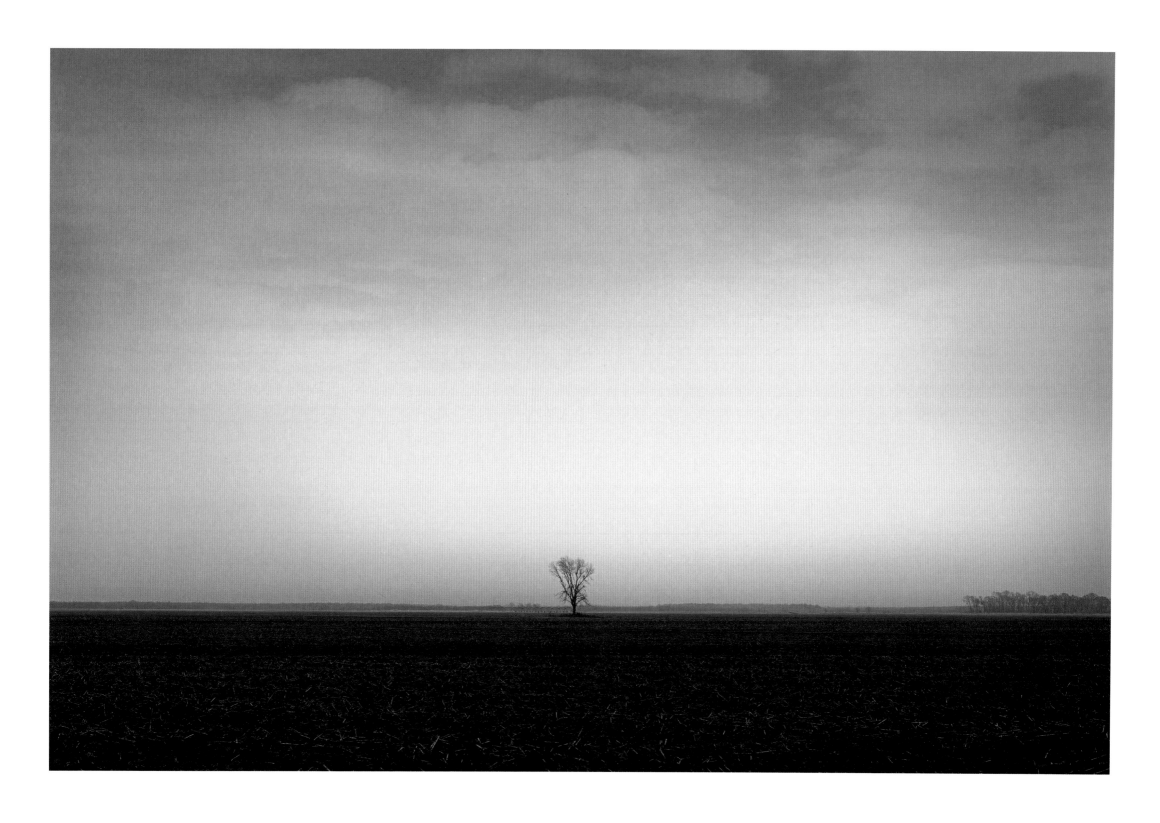

ALABAMA TOWN FRONT

2006, Alabama

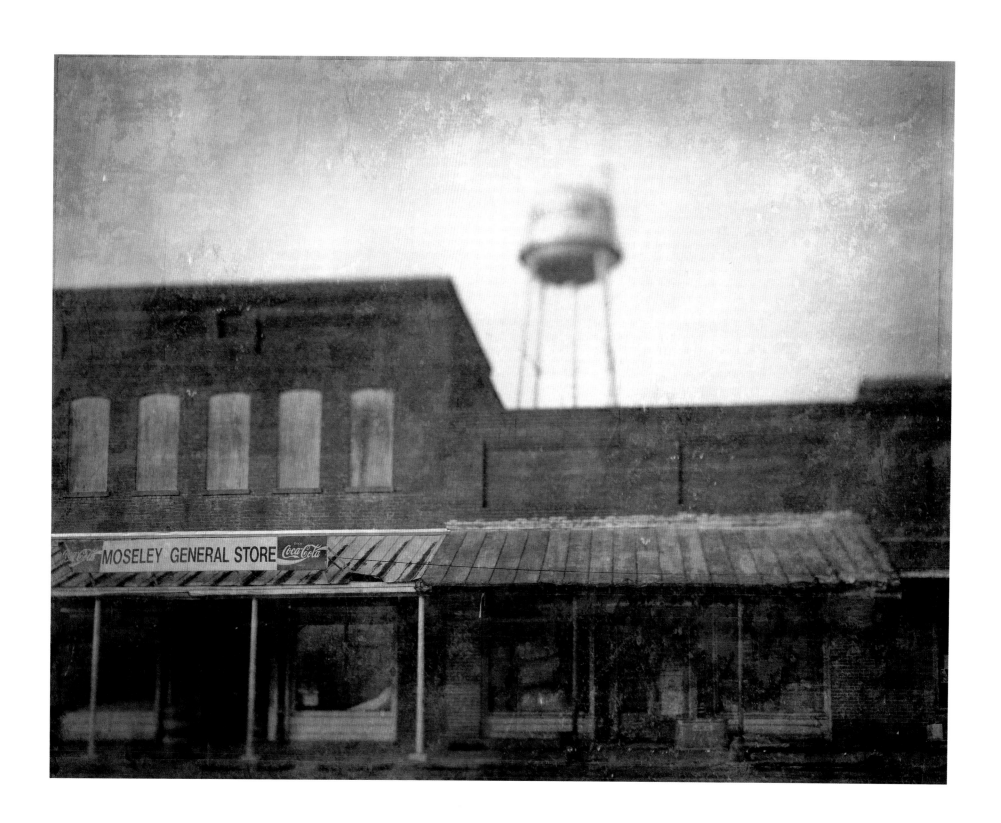

BEACH WALKER

2010, Crescent Beach, Florida

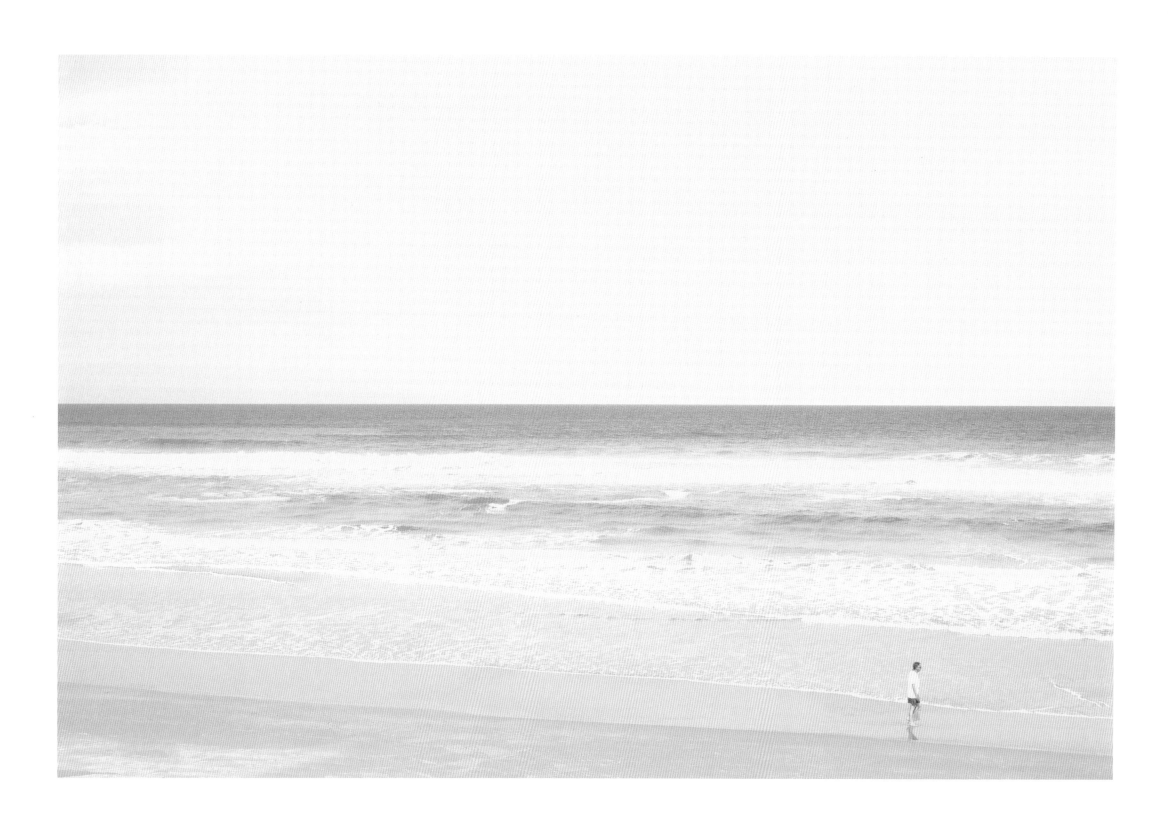

STARFALL

2008, St. Augustine, Florida

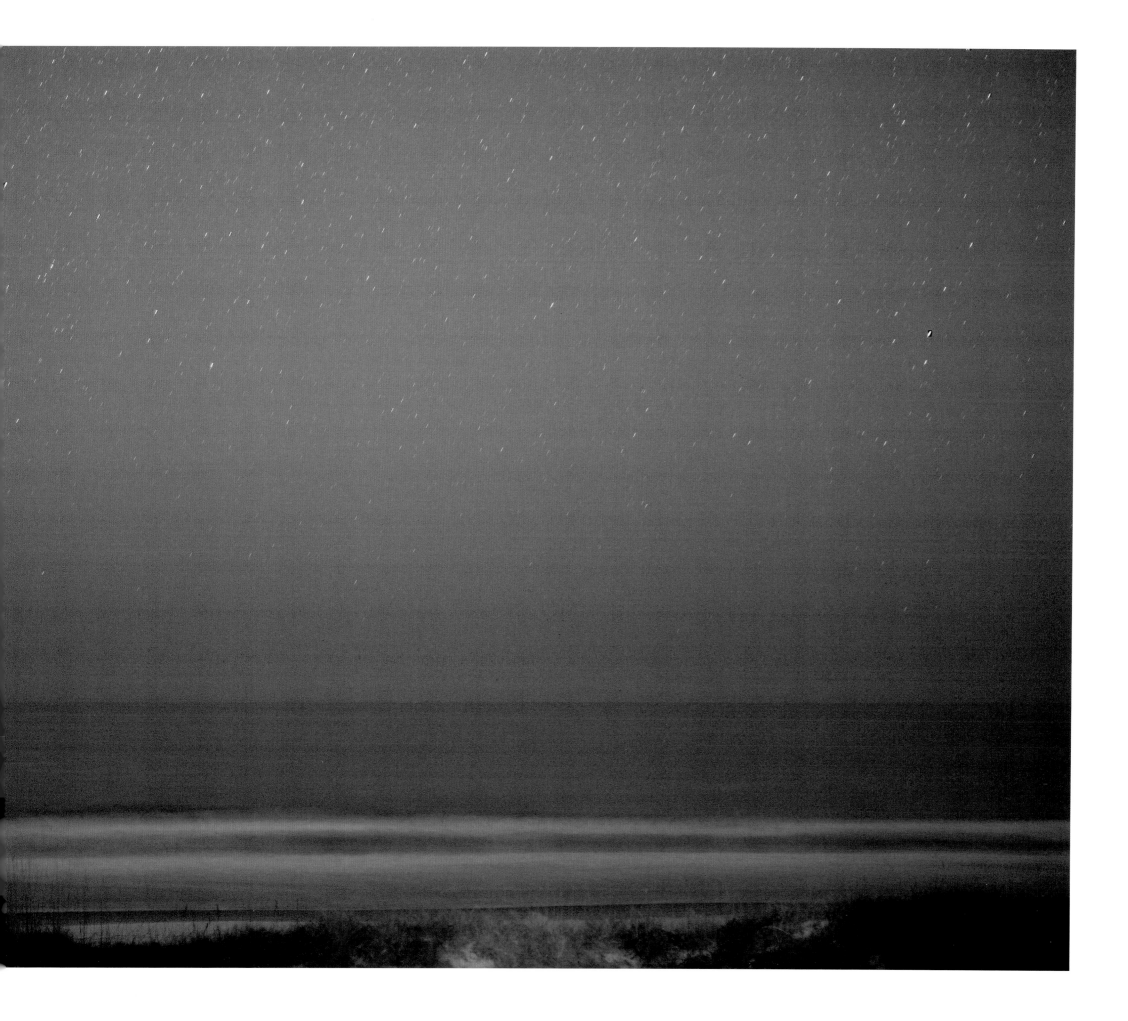

GIRL ON A BEACH

2010, St. Augustine, Florida

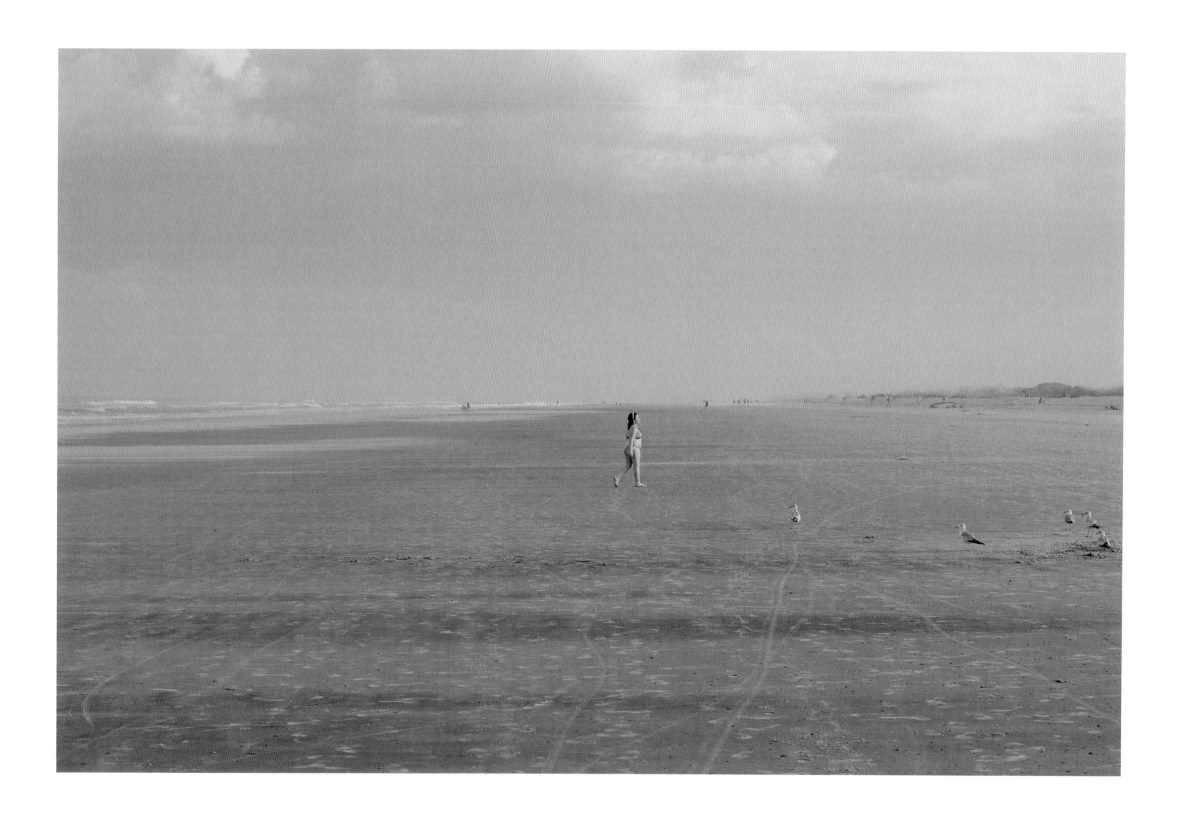

KEY WEST

2008, Key West, Florida

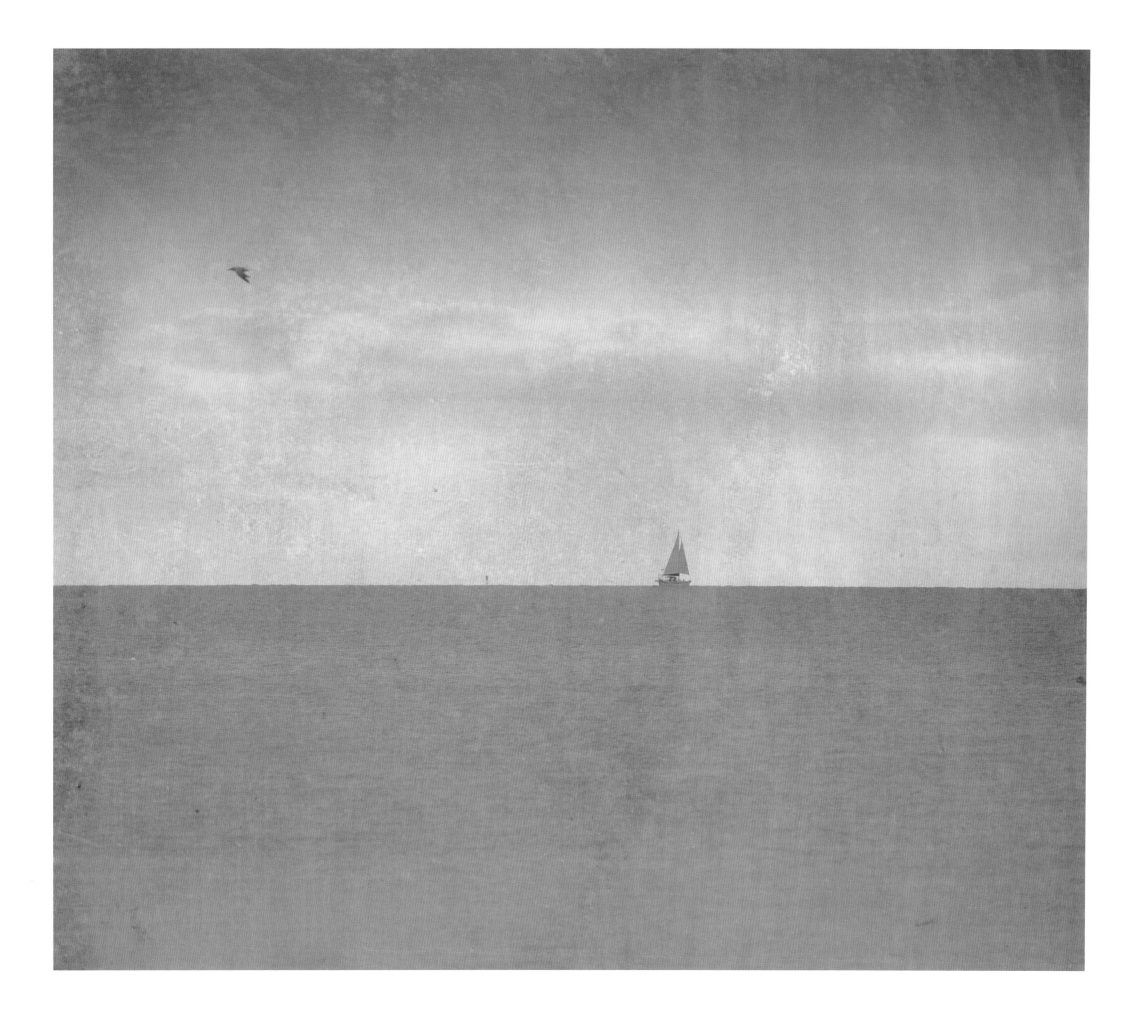

SUNDAY AFTERNOON

2010, St. Augustine, Florida

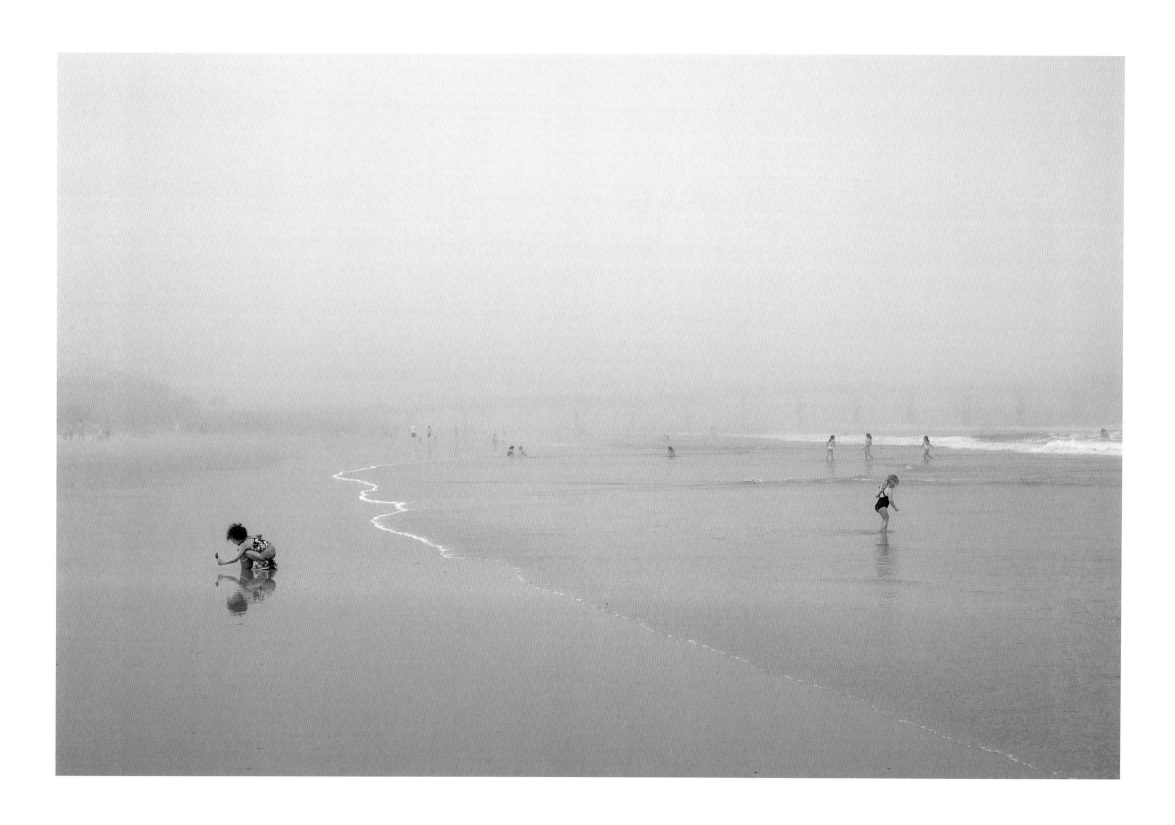

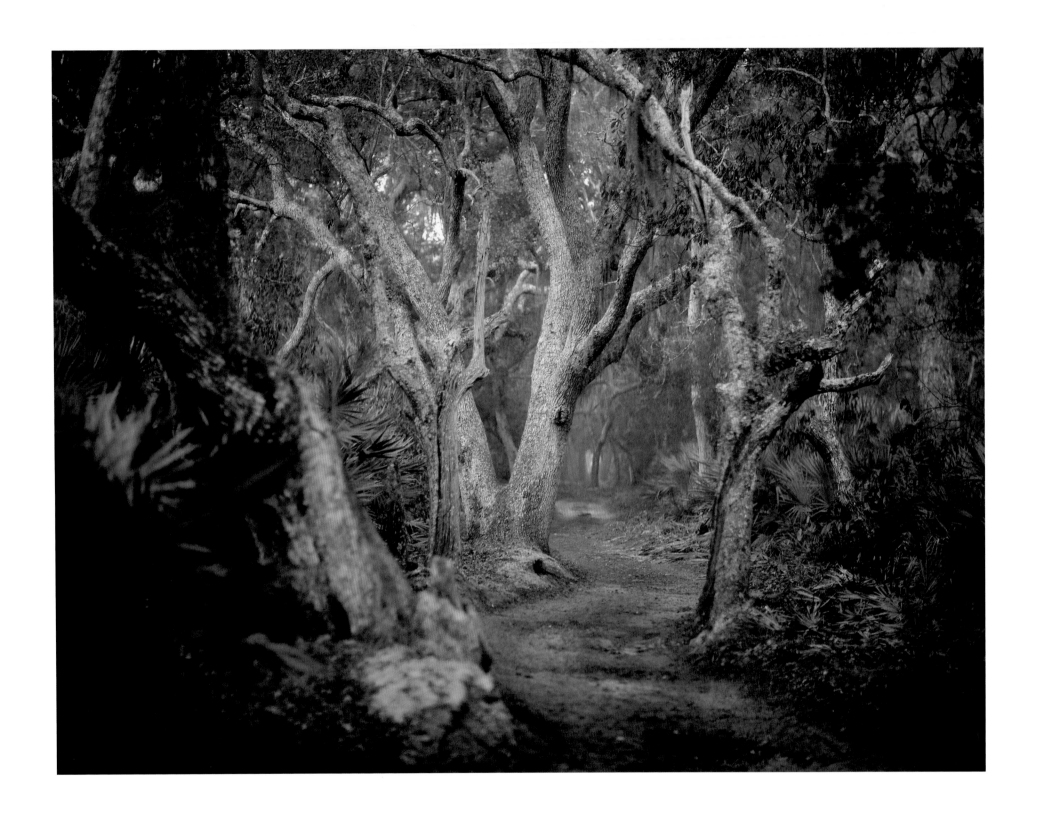

CUMBERLAND II

2008, Cumberland Island, Georgia

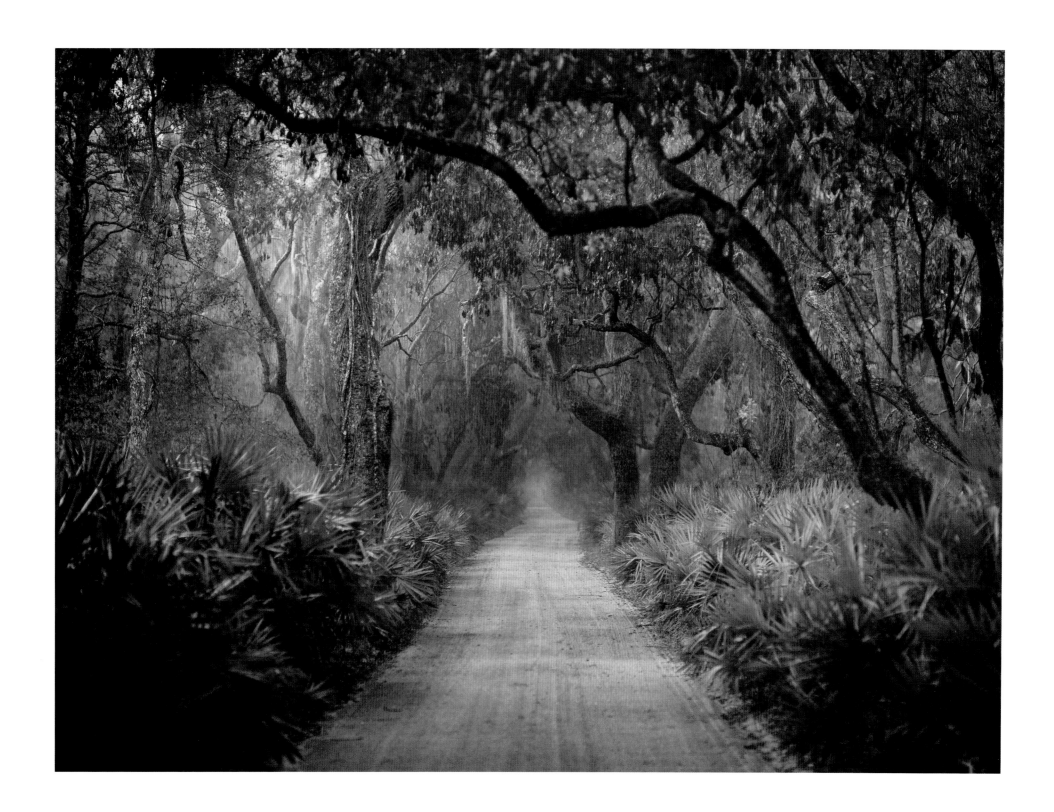

CUMBERLAND 22

2008, Cumberland Island, Georgia

2 WILD HORSES

2008, Cumberland Island, Georgia

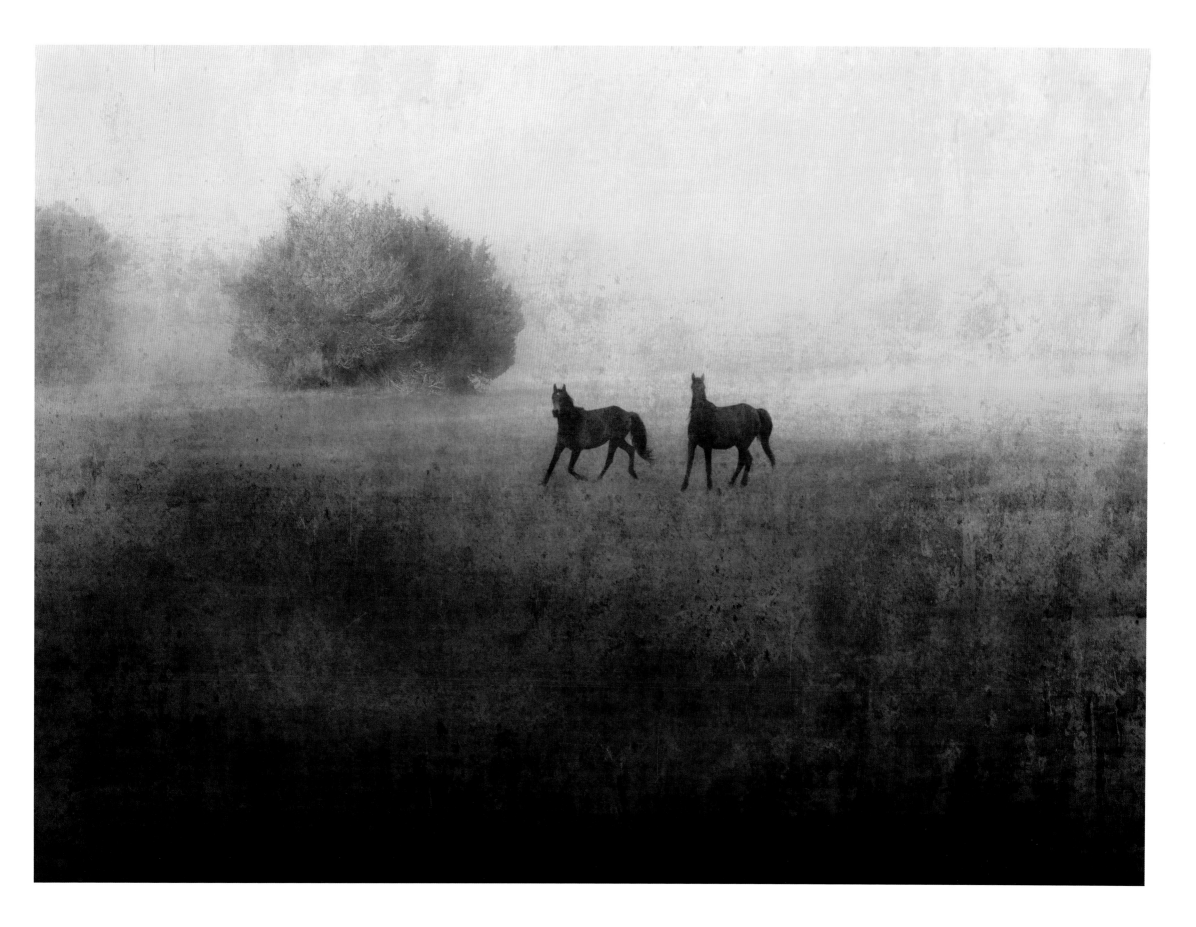

MOONFALL

2007, Valdosta, Georgia

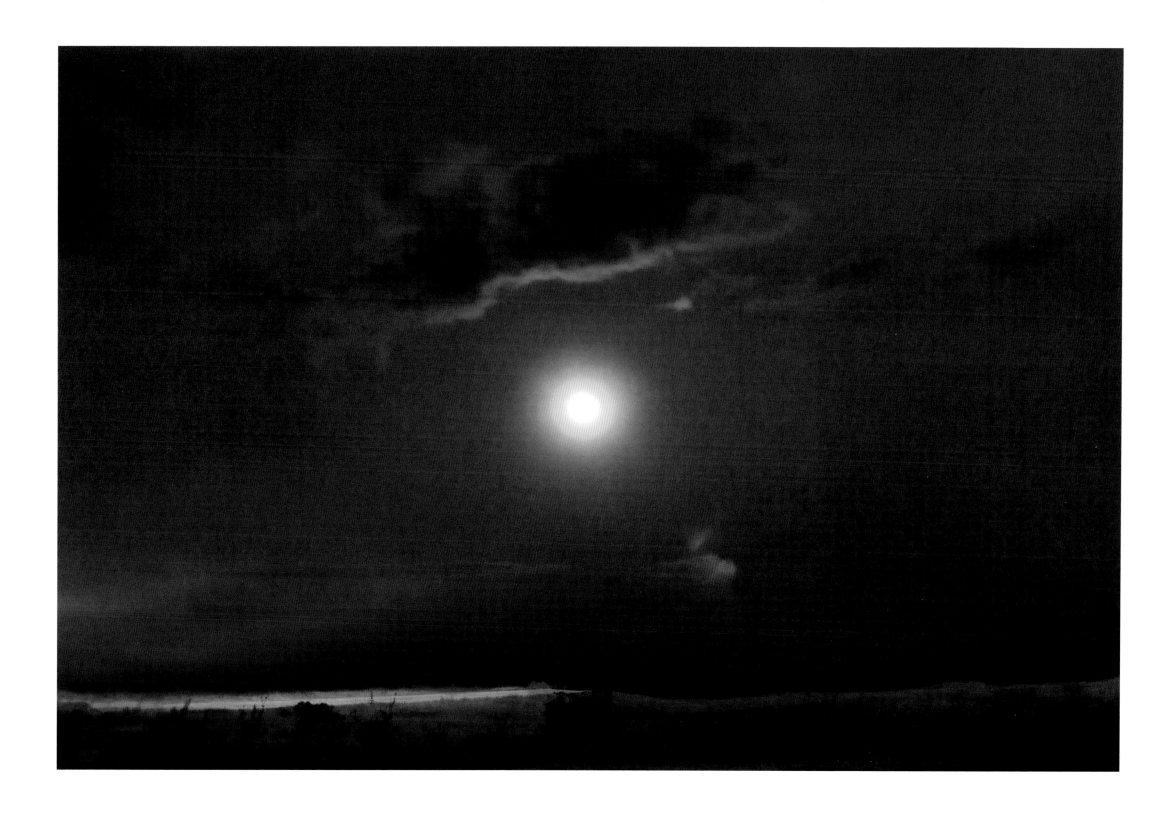

AUDITORIUM

2012, Zebulon, Georgia

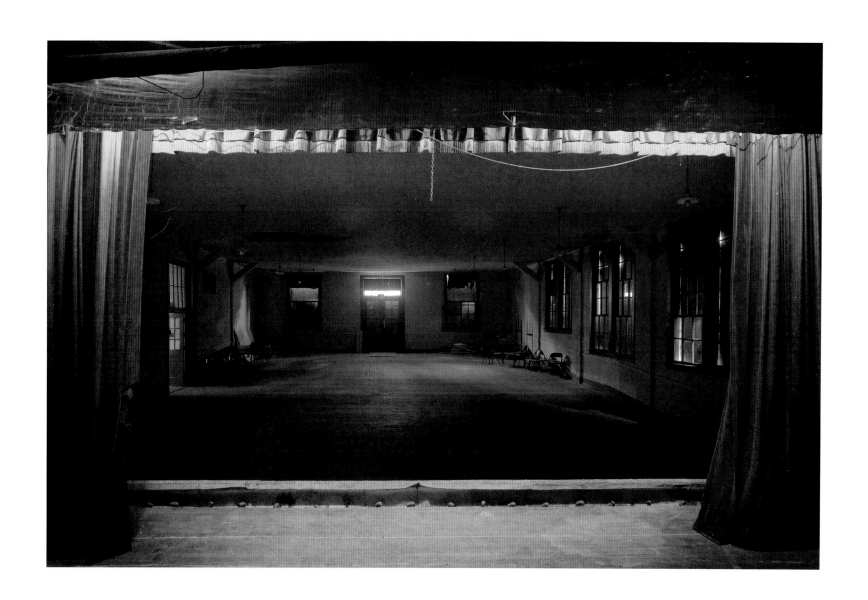

LOW TIDE

2008, Cumberland Island, Georgia

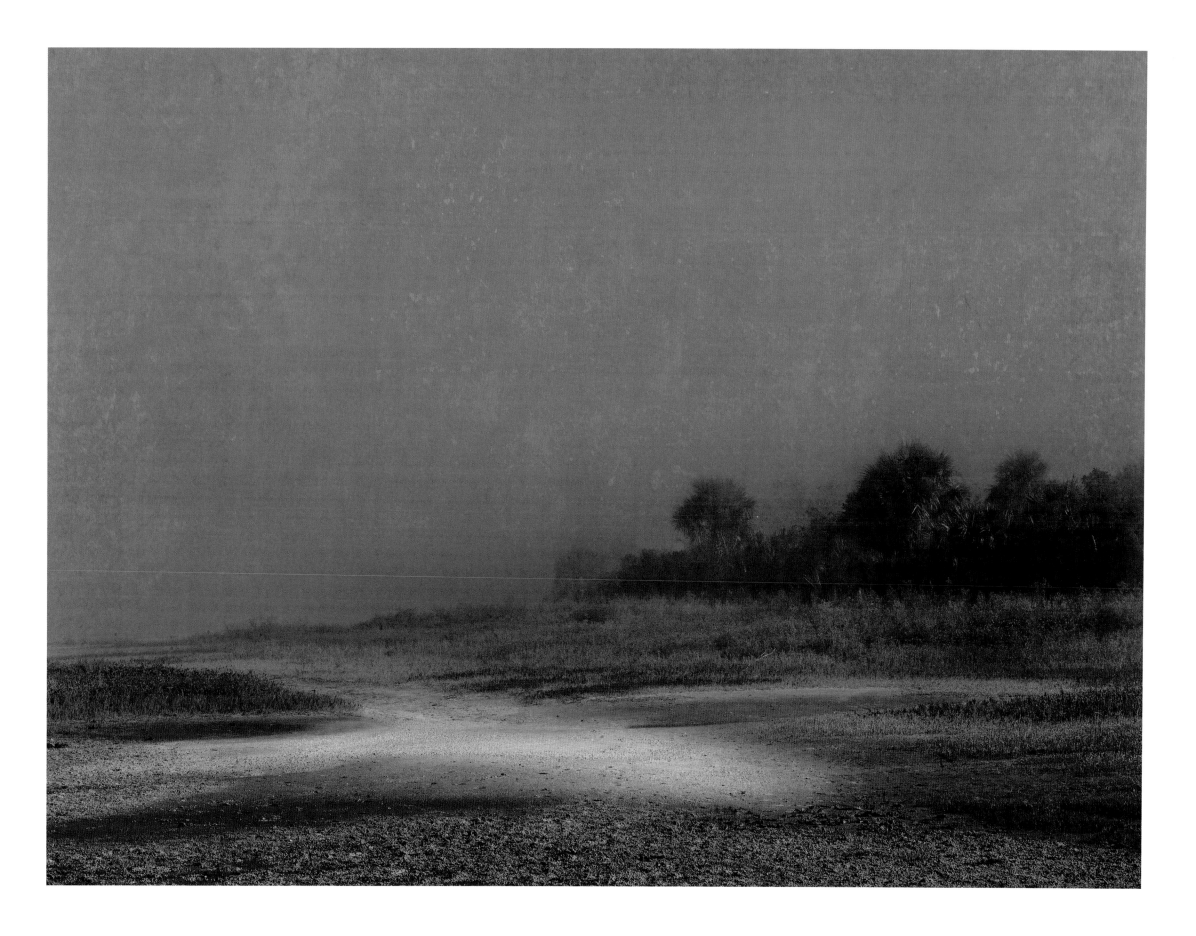

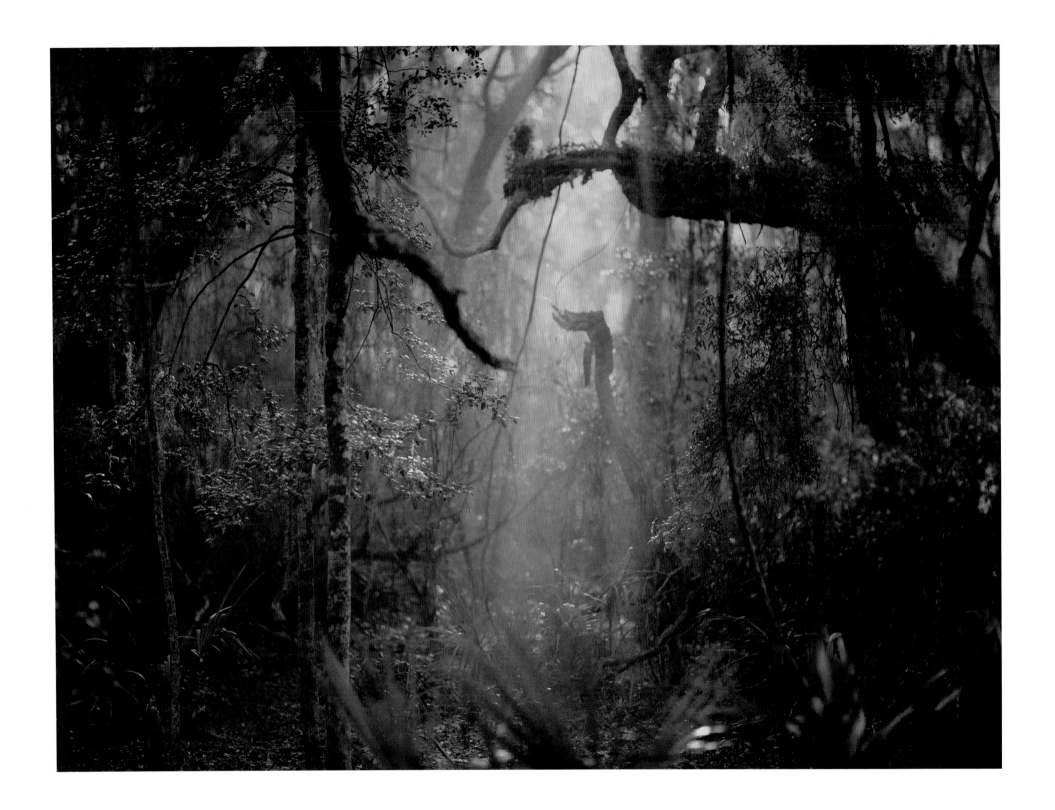

LIANAS

2008, Cumberland Island, Georgia

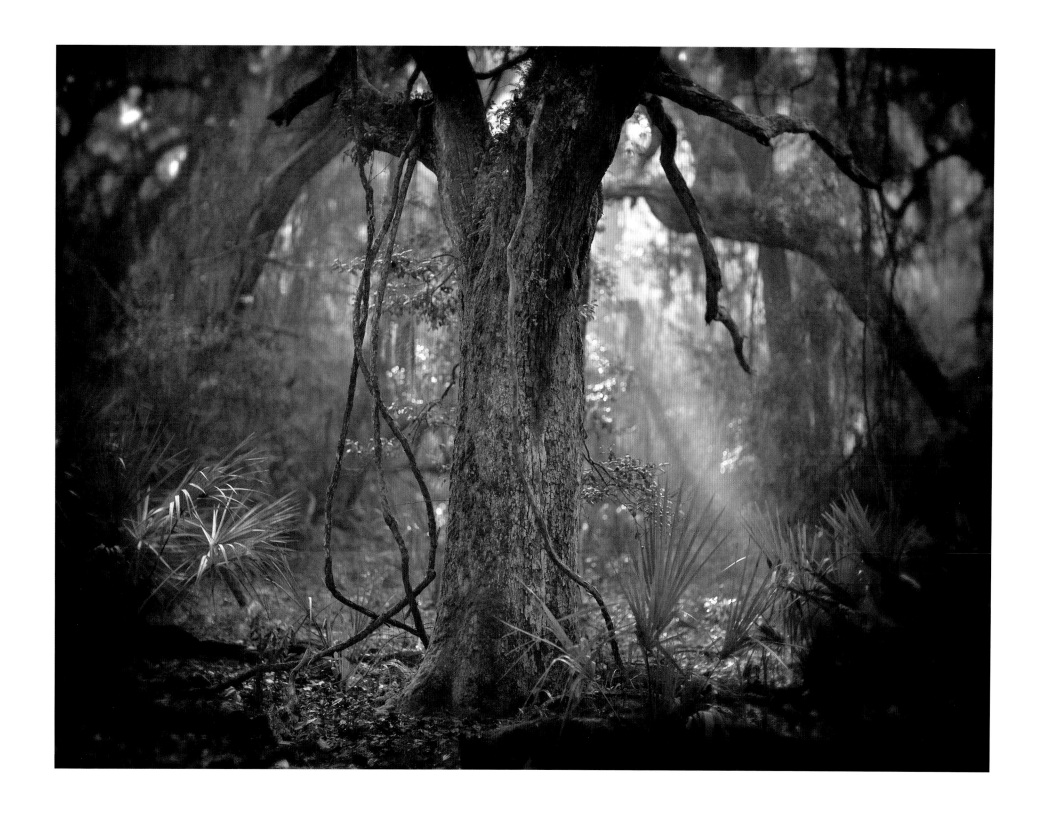

TREE

2008, Cumberland Island, Georgia

GREEN ROOM

2012, Zebulon, Georgia

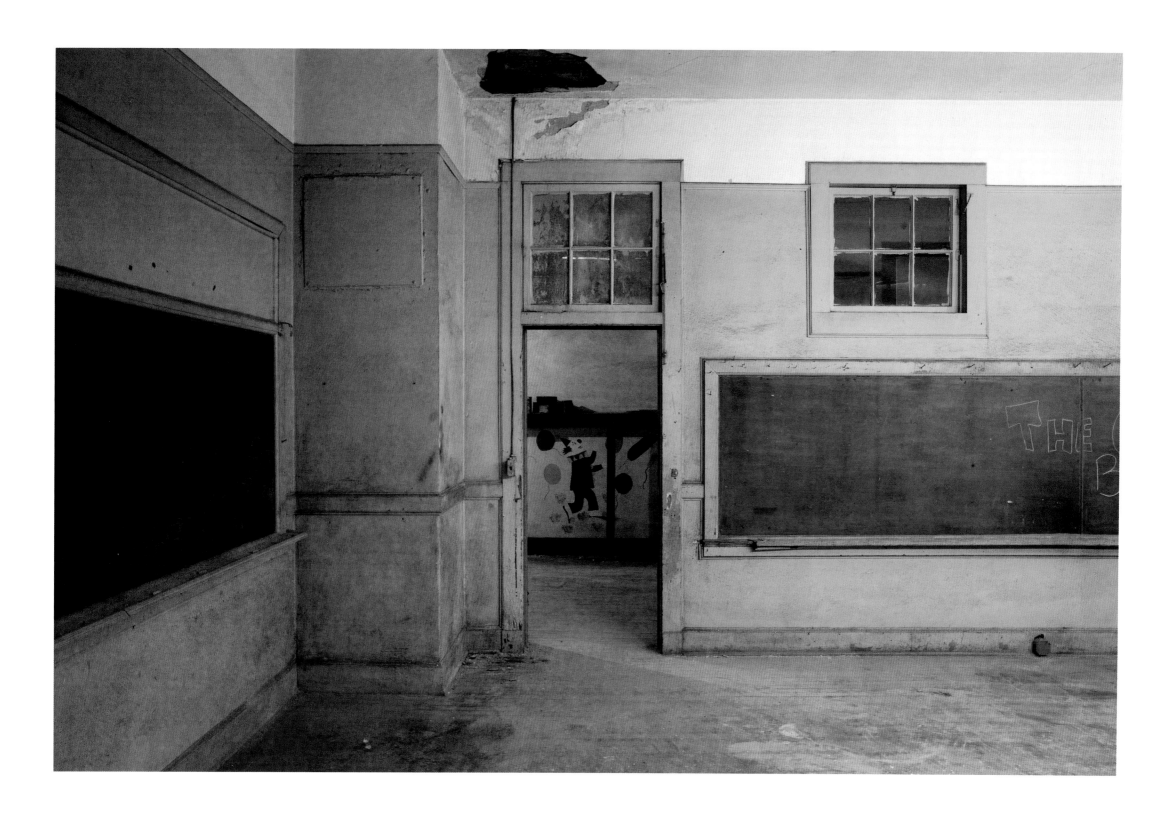

WILD HORSES IN FOG

2008, Cumberland Island, Georgia

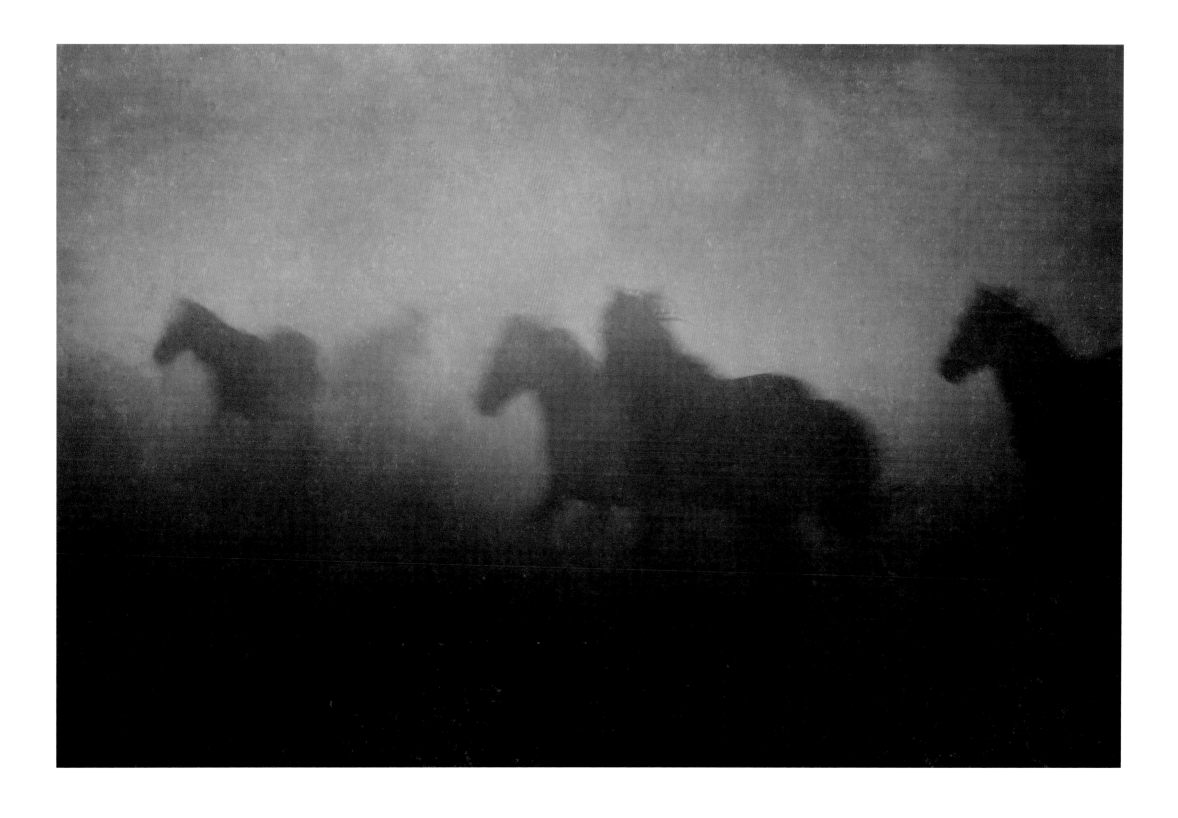

MARSH 55

2007, Tybee Island, Georgia

218

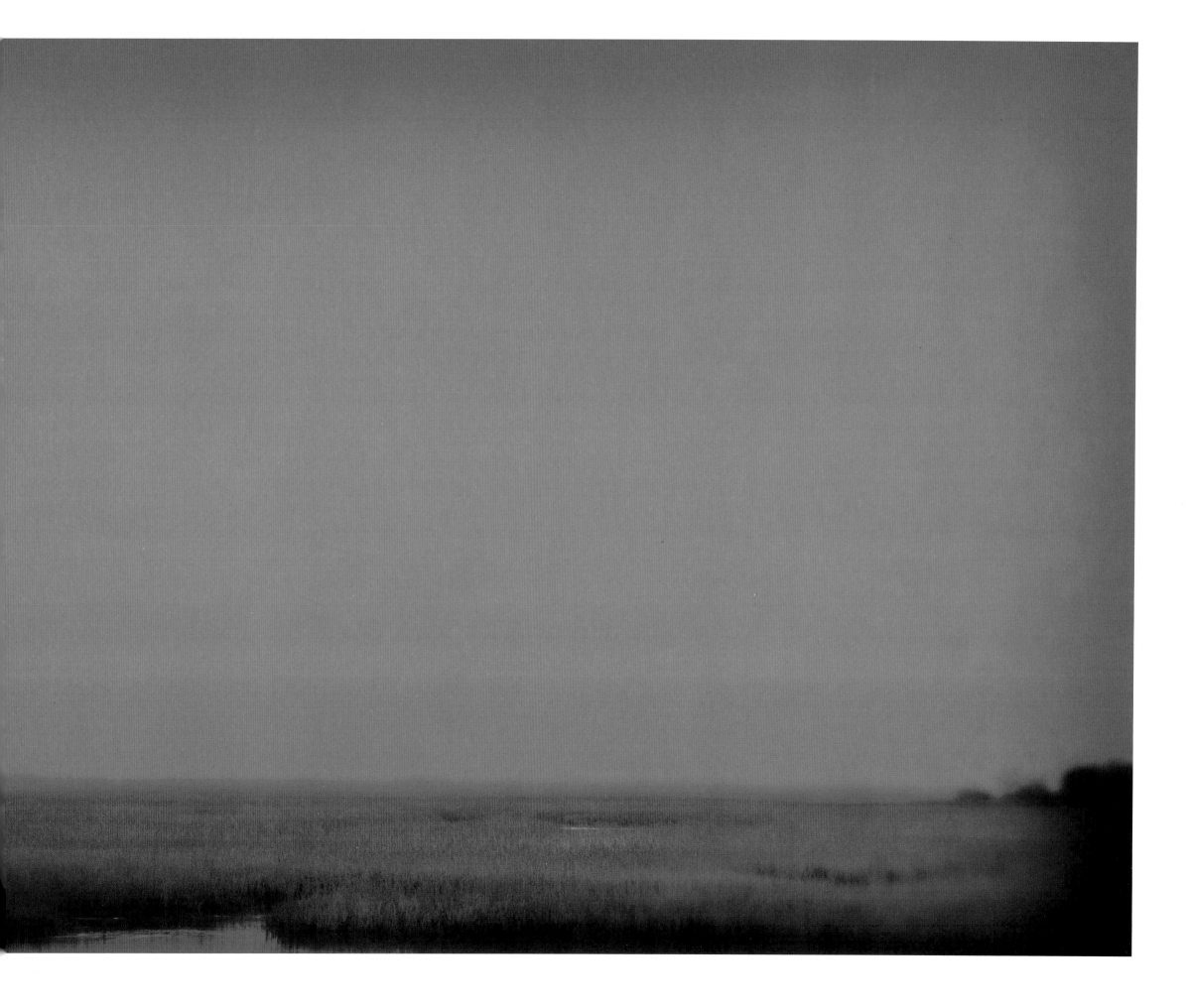

TO GOAT'S WAY

2008, Cumberland Island, Georgia

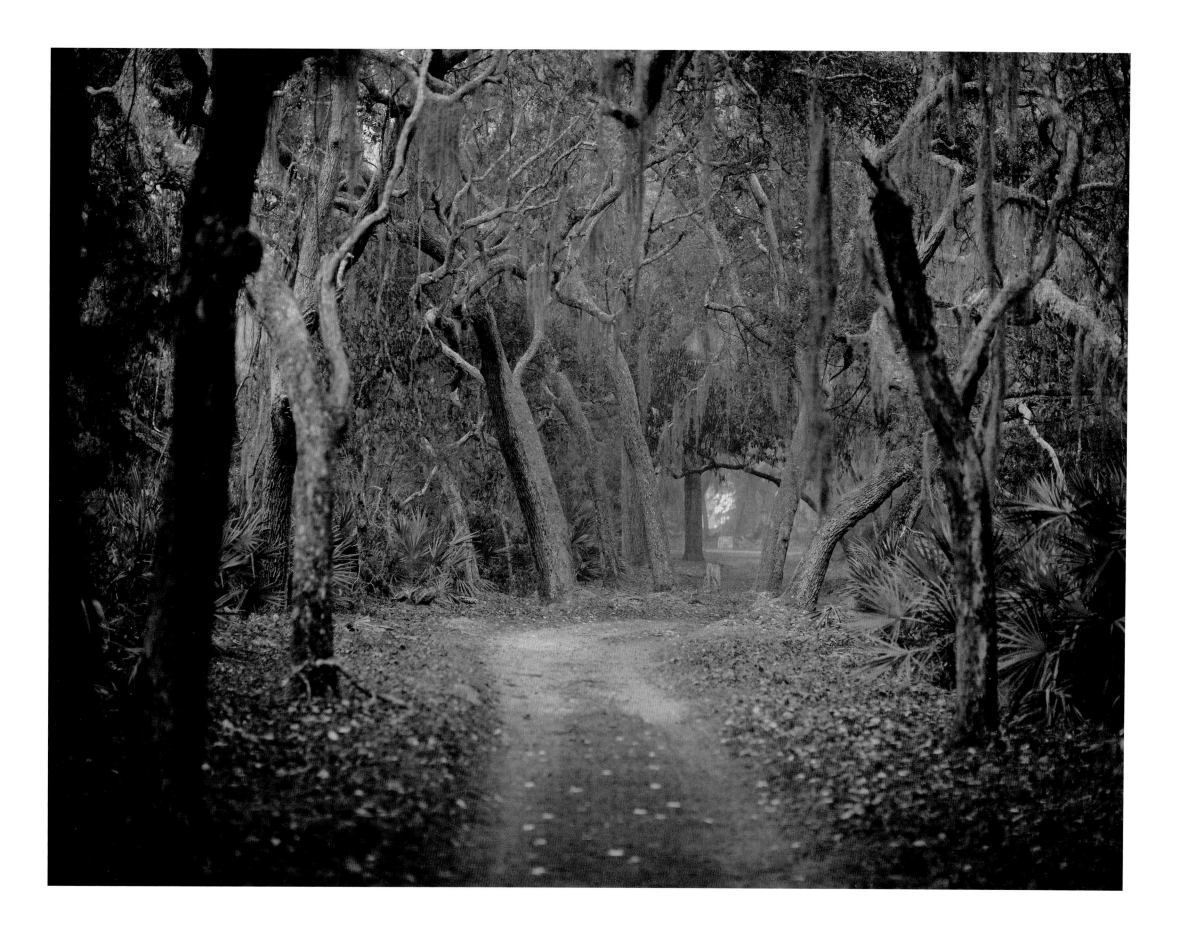

SHILOH

2003, Shiloh, Tennessee

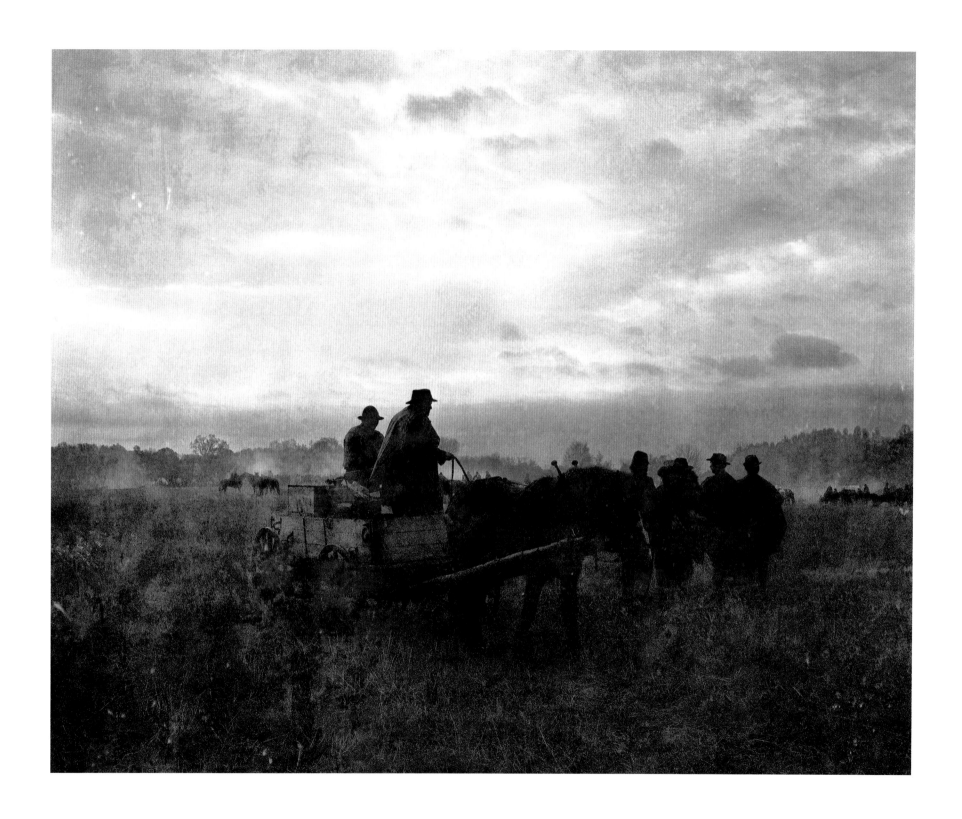

CLEARING

2008, Nashville, Tennessee

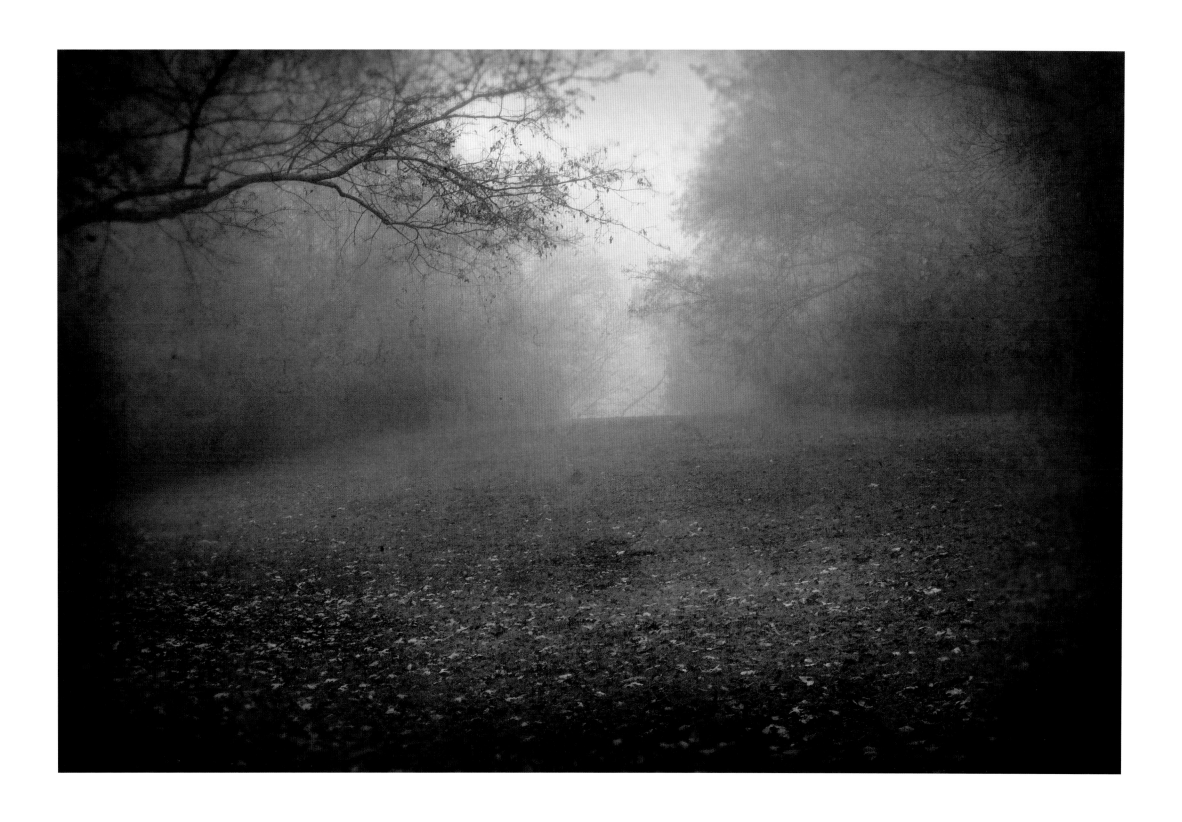

HARPETH RIVER

2007, Tennessee

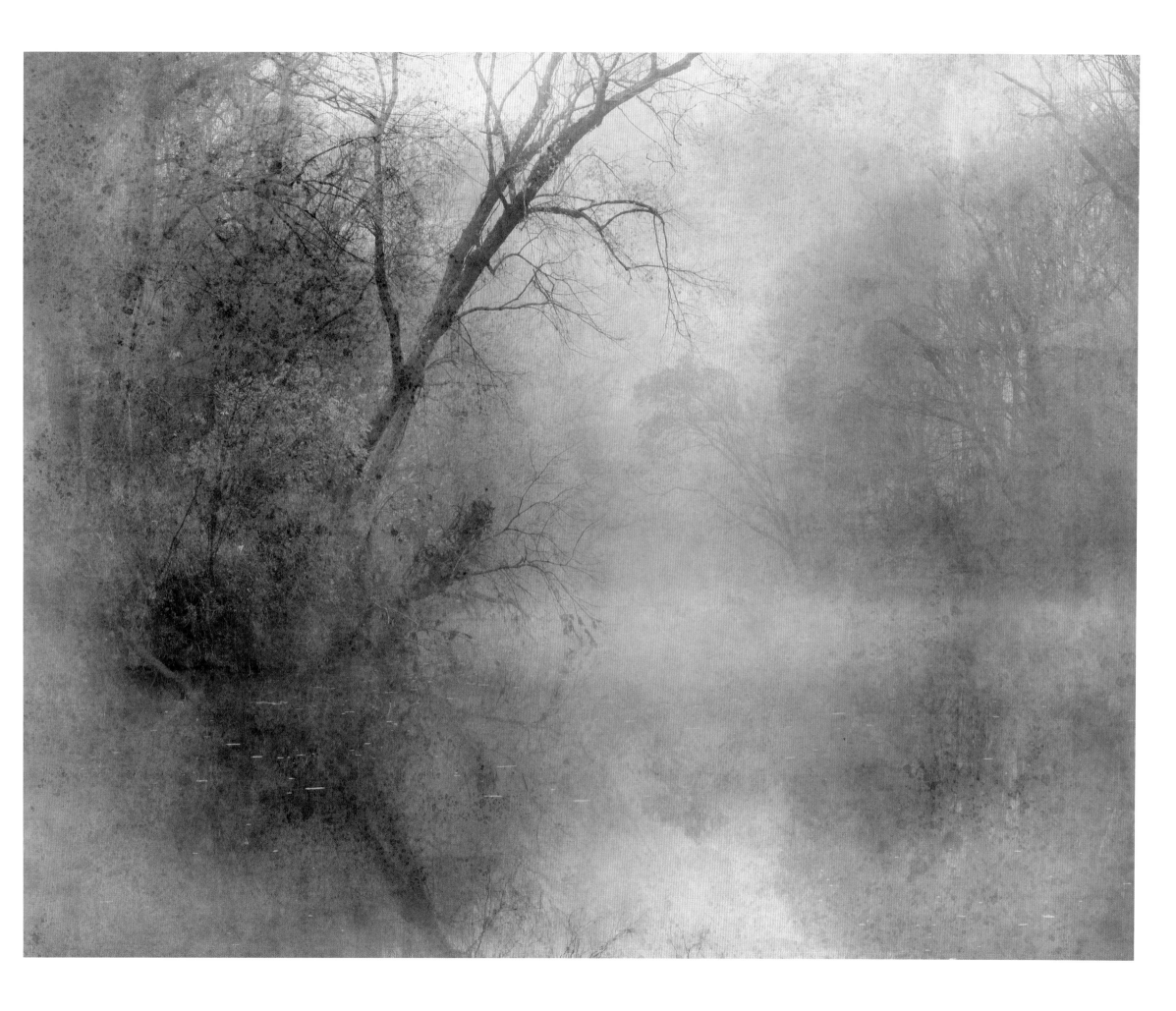

SOYBEANS

2011, Tennessee

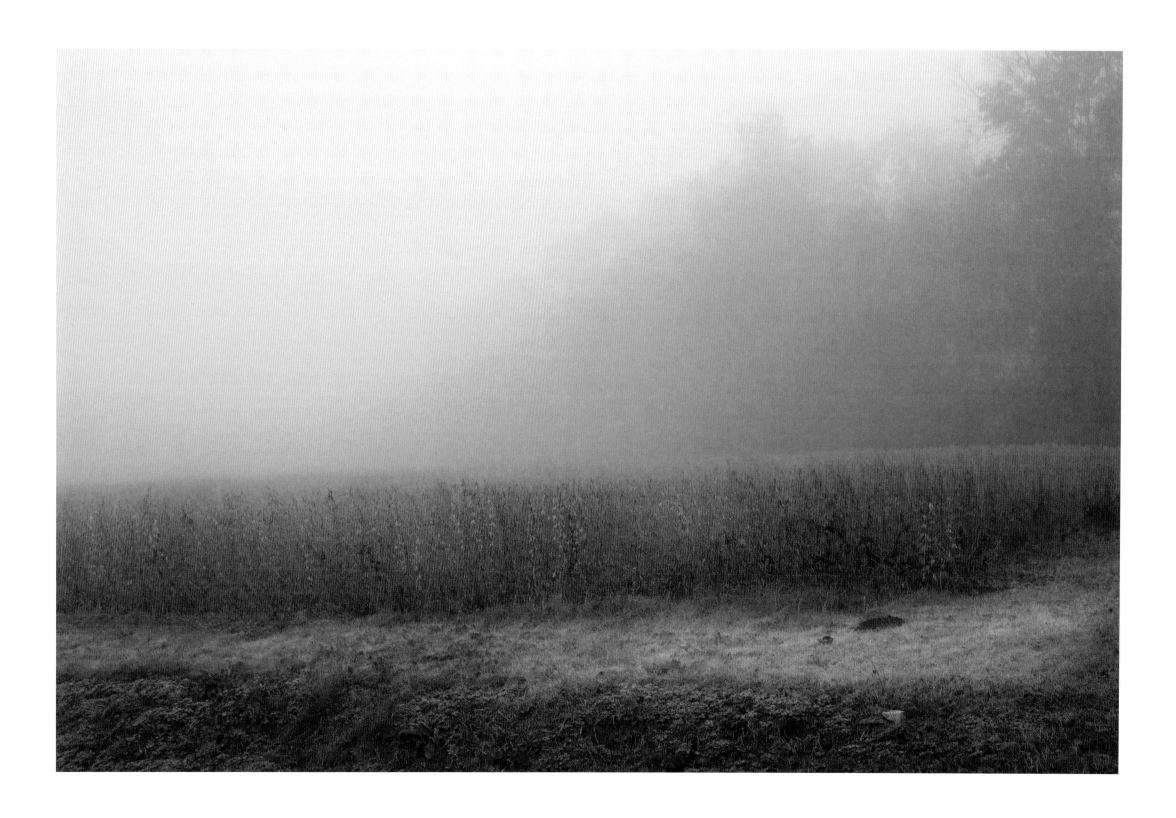

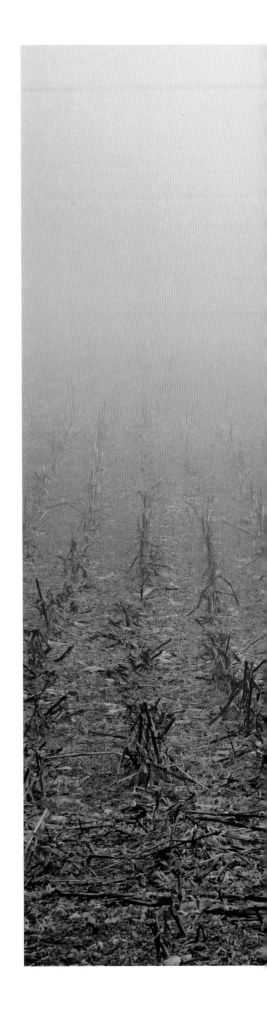

BURNT CORNFIELD

2013, Williamson County, Tennessee

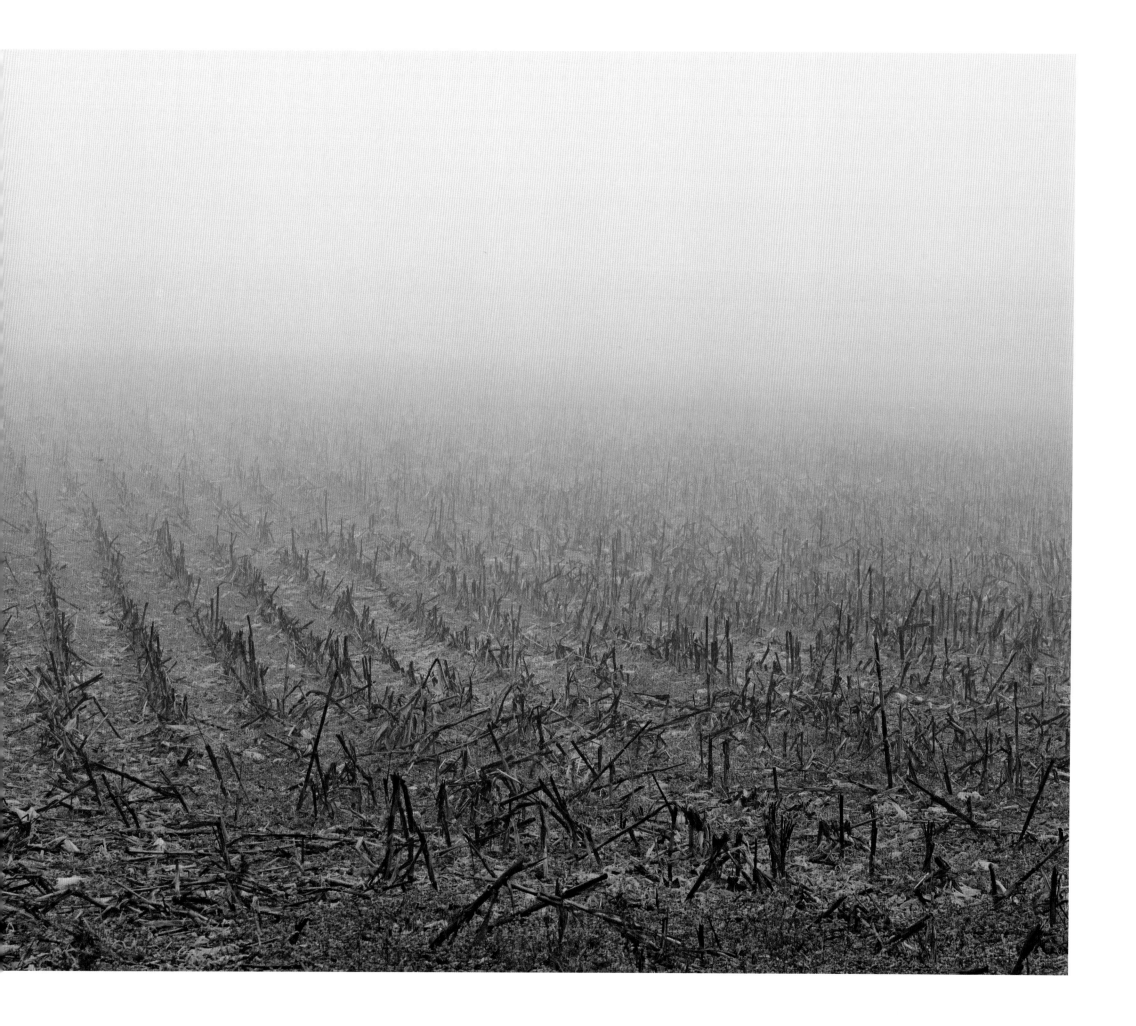

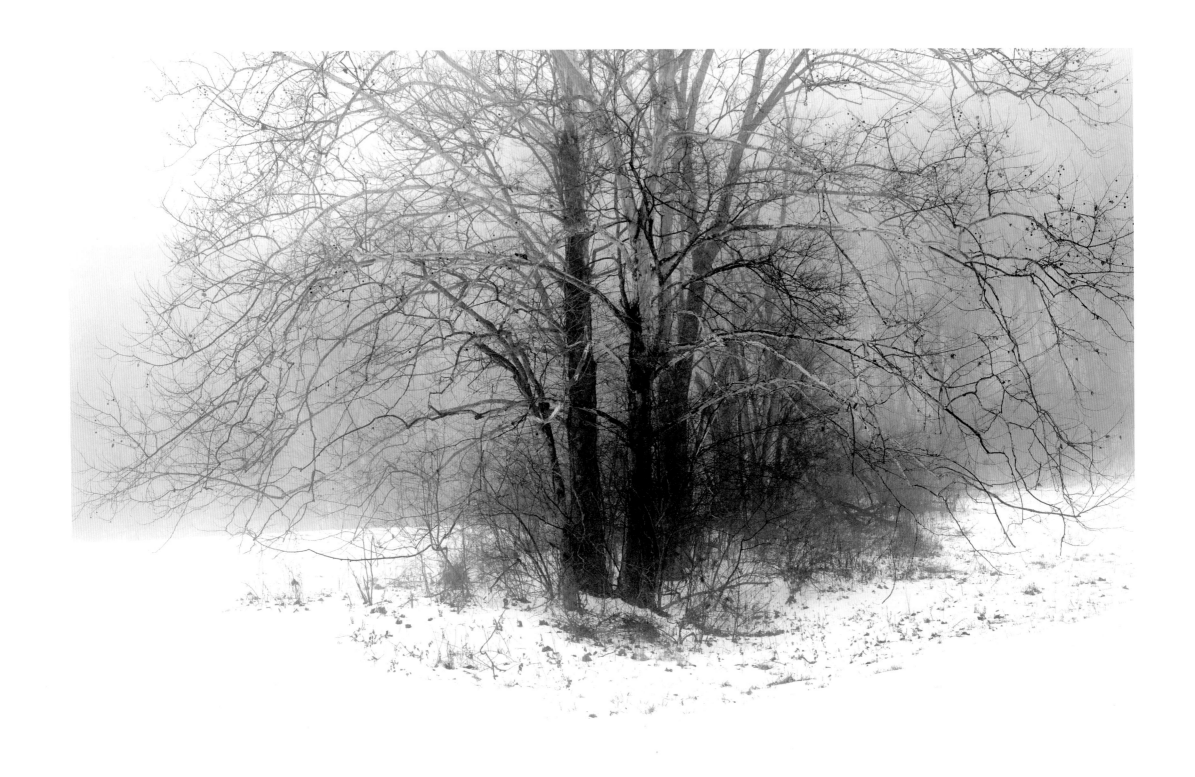

COTTON TREE

2009, Tennessee

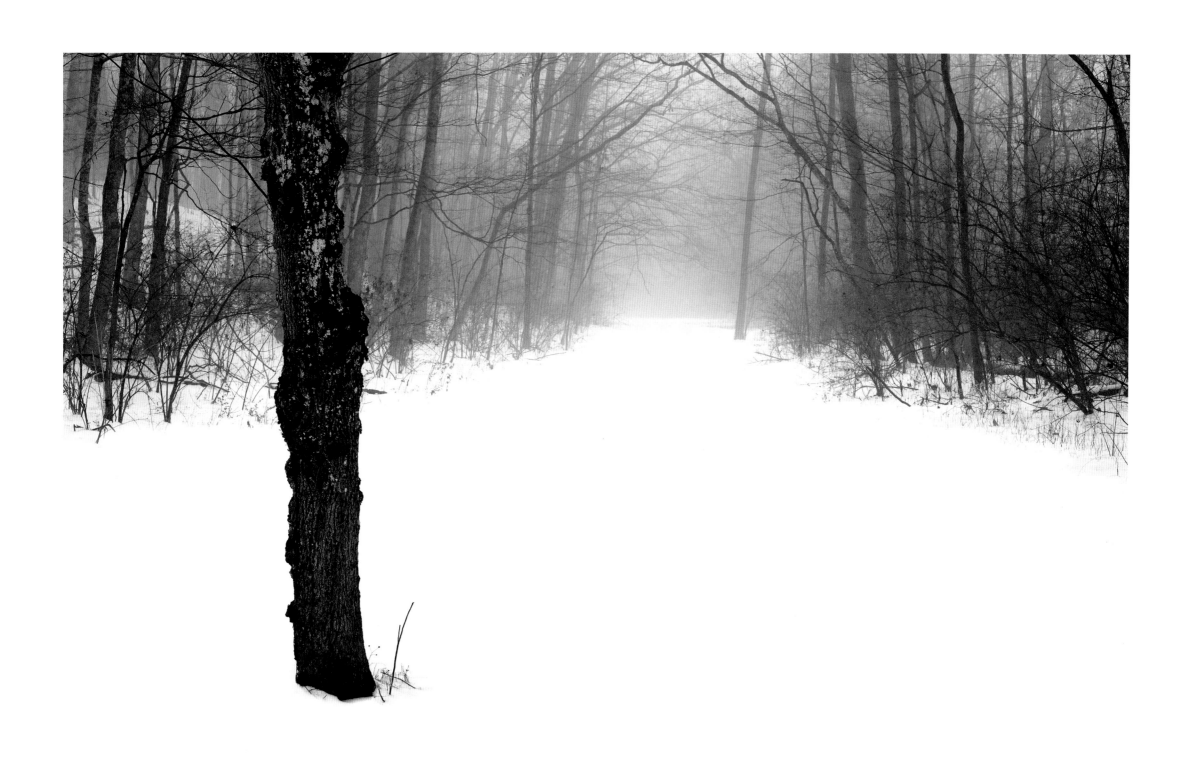

TREE / PATH / SNOW

2009, Tennessee

KENTUCKY FIELD

2013, Kentucky

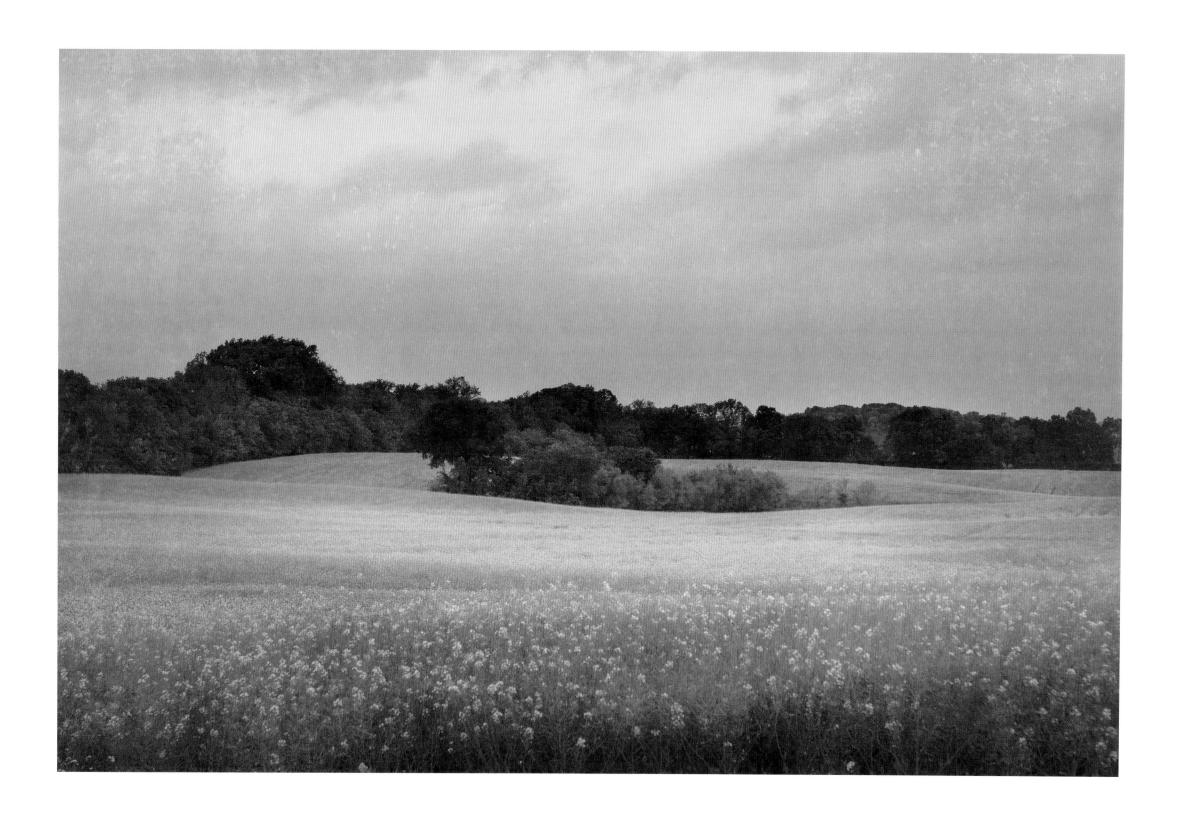

GETTYSBURG #6

2016, Gettysburg, Pennsylvania

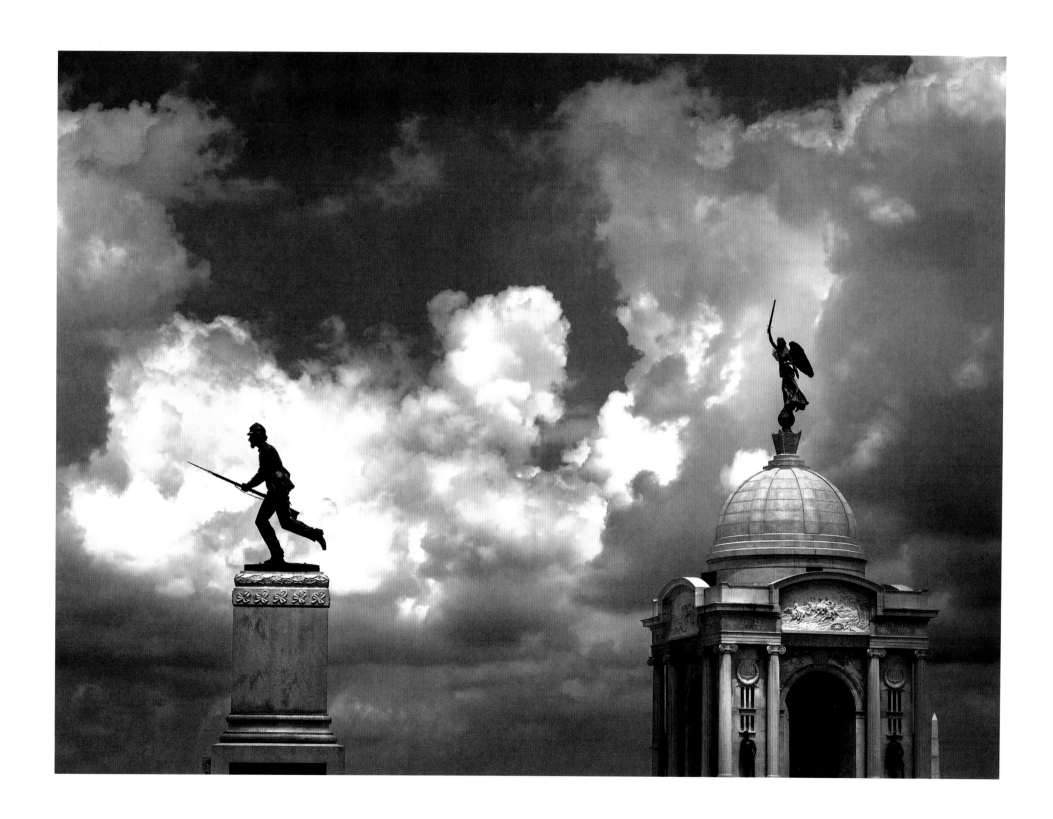

GETTYSBURG

2016, Gettysburg, Pennsylvania

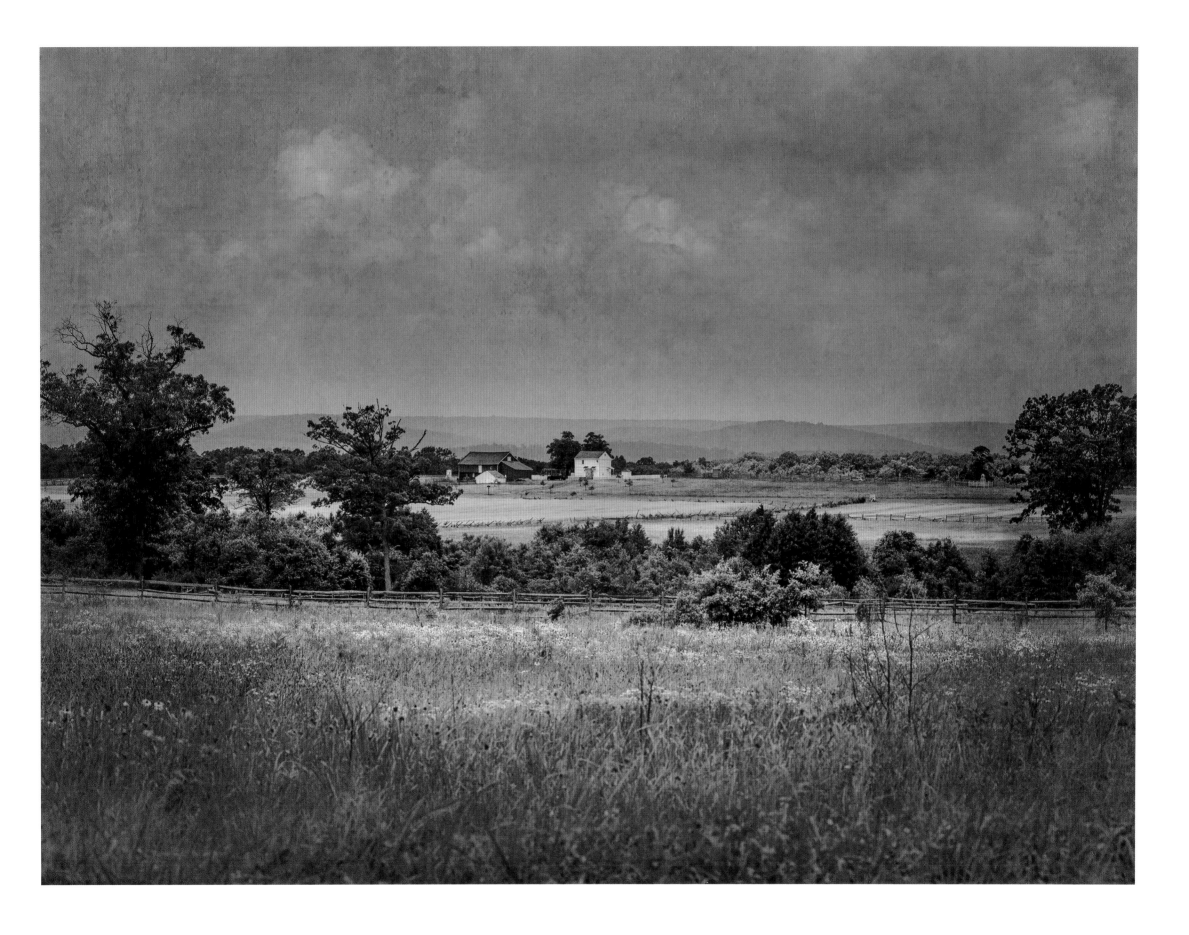

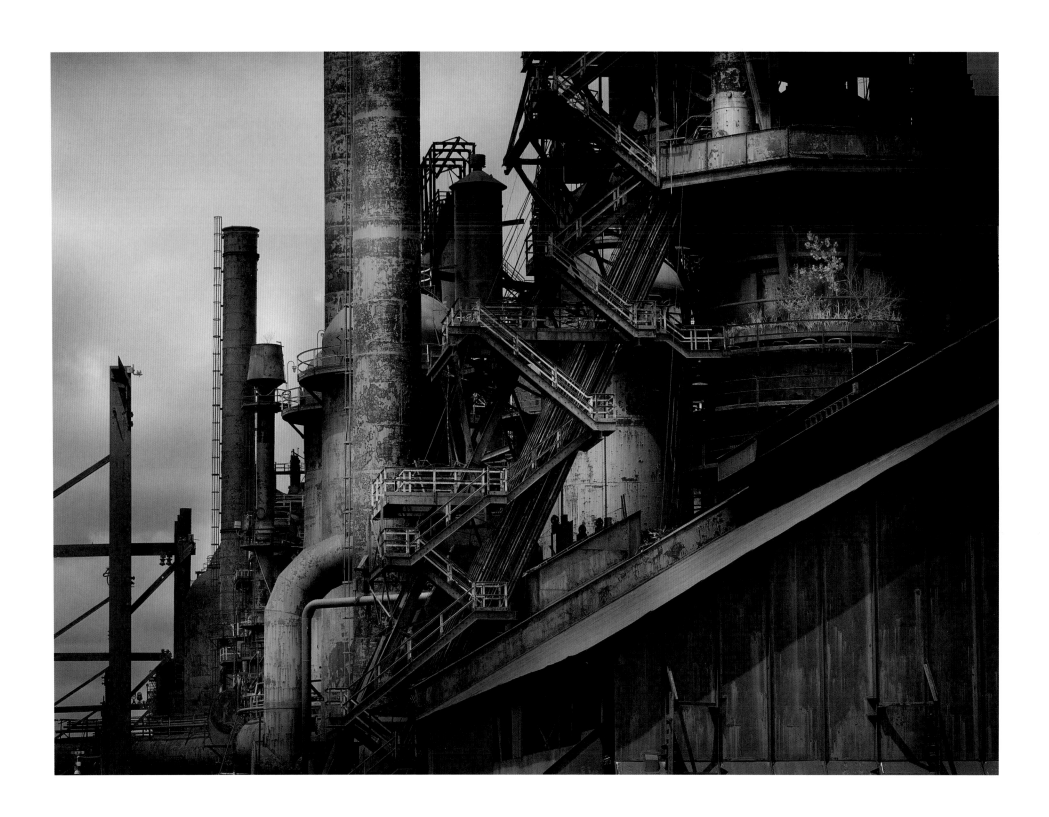

BETHLEHEM STEEL #4

2016, Bethlehem, Pennsylvania

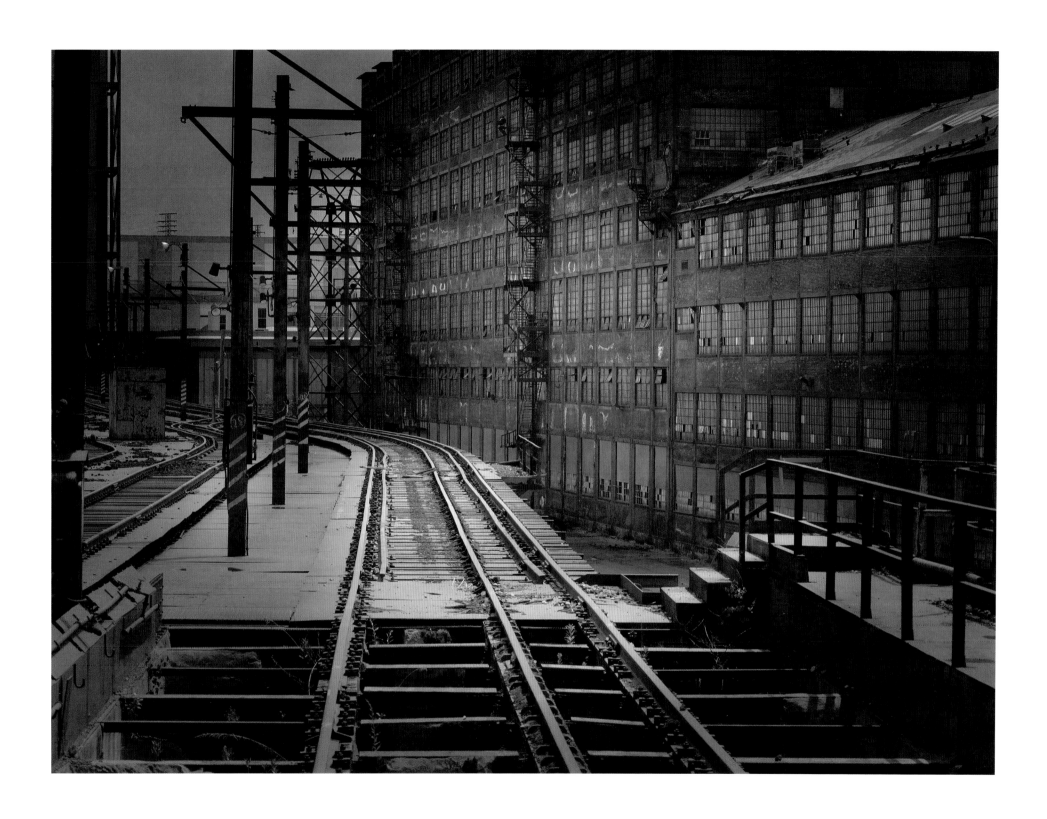

BETHLEHEM STEEL #11

2016, Bethlehem, Pennsylvania

SWAN, LANCASTER COUNTY

2016, Pennsylvania

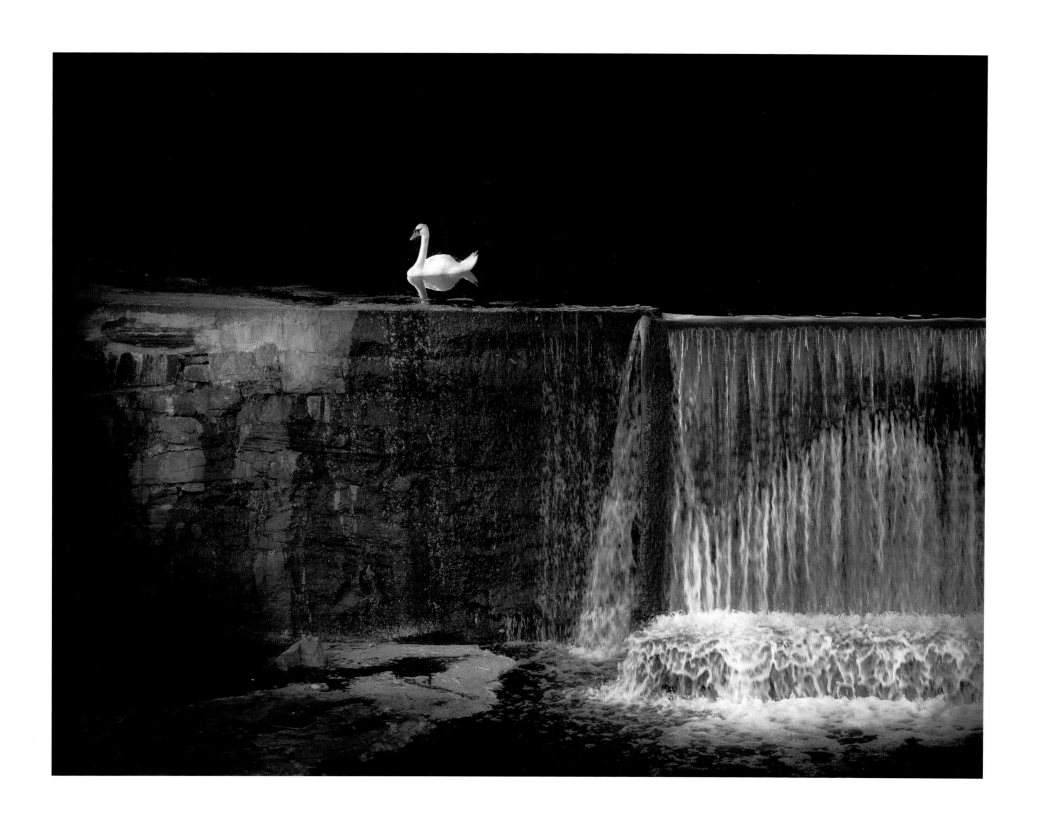

THE PALACE

2007, Asbury Park, New Jersey

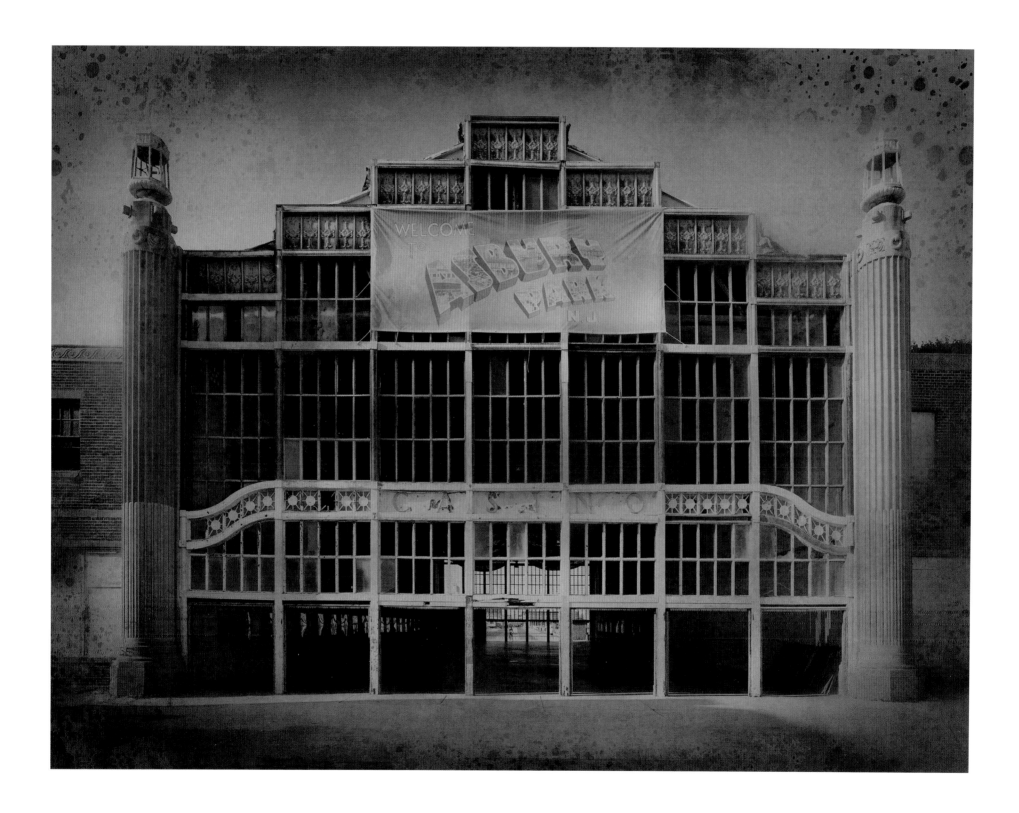

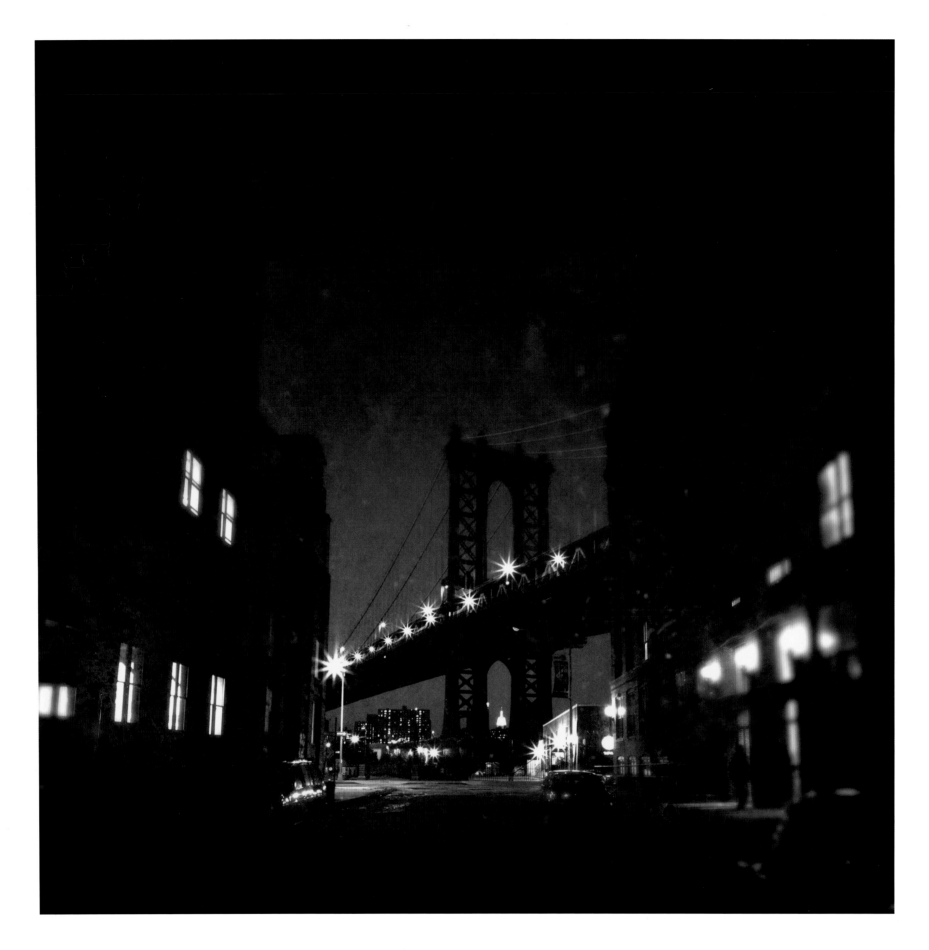

MANHATTAN BRIDGE

2004, Brooklyn, New York

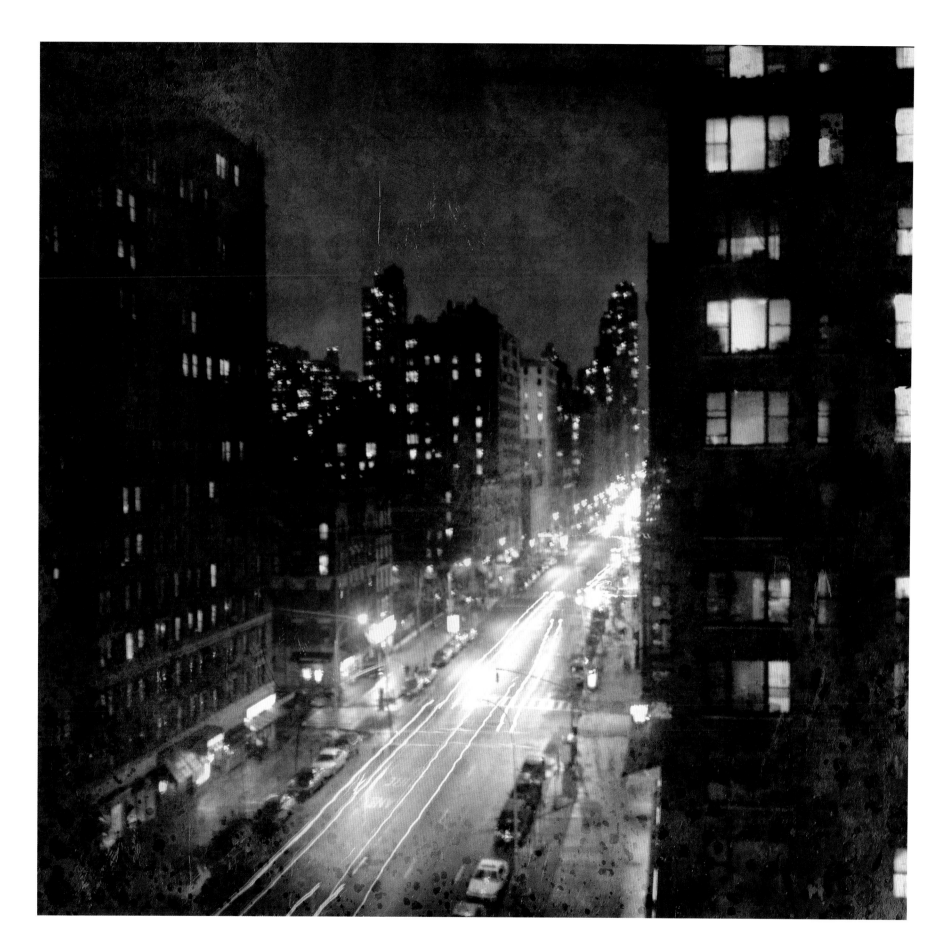

79TH AND AMSTERDAM

2004, New York

BIG PINK

2016, Woodstock, New York

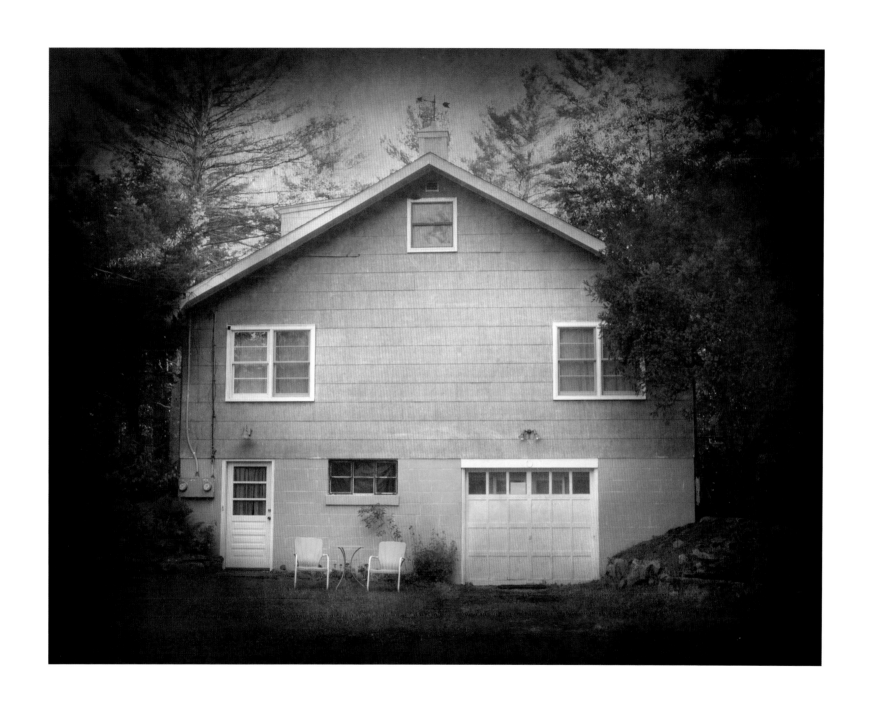

MAX YASGUR'S FARM

2016, Bethel, New York

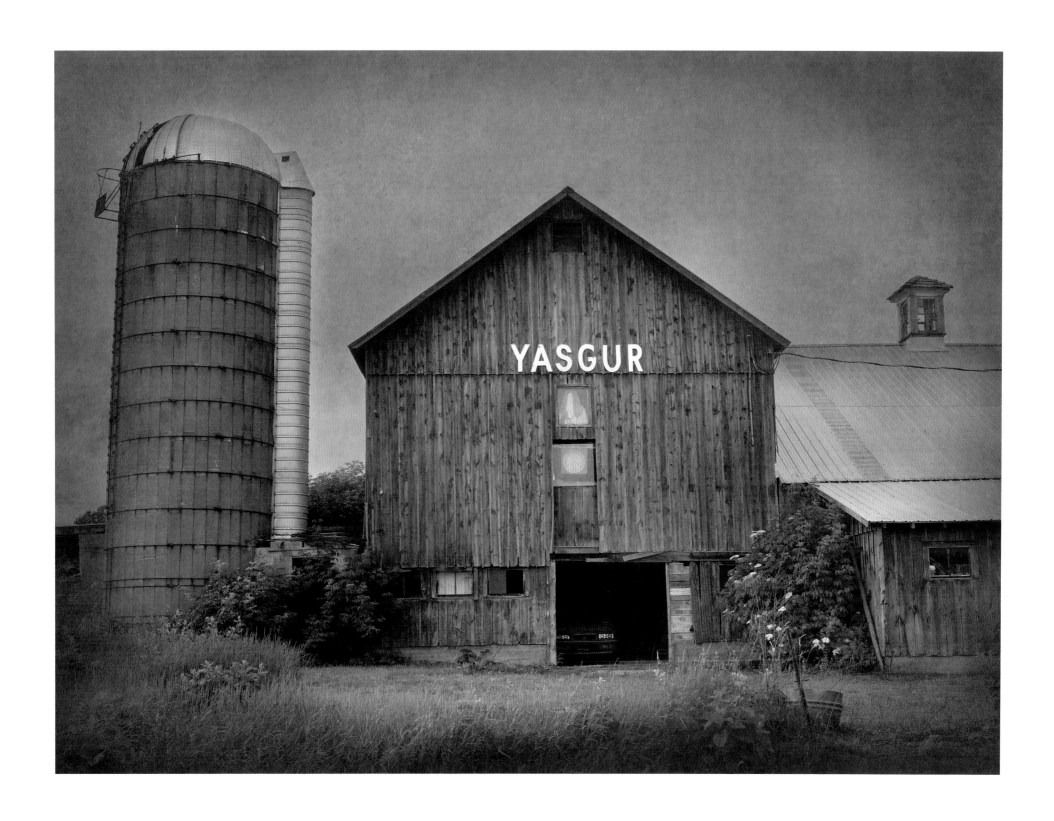

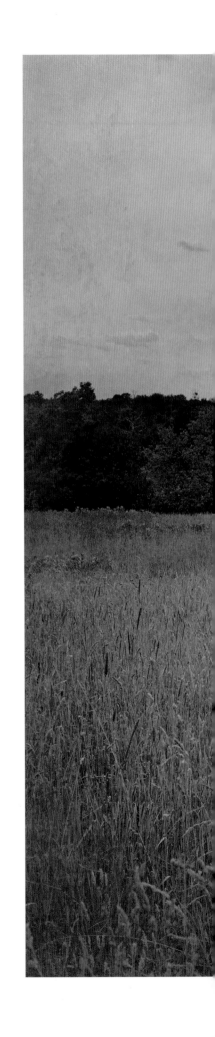

THE HOG FARM

(site of Woodstock Festival), 2016, Bethel, New York

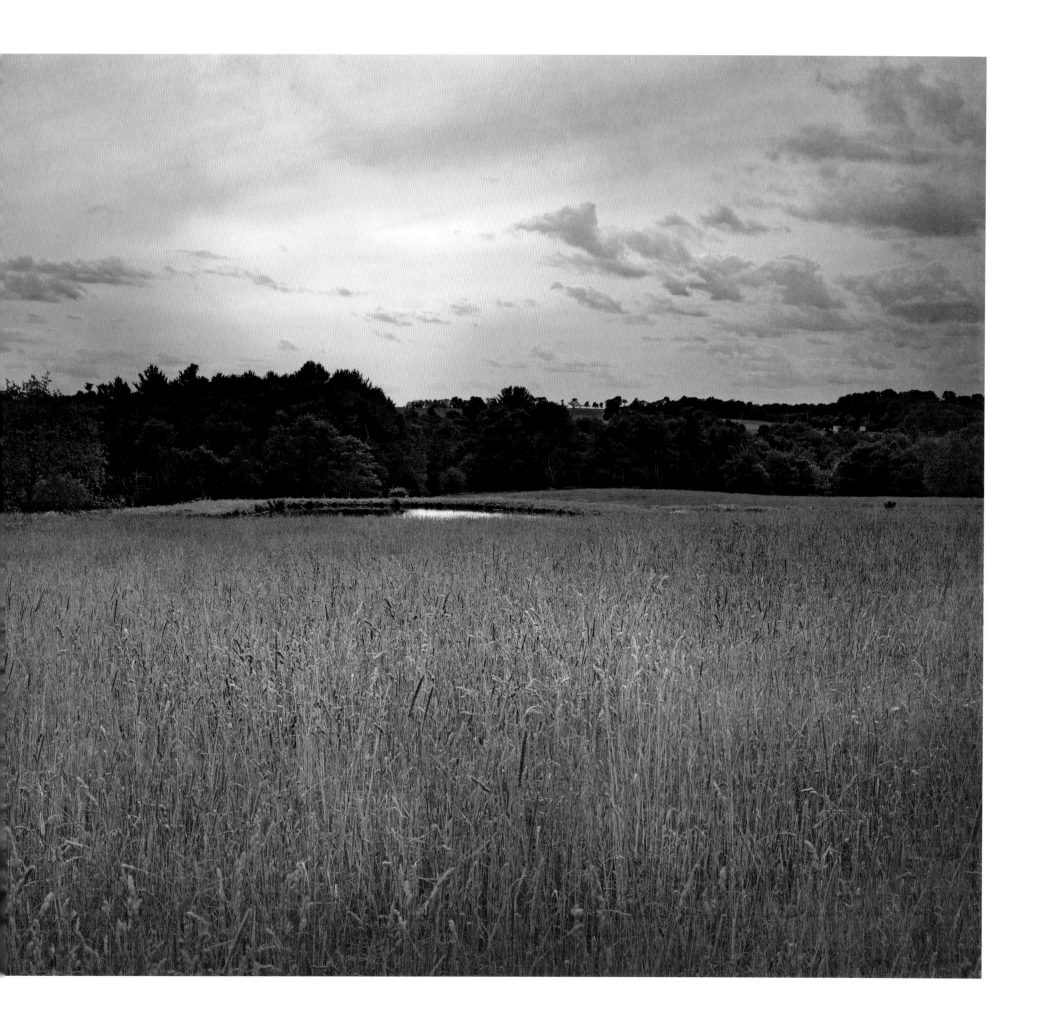

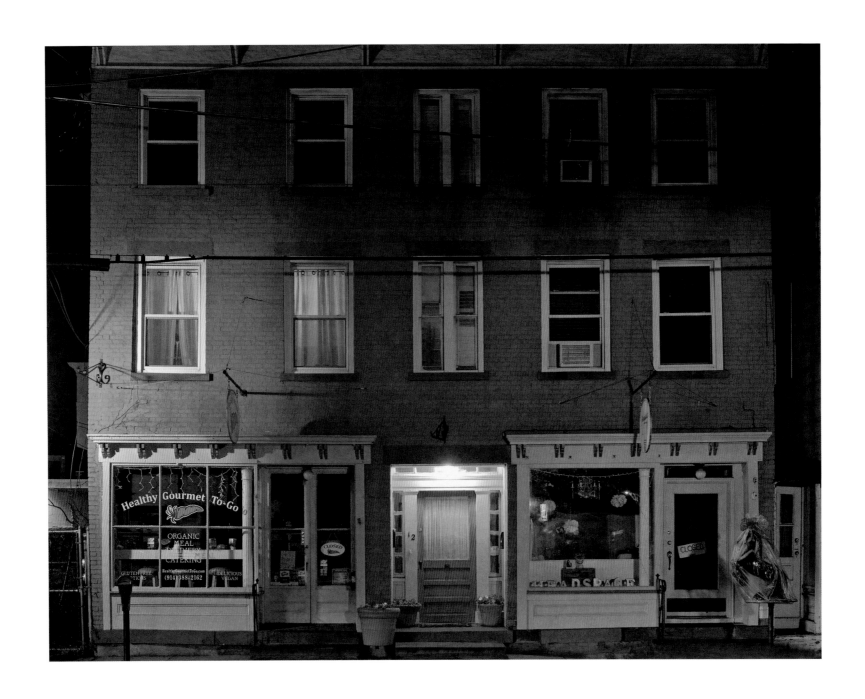

SAUGERTIES NOCTURNE #1

2016, Saugerties, New York

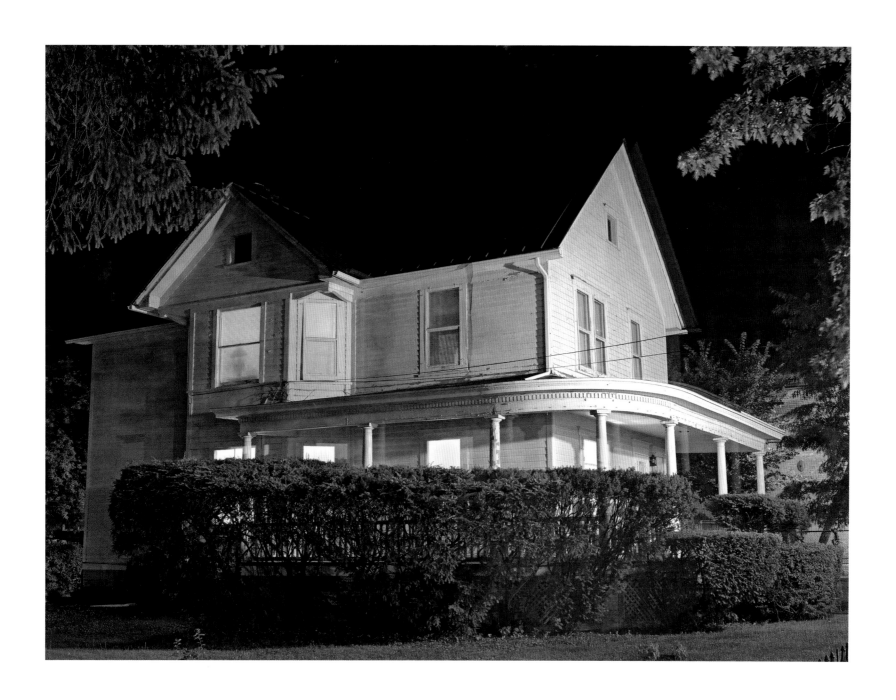

SAUGERTIES NOCTURNE #2

2016, Saugerties, New York

SOLITE MINE

2016, Saugerties, New York

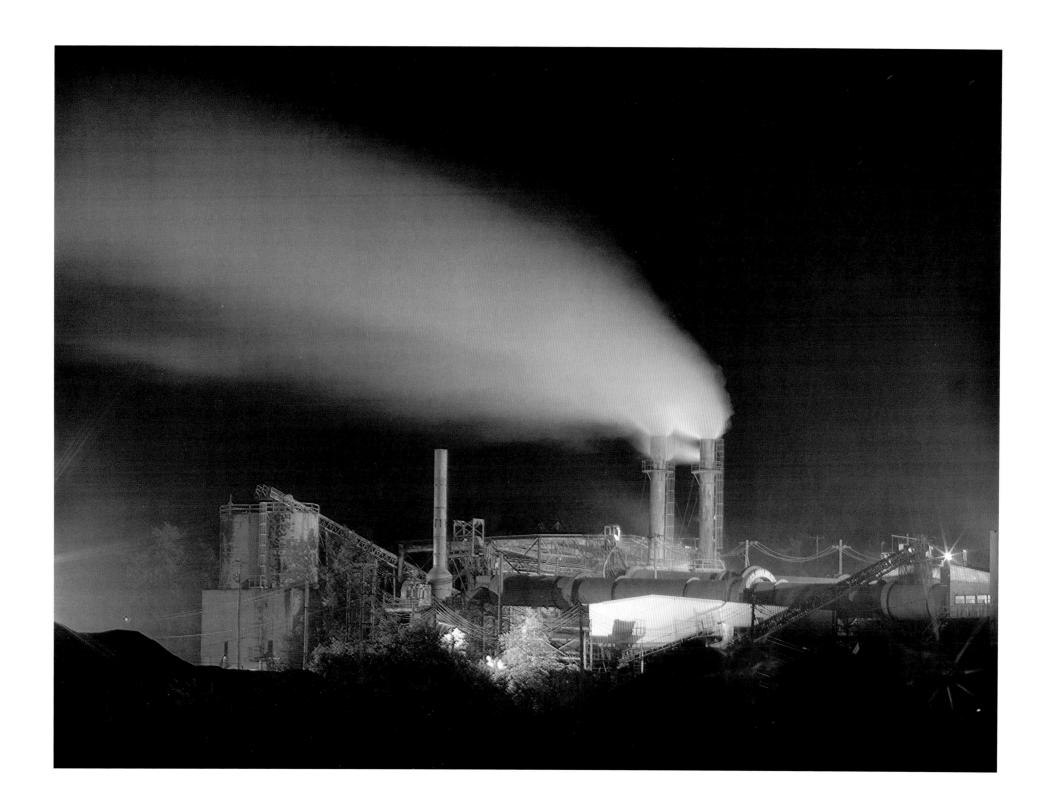

BENNETT COLLEGE

2016, Millbrook, New York

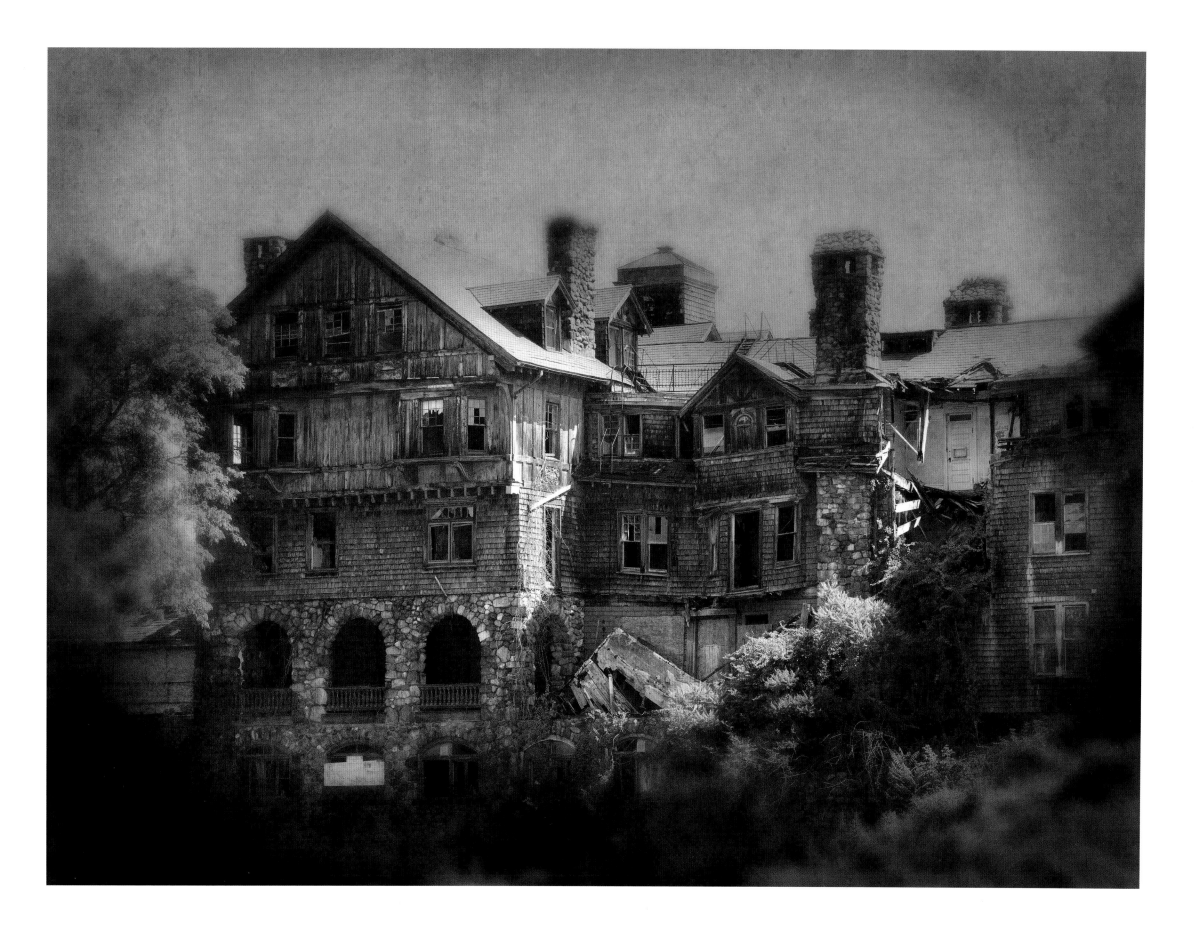

CITY HALL

2016, Buffalo, New York

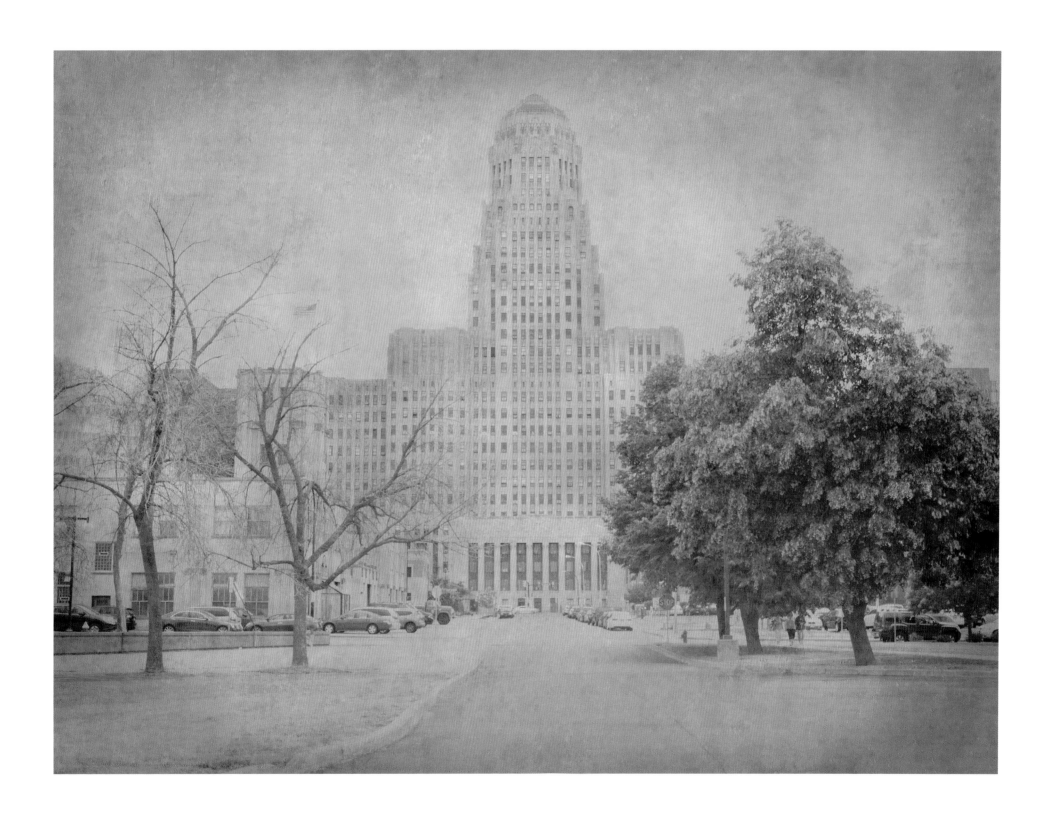

349

2016, Hudson, New York

NIAGARA FALLS

2016, Niagara Falls, New York

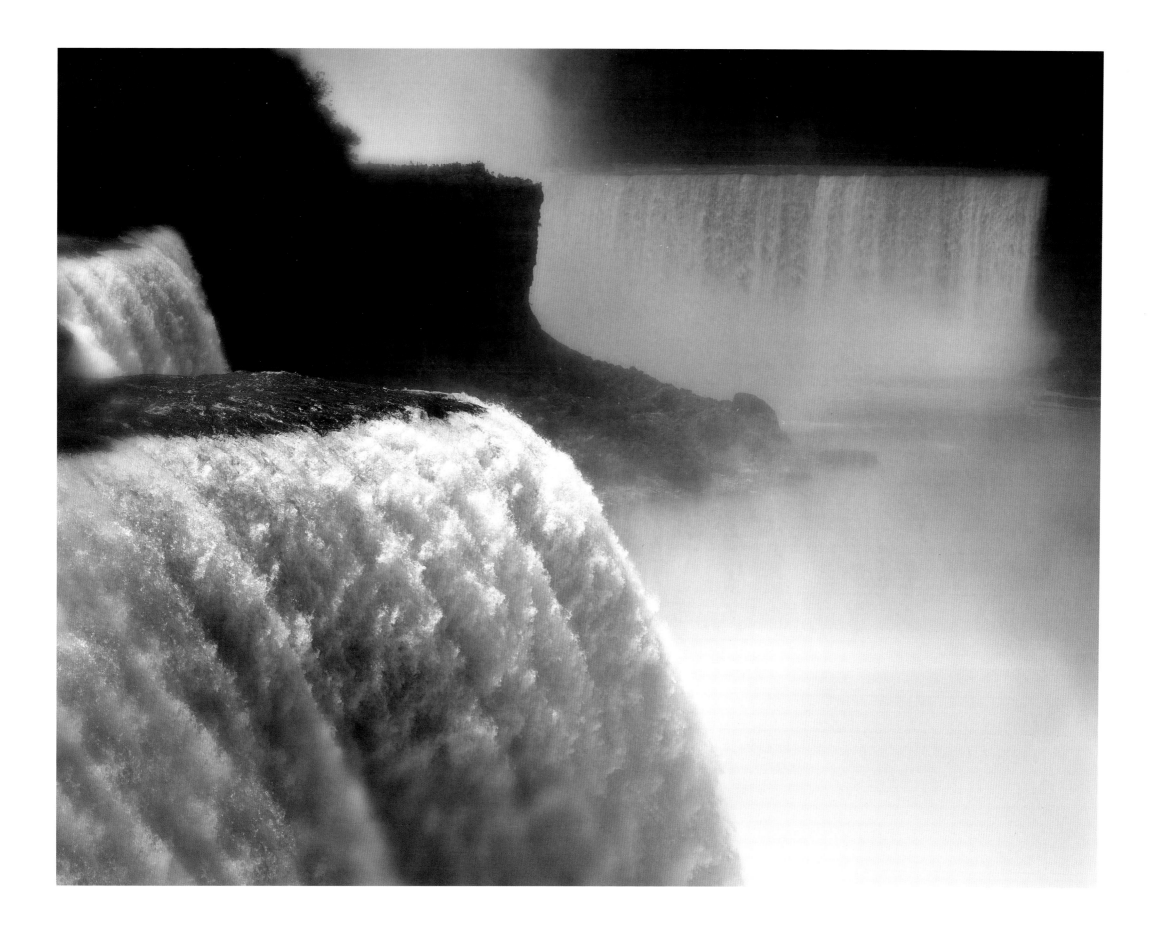

AMISH TRAVELER

2016, Lancaster County, Pennsylvania

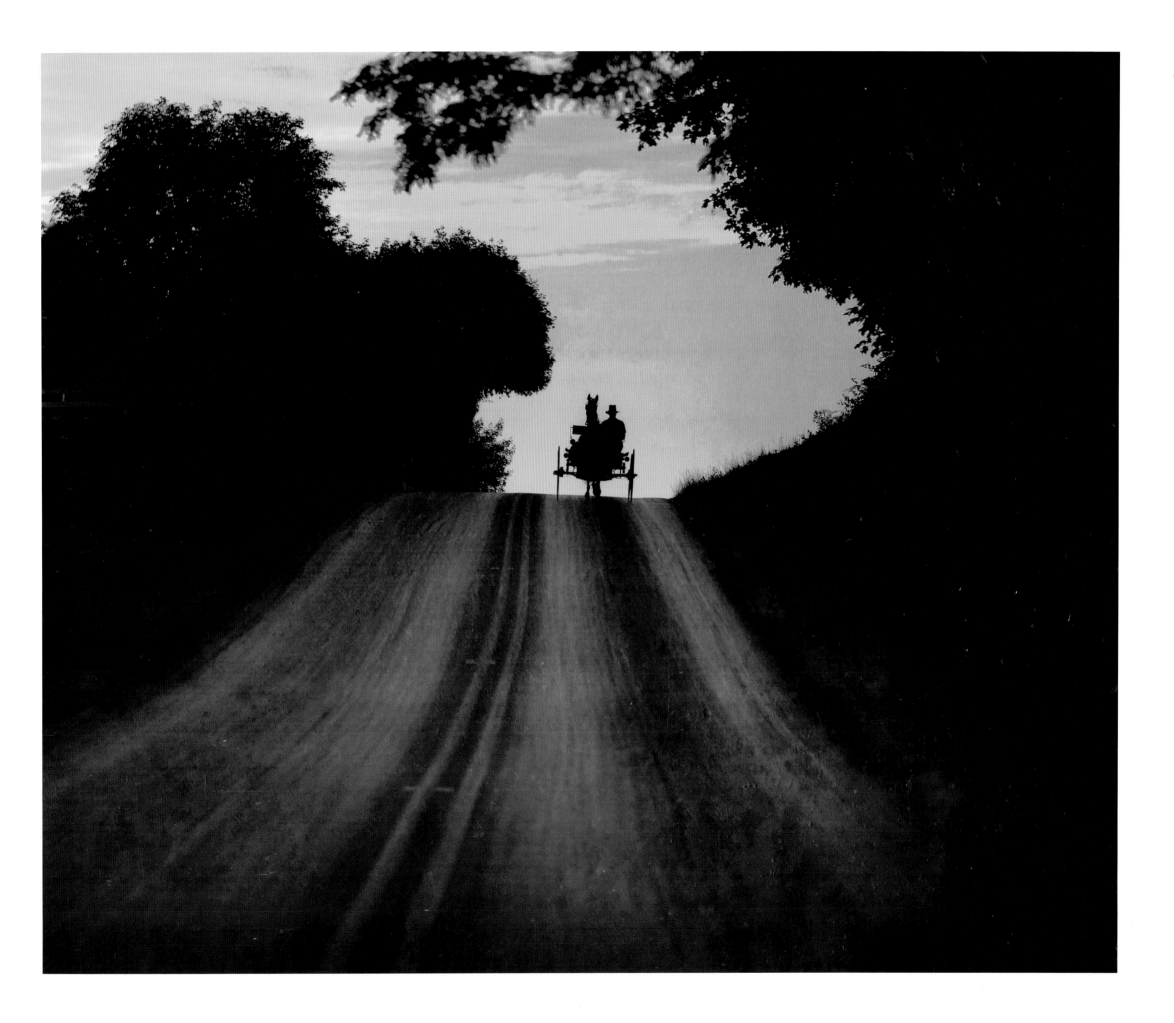

ACKNOWLEDGMENTS

Thanks to Dave Hamrick at the University of Texas Press for friendship, patience, and sage advice. Also to Ellen McKie and Robert Kimzey for their diligent work. A big thanks to Jon Meacham—the smartest guy I know. It's an honor to have him involved in this project. To my good buddy Gary Fisketjon (the Word Master), who urged me to "let 'er rip" and then rearranged my words to make me look halfway intelligent. To those dear friends who gave moral support and encouragement along the way, especially Ken Levitan; Mickey Raphael; Keith Meacham; Julia Reed; Billy and Jennifer Frist, Susan Edwards, Mark Scala, and the entire staff of the Frist Center for the Visual Arts in Nashville; Steve Clark; Anna Walker; Courtney Lee Martin; Malia Schramm; and Gail Severn. For their aid, friendship, loyalty and assistance, Jon Morgan, David Maxwell, Shannon Randol, and Audry Deal-McEver.